# PRAISE FOR *SKETCH BY SKETCH*

'Through profound yet simple teachings and practices Sheila Darcey invites our innate human creativity to express and transcend our turbulence. Following her guidance, we move from turmoil to peace by liberating the artist that lives in us all.'
—Dr Gabor Maté, author of *When the Body Says No: The Cost of Hidden Stress*

'An exquisite inquiry into the deepest parts of yourself. This book will help you bring to light the things that have been haunting you so they no longer hold you back. Highly recommended.'
—Pedram Shojai OMD, *New York Times* bestselling author of *The Urban Monk*

'Drawing, sketching, and even doodling have two remarkable benefits. It is a natural form of self-regulation, calming and soothing body and mind. It also is a way to unpack our personal narratives because even the simplest mark-making stimulates telling the stories of our lives. Sheila Darcey has captured these benefits in this remarkable book; her articulate observations will support you on your own path of discovery through a wonderful series of hands-on practices and wisdom. *Sketch by Sketch: A Creative Path to Emotional Healing and Transformation* is a user-friendly, accessible guide that will introduce you to powerful creative methods and help you integrate the healing practice of sketching into your wellness routine.'
—Cathy Malchiodi PhD, author of *Trauma and Expressive Arts Therapy: Brain, Body, and Imagination in the Healing Process*

'In *Sketch by Sketch,* Sheila teaches the reader to use their innate creativity to bring comfort, ease, and awakening into our lives. She offers a step-by-step guide to help you improve your emotional responses to life. This is like *The Artist's Way* meets *The Gifts of Imperfection!'*
—Laurie Kanyer MA, counsellor, author of *Collage Care: Transforming Emotions and Life Events with Collage*

'*Sketch by Sketch* is an amazing guide to facilitate processes of insight and healing. Sheila Darcey has written a well-crafted invitation to discover the expressive potentials of the artist that dwells within us all.'
—William A. Richards, author of *Sacred Knowledge: Psychedelics and Religious Experiences*

'Art doesn't have to be intimidating. In *Sketch by Sketch,* Sheila Darcey empowers everyone—artist or not—to pick up a pen and begin a transformative creative practice that will change the way you express and experience your innermost self.'
—Alexa Meade, artist

'Reading *Sketch by Sketch* is like diving into a world of creativity, artistic possibility, and expansion. It's a guide to discovering your unconscious blocks and unexpressed possibilities. Read this book and experience personal transformation on every page!'
— Fritzi Horstman, founder of Compassion Prison Project

# Sketch
## ~ by ~
# Sketch

# Sketch
*by*
# Sketch

## A Simple, Daily Drawing Practice for Emotional Healing and Transformation

## SHEILA DARCEY

### with Dr Rachel Smith

**HAY HOUSE**

Carlsbad, California • New York City
London • Sydney • New Delhi

*This book is dedicated to my mother, Micah, and Leila, my trinity of faith, hope, and love.*

*And for Nanay, whose silence was so resounding it spoke to—and through—me.*

Published and distributed in the United States of America by:
St. Martin's Essentials, an imprint of St. Martin's Publishing Group, St. Martin's Publishing Group, 120 Broadway, New York, NY 10271

Published in the United Kingdom by:
Hay House UK Ltd, The Sixth Floor, Watson House,
54 Baker Street, London W1U 7BU
Tel: +44 (0)20 3927 7290; Fax: +44 (0)20 3927 7291; www.hayhouse.co.uk

Published in Australia by:
Hay House Australia Ltd, 18/36 Ralph St, Alexandria NSW 2015
Tel: (61) 2 9669 4299; Fax: (61) 2 9669 4144; www.hayhouse.com.au

Published in India by:
Hay House Publishers India, Muskaan Complex, Plot No.3, B-2,
Vasant Kunj, New Delhi 110 070
Tel: (91) 11 4176 1620; Fax: (91) 11 4176 1630; www.hayhouse.co.in

A catalogue record for this book is available from the British Library.

Tradepaper ISBN: 978-1-78817-707-8
E-book ISBN: 978-1-78817-708-5

Printed and bound in Great Britain by TJ Books Limited, Padstow, Cornwall.

MIX
Paper from
responsible sources
FSC® C013056

# CONTENTS

CONTENTS

# INTRODUCTION

A chair, a desk, a light. A piece of paper and a pen.

Each of these tools represents an invitation to sit and be present with myself. Speaks to the act of mind, body, and working together to express what has yet to be spoken. In this sacred space, time passes to the rhythm of my heart. There is a regular, palpitating beat, beat, beat of anticipation, followed by a slow and steady beat . . . beat . . . beat . . . of a curious mind lost in the creative process. The wordless markings created on the page give voice to all that is stirring within me. Each line develops my understanding of my past. These lines connect to my present, and it is from here I begin to create a future of endless possibilities.

These are the tools of my daily practice, a practice that helps me to articulate what is vibrating inside me. A story that is often filled with anxiety, silence, secrets, and shame. Sketching through the anxiety, I find peace. Sketching through the silence, I hear my heart and my voice. Sketching through my secrets, I see what I have always known to be true but have not had the courage to reveal. Most importantly, though, sketching through the shame, I liberate the glory inside me with humility and grace.

This way of sketching came at a time in my life when anxiety had me spinning out of control, each day was laced with fear and exasperation. Traditional meditation and journaling had not worked. I'd begin and then discard them after a few weeks. They

never took ahold of me. Therapy had helped, allowing me to put the puzzle pieces of my past back together and make sense of the chaos of my present. It also unlocked some happy childhood memories, all of which had something to do with art: drawing a portrait of a family member; losing track of time on my bed sketching in notebooks all day; studying the contour of still-life objects to see how realistic it could look. Each of these memories brought me to a place of peace. Revisiting them brought me respite when the anxiety was overwhelming.

With pen in hand, I found myself making marks as things processed in my mind. There was more to it than doodles. As the lines formed on the page in front of me, my soul was speaking to my unhappiness. Realizing the heaviness that was aching to release, I felt release with each sketch. Without really understanding why, I was compelled to continue. The restlessness within began to take shape. The lines and forms made were the evidence of this, and while there was an innocence to it similar to the way in which a child colors in a coloring book, something about it felt empowering. I discovered the expression of feelings within the marks made on the page. It created a container for whatever it was that needed to come out, and as it evolved the sources of my anxiety became clearer. While similar to meditation, this was not about trying to empty my mind of thoughts. Instead, mindfulness arose and so did the connections to the root source of my discomfort. Sketching allowed me to think, while giving my thoughts permission to run wild. It felt good.

This daily process of self-expression and self-reflection has become a nourishing act of healing and self-care, and a release from the daily grind. It has been both my savior and my evolutionary expander. As it continued, the exercise became SketchPoetic—a creative expression practice. In the pages and sketchbooks that filled in the months and years that followed, I revealed the most vulnerable parts of myself without ever feeling exposed. Sketch-Poetic helped to deconstruct the patterns in my life so that I could

reconstruct a flourishing inner landscape infused with true happiness and joy. By utilizing the power of creativity as a path to awareness, I had found a way to act on whatever was holding me back. I feel, taste, smell, hear, and see everything in my life as inspiration for what is to come. Out of this abundance, I am sharing with you. If this resonates with you, keep reading.

Perhaps you're already thinking, "But I am not an artist!" If that is the case, let me assure you there is no need for training in the arts or for any artistic "talent." We are all creators. We are creating when we visualize our fears and construct our futures in our minds, when we tell stories to inspire and connect with others. Each time we express and release what's inside of us. Each time we engage with the world around us and seek to define our own narrative within it, we are creating without knowing. While ideas are born from those who question, we all have the capacity to create. All that is required to unlock the full potential is your willingness to try.

Artists may read this and balk, but keep in mind—this is not art. This is simply expression. It is a visual learner's version of freewriting. You let your mind wander. You let experiences and thoughts collide. You keep sketching it out of you onto paper. Some of the illustrations in this book were created by me, but many are from those who have completed my workshops. The way I teach you to use sketching in this book is *not* about making beautiful works of art. It's about the process of creating and how that process becomes a life metaphor.

At its core, SketchPoetic is a creative expression that supports your ability to identify emotions, process experiences, and realize outcomes. It can also be a daily exercise that uses design thinking to calibrate you toward what author Dr. Carol Dweck refers to as a "growth mindset." This means believing, or at least being willing to believe, that each mark will get you closer to where you want to be, with the potential to help you navigate a big evolution, and all the little evolutions that come with it. Ultimately, the

> The day came when the risk to remain tight in a bud was more painful than the risk it took to blossom.
>
> —Anaïs Nin

sketches you produce become an expansion of your existence. You make them and they make you.

This book contains forty sketching prompts within twenty-one chapters. You may choose to do them in order, or select the one that speaks to you at that moment. You can also repeat the prompts as many times as you like. However you decide to complete this book, be sure to complete every chapter. There may be chapters you want to avoid or don't think apply to you, but, dear reader . . . those chapters often contain the lessons you need the most. Complete them all.

In this practice, it might also get a little spiritual, but let me clarify that SketchPoetic is not religious. It also does not replace therapy and it is not an art form. I am not preaching a faith, providing counseling, or teaching art. Whatever faith you hold or do not hold, it is all a part of this practice. Whatever issues you have or don't have, they are also part of this practice. Whatever creative skill you have or don't have . . . *all* of it is part of this practice.

You can begin by simply thinking of it as a healthy way to express your emotions. A way of getting anger, sadness, anxiety, or joy out of your body and onto the page, allowing you to bear witness to what you're feeling without any fear or judgment. What you will notice as you embrace this process is that you'll begin to experience a shift in perspective. You will be better able to connect the shadowy workings of your inner world to the events unfolding around you. You will discover that going inward in this way is what gives us permission to be whole and to see ourselves as part of the interconnected web of creation and evolution.

Part of the healing process is recognizing that we are all complex, emotional, and social beings. We all feel experiences in different ways, and the context in which we feel these experiences facilitates the way our feelings are expressed. The process of feeling is not about judgment. Joy, for instance, is not more important than depression. One emotion is not more valuable than another. Rather, SketchPoetic is an act of self-care that allows us to explore

the range of emotions we all experience in a healthy and productive way. In this way, you will learn that all of your emotions are here to serve you. Even the emotions that feel powerful enough to completely devastate you, can serve as guideposts on the path of self-awareness.

In fact, you'll learn through this book that when we choose to deny a certain emotion (i.e., shame, guilt, anger, fear, etc.), we hold ourselves hostage to its impact on our physical, mental, and emotional well-being. In this way, SketchPoetic is as much about self-love as it is about creative expression.

# YOU ARE READY, REALLY

Let me guess, you're wildly intrigued by the idea of art as a tool for healing, but you may already be making excuses for putting off taking the leap:

- I don't have time.
- I don't have the energy.
- I don't have a creative bone in my body.
- I don't have the space or the tools to get started.
- I already have a daily ritual.
- I should be using my time to do more productive things.
- I haven't created art in a long time.
- Daily feels daunting.
- Art feels intimidating.
- I probably won't feel anything.
- I'm not ready to feel certain things.

It may be easy to find reasons this might not be for you. However, instead of thinking of it as a potential burden on your time or a rigid framework or process, imagine it, right now, as a tool you can access at any time and in any way that feels good to you. Any

hesitation you are feeling at this point is actually an indication of your readiness to take action. I invite you to honor each one of the reasons you think you cannot engage because underneath those reasons, you know you need to change or make something happen. In forcing change, it may feel like you are fighting gravity or trying to move mountains. "It's impossible," you think.

It is possible. Keep reading.

Many of us harbor fears of stirring our most deep-seated emotions and the experiences connected to them. We've made it this far in life without "going there," so why start now? In answer to this, let's look at that fear for a moment. You may think your personal fears are there to protect you, or that your denial of fear is what makes you "strong." However, in both instances, fear is keeping you from stepping into endless possibilities for how to live freely in truth.

## YOU ARE ENOUGH, REALLY

There are many tools out there to aid in your SketchPoetic process of transformation and/or healing. My rule of thumb is to keep it simple at first. This isn't about becoming a master artist or having enough supplies to build an art studio. What matters most is that it fits with your lifestyle. Here's my recommendation as a basic starting kit:

- Black pens (wide and thin)
- Blank notebook or loose-leaf paper (choose a size that is portable)

Can I use a pencil? For this experience, the answer is no. If you're anything like me, one of the habits you'll need to break is the need to get it right or make each sketch "perfect." With a pen, there is no option to erase. Each and every line has its purpose.

Every mistake, perceived or real, is meant to be. Even if you have the self-control to use a pencil without erasing, removing this option entirely is part of the discomfort. Can you use watercolor or other mediums? Yes, and you will, but again, starting simply with a pen and a paper has a purpose.

It is most important to focus on the process of creating, rather than the tools or the outcome. Thus, your supplies can be as cost-effective or as expensive as you want them to be. Start with what you have at hand. As you begin to embrace this practice more fully, you'll know when it's time to invest in higher-quality supplies.

Let accessibility and portability determine what to use. As you look for opportunities to sketch that fit into your daily life, you never know when you will suddenly feel the need and have the opportunity to do so. There will be times when you will be sitting around waiting and thinking. Thinking will stir feelings, and you'll wish you had your sketchbook and pen.

## START WHERE YOU ARE

This daily commitment also has to fit with your life and schedule. Thus, setting a place to regularly sit and sketch is something to consider. Ideally, you will find a place where you feel comfortable and safe, but this could be different for everyone. For example, some people prefer to sketch in private, while others are fine doing it out in public. If you do it often enough however, you will find you forget where you are because you so quickly become lost in the process.

I cannot predict what it will look like or become for you, but I can guide you toward finding this place in the chapters that follow. Pick a location and a time when you can be as consistent as possible. Following are examples that have worked for others:

At Home

- First thing in the morning with tea or coffee
- On a break from work or chores
- Before bed with a candle
- While the kids play or the baby naps
- As a replacement for time spent on social media or binge-watching shows

At Work

- During coffee breaks or at lunch
- Before or after a meeting
- In transit on a bus, taxi, train, or plane

If you have the luxury, pick a time and schedule around it. If not, be spontaneous, and simply be on the lookout for opportunities to leap into it.

## LET'S BEGIN

Focus on introducing this new habit into your life. Spend at least ten minutes a day to begin with. Then, over the next twenty-one chapters we will build up to sketching for up to thirty minutes a day. If you have more time, then go with it! Don't feel you have to follow my instructions so rigidly that you feel you can't explore and expand. Use them as fuel for your own fire.

Keep reminding yourself that this is not about creating art. It is about the process of creating *and* about the creation itself. Each time you sketch, pay attention to how you feel while you do it. Feeling unlocks the flow. Let your mind and all your thoughts surface, swirl, and spin. Get lost in the act of creation. Follow your

curiosity into the unknown and be in flow with the uncertain nature of it all. Trust me. It is easier than it sounds. You read it correctly. It is *easier* than it sounds. I'll share cues and prompts throughout this book to help you experience this.

For now, here are a few final guiding principles as you leap into it:

- You are an audience of one. This is probably the hardest truth of this journey, but also the most rewarding. Artist or not, we all tend to create with an audience in mind. It could be a person, a group of people, or even a stranger. Someone who is there to critique or validate you in some way (both equally appealing to the ego in their own ways). But this is for you and only you. If you decide to share your sketches at any point, then this is a choice you can make. I will offer advice on this also. However, it is not the purpose or the "why." You must learn to create solely because it is what you must do for yourself.
- Be ready to release emotion or energy. If you go into this with the understanding that you are choosing to release something into your sketches, then you are already halfway there. Intention is a part of it. Think of SketchPoetic, first and foremost, as a healthy way to express something that's become lodged in your mind, or in your heart. Something that has been weighing on you. Something you are unaware of that needs to be released.
- There is no right or wrong. The less you focus on any perceived "imperfections" in your sketches, the more freedom you will have to explore your inner life. Allow yourself to be afraid, to have doubt, and to feel intimidated. Allow your technique and execution to be perfectly imperfect. This is the best gift you can give to yourself.
- There is no such thing as a mistake. Each and every line, dot, space, spill, etc., is a mark that your subconscious intended you

to make. Part of the journey with SketchPoetic is learning how to let go, and how to see the beauty and the intention in everything. This means freeing yourself from judging what comes out of you, going with the flow, and indulging in the process.

• Be patient with yourself. The act of creation is healing in and of itself. Interpreting the meaning of what you create is an extension of this journey, but this will take time. Even if you don't know what your art is saying or expressing at first, it doesn't matter. Over time, this will begin to shift. You will start to connect the imagery or themes in your art to the way your inner life is being projected onto the world around you. When this happens, you will find yourself moving beyond the process of creation itself and going deeper into it. Do not rush to get to this place, though. Allow everything to unfold in its own time. Your job is simply to be patient and trust in the process.

With this book, I am inviting you to sketch with me down a road you've been wandering your whole life. While my invitation to daily sketching was laced with anxiety and confusion, yours may be filled with excitement and anticipation. Whatever experience led you to pick up this book, it is important to embrace this as your ignition point. SketchPoetic is simply a tool to help you get started—what unfolds from here is the next step on the evolutionary path you have always, and will always be walking.

As we make our way, you will awaken the truth of where you've been, where you are, and where you are going with new understanding. The truths uncovered through SketchPoetic are marked out like milestones on a map in the chapters that follow. In my creative journey, it began one way, wandered another way, chose this way, worked that way, and encountered my fear in every way, until I was ready to find the way back inside myself—the way of

true love and liberation. Each day, my sketches lead me to a place where my inner compass stops spinning, and I can calibrate toward my truth. You, too, will soon begin to see that your truth will take on a life of its own when it wants to set you free. All we have to do is say yes to it.

Dear reader, let's leap into this with faith, hope, and love. Let's examine our beliefs, trust the process, and find our courage. To stare at the purposeful movement of your pen on paper as it enraptures your senses. And to fall into the flow as you surrender to a greater creative force. Keep in mind as you do that this force is as instinctual, as involuntary, and as protective, as the force of your resistance to surrendering. It may feel as though you should be doing something more useful with your time at first, but do not abandon the practice . . . or that feeling of conflict. In fact, sketch it. You will become something from it.

Ultimately, a greater good will rush through your soul as it makes its way out of you onto paper. The light will come on inside you, and you will gaze in awe and wonder at what you have made. It will plunge you into the depths of your emotional processes, and in doing so awaken you to your connection with the universe and your role as a creator in it. Allow this practice to illuminate the places and the truths that you have always wanted to visit inside yourself but have never dared.

All you need to do is begin.

# VISUAL LIBRARY

The following guide is a Visual Library to help get you started with creatively expressing your emotions on paper. Use it as a reference point or a source of inspiration throughout your journey. Your own intuition will always be your primary compass, but this collection of sketching examples may help spark your imagination. When you are approaching a new prompt and notice a block, practice scanning your body for emotions and then look for the mark in this guide that best connects with how you are feeling. If one pattern is calling you, this is the one to explore. If there are multiple, perhaps try blending variations of each into your sketch. Once you begin, you will know what to do and where to go.

Start creating your visual library by adding your own marks in the empty squares below.

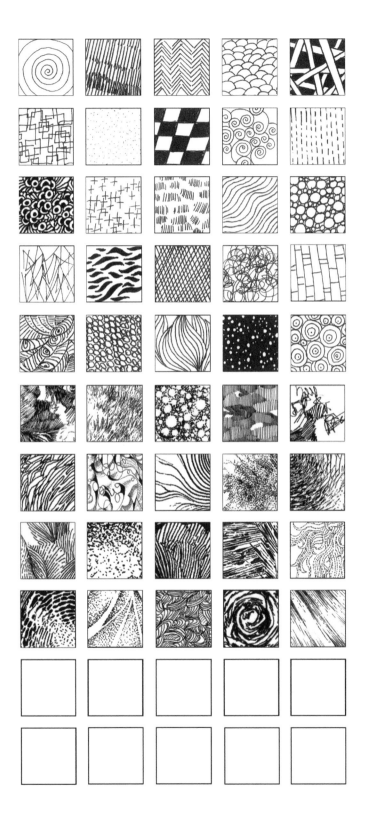

# THE FEELING WHEEL

In addition to the Visual Library, I am including this model created by Dr. Gloria Willcox, who developed The Feeling Wheel: A Tool for Expanding Awareness of Emotions and Increasing Spontaneity and Intimacy. I use this model in my workshops to help others identify the words that best describe their emotions.

If you are like me, you may find it challenging to label or understand what it is you are feeling. You may also find that you are feeling more than one emotion at the same time. Do not let the language of emotions be a barrier to your taking this leap. Rather, use it as an opportunity to deepen your emotional vocabulary and connect with the many layers within. It is truly liberating.

To help you get started, refer to this feeling wheel whenever you are uncertain or unsure of what it is you are feeling. Use it as a reference or inspiration to guide you.

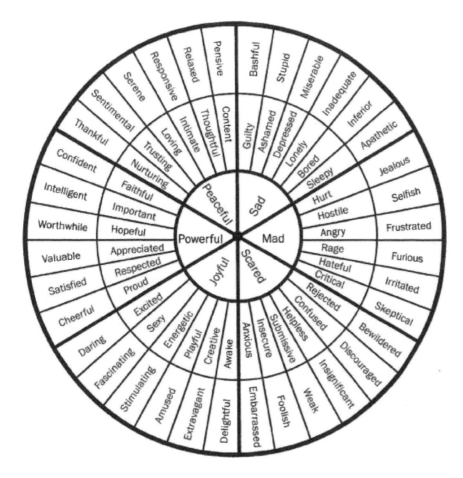

# I

# SKETCH HOPE

*Knock-knock. Knock-knock, knock-knock.* When the winds of change come knocking at the door of my heart, the sound always startles me. *What is this? Who is that?* But then I recognize the sound. The knock of change is distinct and familiar. Its rhythm is consistent and persistent. It cannot be ignored. Instinctually, I move toward the sound, but hesitate. The force of nature stands on the other side. It is a force difficult to fight. When the door opens, chaos will consume me. The wind will swirl, disrupting everything carefully put into place. As it does, it will ask to believe all things are possible, hope all things will work together for some greater good in my life, and endure all things that rush at me. *Beat-beat. Beat-beat. Beat-beat.* The beat of my heart matches the rhythm of the knocking. *Why would I invite this chaos in?*

There is a fine line between anxiety and anticipation. Anxiety is a mindset of fear. Anticipation is a mindset of hope. It is possible to feel both at the same time. Fear the chaos and unknown outcomes of change while also anticipating what opportunities will come as a result of it. However, only one of them can govern my actions at a time.

Listening to the knocking with anxiety, the door to change

I fight pain, anxiety, and fear every day, and the only method I have found that relieves my illness is to keep creating art. I followed the thread of art and somehow discovered a path that would allow me to live.

—Yayoi Kusama

cannot open. Instead, I become paralyzed with the compulsive need to protect the peace and fear the worst is about to happen. Total destruction is imminent. The winds have to force their way in, and the change feels invasive and violating as a result.

However, if I listen with anticipation and let the winds of change enter, this breath of fresh air provides extra oxygen into my lungs. My inhale collides into, over, and around me. My exhale becomes part of its force. All at once, I am elevated and part of the change rather than a fighter of it.

*How do I turn the same anxious energy into anticipation?* you wonder. So did I. In fact, that is how my journey to SketchPoetic started.

I was an anxious flyer and still am to some degree, but less so now.

Whenever an airplane quickly lost or gained a fraction of altitude, the leap up from the seat completely untethered me. Constantly traveling for work further exasperated the anxiousness in ways that were becoming all-pervasive. The awareness of chronic imperfections waged war with my perfectionist tendencies. My people-pleasing personality felt like it could not please anyone, and meaningful relationships felt void. Gaining control of external circumstances was a constant battle. Professionally and personally, I seemed to have a handle on life, but instead I was losing my grip on it.

Through the years, my fear of turbulence worsened. The unanticipated shake of the fuselage. The roar of the engines. The utter lack of control. It all rattled a strongly held, yet previously unexamined, belief of mine—*If I am good and do good then nothing bad will happen,* but every time turbulence came, none of my goodness mattered.

After trying journaling, yoga, exercise, meditation, and almost everything to make peace with the rumbling and restlessness in my soul, I found myself doodling on my notebook at work one day, processing the content of the meeting with more

awareness and understanding. There was a calmness—an escape. There was less anxiety and nervous energy. It wasn't meditation, but it was meditative.

There came a point where tackling the source of my anxiety alone was not ideal. I had been putting off seeing a therapist. *Therapists were for other people with pathological issues. My issues aren't pathological. I can handle this on my own. It will eventually get easier.*

It did not.

I could express my positive and negative emotions in a healthy way through sketching, identify them, and accept them, but couldn't understand the reason why such fierce and strong illogical reactions were happening in the first place. Shortly after, I made my first appointment and began investigating, with *much* trepidation, the root cause of my fear.

At first, the turbulence of my childhood came back to me in pieces . . . the unpredictable anger of my alcoholic father . . . his possessive love and wild jealousy . . . the fury and the silence of his abuse on my mother . . . Memories that laid dormant started to arise. All the anxiety and fear woven into these experiences unearthed like buried ghosts.

Let me pause here and say that on some level, I knew *why* my anxiety was there all along. I could hear it thumping on the inside of my soul for years and built my life over it. It was louder in my youth, but as time passed, the sound grew fainter. Unearthing these ghosts of my childhood through therapy did not bring immediate relief. It made me more aware of the fact that the distance created wasn't safe enough. These memories could reach me at any time. This realization was not liberating. It was terrifying. There was no solid foundation to stand on. I was suspended above it—disconnected and trapped. Less in control than ever before.

Sketching through this time in my life helped me express the anxiety and despair. It supported the process needed to make

connections between the past and present and as much as I didn't want to revisit these experiences, doing so helped me to face the shame with grace.

It was about a year into daily sketching, when the memory of my grandmother surfaced. My *nanay* had been a second mother. We had a special relationship and a connection that didn't require many words to be exchanged between us. It was a simple shared understanding of each other and our interaction with the world.

Remembering her laugh left an ache in my heart. When she was diagnosed with cancer, my mother told me her condition was deteriorating quickly. We didn't know how much time she had, but we all knew we needed to be with her. My mother immediately planned a flight to Australia where my grandmother lived, but I did not.

The news of my grandmother's cancer happened during a very difficult time at work where the pressures of growing the business were all-consuming. It was my priority. It was my future. I had also managed to convince myself that I could not watch my grandmother die. "It would be too painful to say goodbye," reason would say. "I want to remember her the way she had always been . . ." These narratives played over and over again until the truth became buried—my grandmother's death would be a devastating loss and combined with the reality of being trapped on a plane for fifteen hours with turbulence . . . no. I could not. I would not. I didn't.

At the time, it seemed rational. It was not a conscious choice and unknowingly, this choice would haunt me years later. The shame flushed my face as this connection was made. It still flushes me to think about it.

I let my grandmother die without saying goodbye.

This sobering truth still hits me harder than many of the truths encountered while sketching. *How could I have made such a senseless or heartless choice? How did my fear become so great it*

*overpowered my heart? And, how was I not aware of how bad my anxiety had become?*

I expressed and processed my despair in my sketches for a while, and over time I was able to find forgiveness, grieve the loss of my grandmother, and heal.

This, my friends, is how SketchPoetic works. It gives you space to acknowledge your anxiety and shame, time to face the sources that cause them, and opportunity to express these feelings in order to process them. Each day, I learn to surrender control of my external circumstances and become more familiar with the depth of hope, courage, faith, truth, and love always accessible inside.

Turbulence, thus, has become a metaphor to describe the leap into SketchPoetic. As I allow myself to express the fear, shame, and despair that turbulence rattles in me, I am able to feel the resilience of my spirit rising. The peace comes from within and my spirit elevates to clearer skies. It does not mean that I no longer feel shame, fear, or despair, rather it means that through sketching, I have found a way to navigate above felt experiences. Fear becomes truth. Anxiety becomes anticipation. Despair becomes hope.

Follow the feelings, friends. Examine the sources. Realize the peace within you. Do not lose heart. Leap into this practice with *hope*.

# HOPE SKETCHES

According to Abraham Maslow's hierarchy of needs, "safety" is a basic requirement for a person to experience self-actualization. Sketching provides a safe space for you to realize your potential. It allows you to become acquainted with yourself as a creator. This is the nature of your truest self.

In this exercise, you will express your anxiety through sketching. You can choose to leap into it with hope or despair. Either way, harness any comfort or discomfort you experience and explore the possibilities in every mark you make. Sketch through what you go through. Let your lines be shaky and uncertain if they want to be. Let them be as wild and nonsensical as you can allow them to be. The blank paper is the safe space you need it to be. Give your mind permission to wander wherever it wants to go.

> In any given moment we have two options: to step forward into growth or step back into safety.
>
> —Abraham Maslow

## SKETCHING THROUGH ANXIETY

( 10 MINUTES )

### *OBSERVE*

How do you cope with anxiety? How do you respond to events that are out of your control? How would you like to respond to events that are outside your control?

When life is turbulent, you may wrestle with anxiety as I do at times. Think of a time in your life when your sense of safety and security was shaken. The circumstances may likely be related to a change in your life, relationships, job, health, or general well-being.

As you think about your reaction to the experience and the anxiety you felt (or currently feel as you recall it), notice the way your body responds. Reflect on your answers to the following questions:

- Did the pace of your breathing change?
- How is your body responding to the thought of anxiety?
- Did you find your mind drifting or focused in this recollection?
- What else is happening to you at this moment as you remember?

As you engage in this first sketching experience, pay attention to your body and allow your pen to move on the paper in synchronicity with the emotion. If your legs are shifting or tapping, let your pen move in rhythm with it. If your shoulders are tense, allow your lines to express this tension. If your mind is jumping from one thought to the next, let your marks jump with it.

*Whether you succeed or not is irrelevant, there is no such thing. Making your unknown known is the important thing.*
—Georgia O'Keeffe

## SKETCH

Using turbulence as a metaphor, sketch a series of waves starting from the bottom of the page all the way to the top. The goal is to represent the motion of turbulence.

Imagine the first wave being the most extreme example of turbulence you can imagine. Let your pen move up and down in varying speed, height, and distance as you feel your way through this sketching experience. Repeat the waves over and over again until you reach the top of the page.

Notice the way you hold your pen as you sketch. The tightness of your grip represents the intensity of your anxiety and the control you want to have over the movement. The looseness of the grip represents the hope and anticipation you have in passing through this moment to get to your destination.

At some point in the sketch, grip the pen super tight, almost as if you are cutting off the circulation in your hands. Then release your grip on the pen to something noticeably less intense as you sketch.

## *REFLECT*

When you are done, take a moment to reflect on what you sketched:

1. What patterns, themes, or images arose?
2. What emotion(s) did you feel during the sketch?
3. How did your body respond throughout?
4. Did any memories, thoughts, or insights surface?
5. Did you observe any shifts in energy or perspective?

# SKETCH

# SKETCHING WITH ANTICIPATION

## ( 30 MINUTES )

### *OBSERVE*

The secret of change
is to focus all of your
energy, not on fighting
the old, but building the
new.

—Socrates

Think about a time when you anticipated an experience. You knew it was coming but you didn't know what the outcome would be. Perhaps it was just before a performance, presentation, time of travel, or life event.

Consider the way in which your body reacts to anticipation and compare it with anxiety. Notice the way in which your body responds.

- Did your heart beat faster at the thought of it?
- Did the pace of your breathing change or did you stop breathing altogether?
- Were you filled with hope or dread?
- Are you tense or giddy?
- Did you rehearse all the possible scenarios?
- Did your thoughts seem clear or scattered?

Consider engaging your body in the following sketching experience by allowing it to move in synchronicity with the motion and emotion of anticipation just as you did in the last sketching experience.

### *SKETCH*

Using dots, lines, patterns, or shapes, create a visual representation of your experience with anticipation and what it feels like to you.

Remember, it doesn't have to look like any particular *thing*—it does not need to factually represent a person, place, feeling, or object. It is more important to focus on releasing this anticipation and putting it on paper. Think of your pen as the mechanism for communicating and let it flow from one mark to the next.

## *REFLECT*

When you are done, take a moment to reflect on what you sketched:

1. What patterns, themes, or images arose?
2. What emotion(s) did you feel during the sketch?
3. How did your body respond throughout?
4. Did any memories, thoughts, or insights surface?
5. Did you observe any shifts in energy or perspective?

When an airplane hits turbulence, the pilot seeks a higher elevation to rise above it. How did you navigate both of these prompts? Reflecting on your sketches, consider your answers to the following questions:

- How are the sketches similar and different?
- How did the intensity of your grip impact you and the result on your paper?
- What did you spend the most time thinking about?
- In times of uncertainty, why is it difficult for you to have hope?
- As you look at the entire sketch, what does it reveal to you about your experience with anxiety and anticipation?

Sketching allows me to hope. It acknowledges fear as a rational, instinctual reaction and allows me to anticipate the sudden changes in my life with a form of acceptance. I can work with the

wind instead of fighting against it. I can navigate it with curiosity rather than the sense of impending doom.

If this first chapter resonates with you and you're not ready to move on, go with that instinct. You are welcome and encouraged to repeat this experience. To repeat an experience is part of the process.

There is no timeline for completion. Repetition is the way progress is made. Use repetition to mark, measure, and track your own development. The more evidence you have of the hope that lies within you, the more you will navigate your way through the ups and downs of life with hope.

 SKETCH

## — TESTIMONIAL —

"SketchPoetic is a ritual. I find a comfortable place to settle my bones. My only objective is expression, although this encompasses healing and growth. I close my eyes. Deep inhale. Full exhale. I take note of how my physical body feels. Any aches to tune in to that my body is telling me about? Eyes open.

"I survey which pen feels best to me. Bold? Brush? Fine?—I settle on a fine tip, 0.35 mm.

"Closing my eyes again, I take a deep breath and I observe my headspace. How am I feeling? Joy? Anxiety? Grief? Shame? Is there a memory or thought replaying in my mind that needs attention? Maybe I don't know today, or I feel nothing—that's okay too. I open my eyes . . . or maybe I don't, and I put the pen to the page, unsure of what will flow out.

"It's late today, I feel centered, content, and drowsy—starting in the center of the page a vague Buddha figure appears. I color in the bottom for some reason—it feels weighted down now. Flowing lines radiate out from that. The energy feels good.

"Naturally my mind wanders, I start to worry—dark intense circles tunnel out and swirl like a tornado across the top of the page. I reassure myself, and let it go. A desire to fill the page moves me toward the bottom right corner. I playfully begin to draw a profile using swirls and circles (I'm too intimidated to try something more detailed). As I continue to sketch I start to focus on making the figure more refined—frustrated by this perfectionism I draw squiggles protruding out in all directions to 'mess up' the figure on purpose. An act of defiance.

"My eyes feel heavy as I begin to scribble in order to fill the remainder of the page—these scribbles flow from my hand almost like a buried language I'm unable to read. I get into a flow of enchantingly writing these words as the timer goes off.

"Whatever I'm able to release on the page leaves me with a

new perspective. These pages are a safe place for expression, along with this community created by Sheila. I am grateful to be here and for this tool."

—Amy Weible, @boneneem

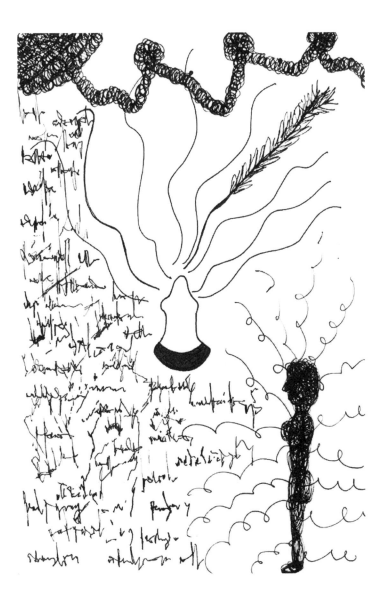

# 2

# SKETCH FAITH

Faith is almost the bottom line of creativity; it requires a leap of faith any time we undertake a creative endeavor, whether this is going to the easel, or the page, or onto the stage—or for that matter, in a homelier way, picking out the right fabric for the kitchen curtains, which is also a creative act.

—Julia Cameron

Faith is belief in action. There is a truth vibrating within us. We don't always trust it because we cannot always see the evidence of it. To see it, we first must believe it. The vibration of truth increases as we approach an action we need to take in our lives. It feels like anxiety or anticipation depending on how we interpret the circumstances signaling the action we need to take and how we predict the effects it will have in our lives. Am I inviting everything I have ever dreamed of into my life or welcoming a nightmare? Is this a fantasy or certainty? Is this a wish or something I'll resent? Can I hope or is this hopeless? Can my imagination become my reality? What is possible for me? Many of us believe in a purpose for our lives and that we are designed to be part of a greater good at work in the world. The life that I seek to live serves as the evidence of what I know to be true within me. It defines my faith.

Some of us started following our faith in this greater purpose from a young age. We lead "good" lives set upon the straight and narrow. We live to do justly, love mercifully, and walk humbly through our lives. We do whatever is considered to be the right thing to do . . . the good thing to do . . . the wisest way to live. We

believe all things and hope for all things. Our faith in goodness protects us from harm. We just have to believe without wavering and no evil will befall us.

At some point, though, an evil befalls us, and in doing so, it shakes every assurance we have to its core. It rattles the foundation of our truth and we wander off the straight and narrow wondering what else is untrue. The new uncharted path is long. It is winding. It is wide. Along this road we deconstruct and question everything in which we ever had faith only to come to the place where we started with new sight and insight.

Many of us have had the faith inside of us shaken early on in our lives and have grown up with some sense of doubt that anything extraordinary could ever be true. Goodness has always been arbitrary; happiness elusive; love a myth. It is a fundamental belief of ours that contentment is clearly for someone else. Our faith has been deconstructed and constructed so many times that the only faith remaining is the one we have for ourselves. We are nonplussed by any obstacle that comes our way. Then one day, we take the opportunity to help one or more people with the experience we have had in the world. This makes us think: *Was I meant for more than this? Can I do more good than this?* The inside faith is shaken in a different way. It is shaken by the evidence of a greater good. *How do I know, though, if my experiences were meant for something extraordinary?* you ask.

Finding our faith in the extraordinary starts with how we value the ordinary. Ordinary days that are filled with meaningful connections and acts of kindness, compassion, and gratitude add up to extraordinary lives. The difference between them is found in the actions we take.

*I should be looking for a job,* Rachel thought as she laid out her watercolors and began to paint. *What am I doing? I am wasting so much time.*

Her fifteen-year relationship with her husband had ended a

year prior. She had a one-year-old son and a five-year-old daughter from the marriage that she needed to care for and a mountain of debt from postgraduate school, but despite over sixty interviews, she still had no job. She had hired a career coach, revised her résumé, and done everything in her power to find work.

Evidently, she had taken too long a hiatus from her administrative career in education to have her children and finish her doctorate. She was too experienced and educated as an administrator to get a job as a teacher again; however, she did not have enough experience to be an administrator again. She was not even sure she wanted either anymore. It never crossed her mind she would ever have to concern herself with the optics of her career because the economics of her husband's income sustained their family.

She was out of ideas. Scrolling around on Instagram, she started following SketchPoetic. It sparked in her a desire to reconnect with her roots as an artist, so she began creating without any plan in mind. She just started painting.

*What am I going to do?* She wept as she poured water onto the paper. Her tears mingled with it. *How am I going to make my life work on my own and raise my kids? What do I do with waste in my life?* She poured old sour wine onto the paper and let it stain. *How do I repurpose my life?* she wondered. Night after night, she wrestled with these questions and night after night, she let tears, watercolor, and wine stain page after page. She knew the answer was in her somewhere.

Staring at the stains on the pages she made every night, images began to emerge and then she would sketch them. The only possibilities she could see were in those images. It inspired her to begin to look for possibilities in herself. She earned some money doing some side work writing, researching, and consulting in educational technology. The thought occurred to her as she was mindlessly sketching one night that maybe she had been climbing the ladder in an industry she was not meant to continue working

in . . . what would it take to leverage my education and experience in instruction, writing, research, and leadership into another career? she wondered. That thought followed her as she kept sketching through her anxieties. It sparked a shift in her mindset. A sense of anticipation began to develop.

*What possibilities could I make of my life? Where would I work? Near the beach? In the mountains? Maybe I can teach college writing classes or start my own instructional design firm.* Her mind swirled with ideas. She made a website.

A short while later, on a hike with her children, she heard her name in the distance.

"Rachel?" a voice called out from behind her. Rachel looked and a woman on a horse trotted up to her.

"Yes?" She was surprised to encounter anyone who would know her, and she didn't immediately recognize her. The woman was a classmate of Rachel's from grad school.

"Joan! I can't believe it's you. How are you?!" Rachel exclaimed when she realized who it was.

"It's so funny that I'm running into you because I was just thinking of you the other day." Joan laughed. "I met someone on an airplane a few weeks ago and his wife and I got to talking about horses and education. Anyway, one thing led to another and we exchanged information. He is chair of an arts college here in Southern California, and he is looking for a writing teacher to take over the thesis classes for the master of fine arts program. I am fully committed for this spring, but would you happen to be free? I saw your post on your website the other day and with your background, I think you'd be a perfect fit for the program. Would you be interested?"

This was the first of many opportunities and possibilities that began to snowball into Rachel's life as she began to look for and have faith in what was possible. Painting and sketching had initiated her faith. It initiated her ability to see, to imagine, and to

design. With each sketch, she believed with more certainty that answers to unanswerable questions shaking her soul would make themselves known.

It was not about the art. It was about listening to the small voice inside her that said: *"Create."* So she did. As she did, the answers gradually came to her. When we move through life without testing and trying our faith, we miss the chance to expand it. Don't read that the wrong way. Sometimes we *need* to move through life just to survive it, but I am assuring you that once you have survived, you don't *need* to continue living that way. Believe in what compels you to create. The evidence of what you are looking for lies within you.

Dear reader, I have no doubt that you have come through a number of obstacles to reach the place you are with this book in your hand. You may have found yourself standing on the edge looking at an uncertain destiny—*sketch*. Do you know in your soul that there is another side to the circumstances you are in, but you can't see how to get to it—*sketch*. The chasm between where you are and where you want to be may be wide. The leap your faith needs to take to get there must supersede all the truths you've ever been told. Today marks an important turning point in terms of developing your *inside* faith.

Leap forward with faith.

# FAITH SKETCHES

Rachel's curiosity and surrender led her down an extraordinary path. Through her journey of self-discovery, she was able to distinguish between true faith and blind faith. She trusted her intuition and gained the confidence in herself to question her beliefs.

This same questioning and desire for understanding is the mindset you should take to your experience with SketchPoetic. Do not leap into it with blind faith that it's the answer to all your troubles. Sketching is one of many tools to support self-discovery and personal growth, but it is not the only tool. Be open to your own interpretation of how this can work for you. Turn on your curiosity and let your skepticism guide you. Allow each line to challenge thoughts and respond to questions that arise. Be excited. Be intimidated. Be bewildered.

Creative expression is the evidence of your faith. It translates across culture, beliefs, background, and experiences. The purpose of these next prompts is to have faith in your ability to sketch what you don't see and letting your instinct guide you along the way. It is not about drawing a perfect image or shape. It is about overcoming your limitations and discovering the potential you have inside of you. Over time, your confidence will grow.

Develop and hone your ability through the prompts to trust yourself even when you don't have a point of reference to look at. Before you begin, ask yourself the following questions:

- What childhood advice, wisdom, or truth are you questioning?
- What do you know inside yourself to be true?
- How do you know this truth?
- What leap of faith do you currently need to take?

> You do not need to know precisely what is happening, or exactly where it is all going. What you need is to recognize the possibilities and challenges offered by the present moment, and to embrace them with courage, faith, and hope.
>
> —Thomas Merton

# SKETCHING THROUGH LIMITATIONS

### ( 10 MINUTES )

## *OBSERVE*

Have you ever been working on a project and had something ruin it? Perhaps a coffee stain poured all over a stack of reports you had prepared for work. Water from a leaking roof warped the new wood floors you just installed. A paint can tipped over from the ladder and landed on the couch you forgot to cover. A recipe ruined by too much of one ingredient or the lack of another.

These unexpected events happen all the time. The way in which we handle them depends on the type of problem, context, and faith we have in ourselves to solve it. Can we incorporate the accident into our design? Can we design around it? Do we need to start over? How can starting over lead to a better outcome than originally intended? What limitations can we reimagine?

In this next sketching experience, you will learn to see the positive and negative spaces of a purposeful *accident* on the page and explore the possibilities within.

> Faith includes noticing the mess, the emptiness, and discomfort, and letting it be there until some light returns.
>
> —Anne Lamott

## *SKETCH*

Take a cup of tea, coffee, red wine, or any liquid that can create a stain. Splash or blot the liquid onto the paper. Don't overdo it as you do not want to ruin your paper. Wet it enough so that the stain is noticeable. Now, let it dry or use a hairdryer to speed up the process.

Once dried, take a moment to look at it. Rotate the page and see if any images, themes, or patterns emerged. If so, use your pen

to bring what you see to life. If not, start with outlining the stain then pause once more to see if anything new emerged from it.

Consider the ways in which you saw limitations and possibilities in the stain you made. What thoughts crossed your mind as it dried? How did it feel to see the stain as a possibility rather than a problem?

## *REFLECT*

When you are done, take a moment to reflect on what you sketched:

1. What patterns, themes, or images arose?
2. What emotion(s) did you feel during the sketch?
3. How did your body respond throughout?
4. Did any memories, thoughts, or insights surface?
5. Did you observe any shifts in energy or perspective?

Faith is not something to grasp, it is a state to grow into.

—Mahatma Gandhi

— SKETCH —

# SKETCHING WITH POSSIBILITY

( 30 MINUTES )

## *OBSERVE*

One of the joys of being in nature is to see the patterns that exist within all living things. It is a beautiful thing to behold and is a great reminder that we can often take for granted the patterns in our own lives that help us grow and blossom.

Take a walk or be still with nature. Look around and observe nature's patterns all around us. It is in the trees, flowers, leaves, rocks, and clouds. Whether you are in an urban setting or a rural landscape, let nature serve as your inspiration.

## *SKETCH*

Sketch the patterns you are seeing in nature or the world around you. Observe it from afar or study it up close.

- Stare from a distance at the shape of a skyline, reflection on a lake, or road fading into the horizon.
- Stare at the details of the pattern of a flower, vein of a leaf, texture of a tree, or surface of a rock.

Now sketch the patterns you see on the page. The objective of this prompt is to not perfectly represent what it is you are seeing. Rather, it is intended to serve as inspiration for today's sketch.

Also notice how your current state of being influences the patterns you are drawn to. Does this awareness bring you peace or make you feel restless? Does this awareness connect you to something greater or leave you feeling disconnected? Whatever emotions arise as you observe the world around you, let them guide you.

## *REFLECT*

When you are done, take a moment to reflect on what you sketched:

1. What patterns, themes, or images arose?
2. What emotion(s) did you feel during the sketch?
3. How did your body respond throughout?
4. Did any memories, thoughts, or insights surface?
5. Did you observe any shifts in energy or perspective?

As you think about nature's patterns, imagine the journey each living thing has experienced in its creation. Think about how it came to be, what it has weathered, the challenges it may have gone through. Embody the faith, strength, and resiliency of nature and connect with how it relates to you.

- What patterns in nature are you drawn to and why?
- What patterns emerged in your life as you observed the world around you?
- Which living things do you feel most connected to and why?
- What is it about this living thing that embodies or personifies you?

Similar to human nature, every element on earth is unique. Every living organism holds a certain energy connecting it to a vast ecosystem and life force. Hold a rock in your hand. Place your palm on the trunk of a tree. Watch the current of a river. Listen to the wind in the trees. Smell the fragrance of a rosebush. Let your senses feel the energy and presence of nature.

If there is ever a time where you have a crisis of faith or are unsure of where to begin, always return to nature as a starting point. It never fails to inspire creativity and humble us in its presence.

# SKETCH

## — TESTIMONIAL —

"Accepting an invitation to join a group of people from all over the world, all of whom would agree to focus on sketching and sharing insights with one another quickly ignited a sense of wonderment and nervousness within me. Just the idea of sketching uncovered a direct line tethered to my intuition that reached far back into my childhood.

"It had been so long since I made the decision to sit or lie down with a marker to freely express myself in an imaginative and explorative way, in a way that left a visible mark and in turn could be translated and reflected back to me somehow. It all sounded so simple and yet there was a part of me that was afraid to follow that old path inward again.

"Perhaps the commodifying of art and growing up in a society that ascribes titles to professions and artists through various schools and social platforms were some of the contributing factors that led to my uneasy feelings and notions to abandon the practice of sketching for so long. It's easy to categorize and uncategorize yourself and set limitations based on those categorizations. SketchPoetic offers me access to that direct line I believe we all have access to in some form or another, to our intuitive and expressive nature. There are no wrong moves, no harsh criticisms to navigate, it's grounded in respecting yourself and your ability to garner insight both from within you and collectively within our shared psyche.

"I realized what I was most afraid of was witnessing my own inner beauty again. Catching glimpses of it through shared interpretations of symbolism has helped me to see different ways in which I've been covering up my sense of beauty. I'm still learning how to allow my inner visions or lack of vision and pure emotion to find a way to animate me and make an impression on paper. It's a practice that isn't always easy but consistently offers insight into my own way of being. It feels

like a magical gift to have been reminded that we are all art-
fully expressing ourselves no matter what we do or make or
have to show for it.

"Thank you to Sheila and to my special group of sketching
buddies who continue to offer a beautifully vulnerable and car-
ing community through which I feel enriched."

—Bryce Alber, @allatonceforever

# 3

# SKETCH LOVE

Love is the essential reality and our purpose on earth. To be consciously aware of it, to experience love in ourselves and others, is the meaning of life. Meaning does not lie in things. Meaning lies in us.

—Marianne Williamson

Sitting with my pen poised on paper, the empty space beckons me to take a leap. The smooth, virgin terrain of the paper invites me to dive into and traverse the depths of my own landscape. Filled with trepidation, the sound of its call is reassuring. It is a call to love. In response, I search my soul for the evidence of things I cannot see. Breathing in all that is around me and breathing out all that is inside me. All that remains is to leap into sketching.

The worry sets in. *What if it's not perfect? What if nothing meaningful comes from it? What if none of it makes sense?* These intimidating questions fix me in place. I cannot leap. Indecision is the decision in that way. It is choosing to stay safe in a shell that feels familiar. Believing the impossible, I will not try. Resisting the unknown, I will not look. These thoughts keep me paralyzed in a cycle of inaction.

When I make the leap to sketch, possibilities arise. Questions become curiosities. Worry dissipates and anticipation becomes the focus. *What if something meaningful comes from this? What if life transforms for the better? What if it gives access to more love, joy, peace, kindness, faith, hope, and grace in my life?* The an-

swers to each of these questions are wild, elusive, and unknown, but as I allow myself to leap into the messy, playful space of creation each day, growth soon follows.

All of creation is evidence of love's ecology in this way. Everything created is adaptive, transformative, compostable, and restorative. I create in synchronicity with creation. I don't know the exact science of how it all works or how it fits into the greater scheme of it all, but to create is to love and I was made to do it. This is the kind of "knowing" that cannot be explained. Each time my pen touches paper, I leap into the unknown to make it known. I become the creator. The pen becomes my instrument. The line becomes my creation. Instantly, I am connected to all that came before me, all that is happening around me presently, and all that will come after me. Thus, I follow the curves and edges of thick and thin lines until they reach their natural end.

This is love, dear reader. This is love. Leap into it with me.

"Honey, I don't think you'll ever be good enough to be considered a successful artist," Jackson's sixth grade art teacher bluntly told him when he asked her what he could do to improve his skills. "I recommend thinking about other career choices."

Jackson grew up in a family that focused on academics and excelling in sports, and while he did well in both, he enjoyed the time drawing the most. His enthusiasm, however, wasn't met with much support at home. If it wasn't going to get him into college or make money, why pursue getting better at it, right? Right. His teacher's criticism cut through him like a knife. It validated that mindset.

But Jackson was not asking his art teacher about becoming a career artist that day. He was simply asking her how he could improve his skills. Euphoric from earning good marks on a series of assignments, he felt confident in approaching her with this question about improving his skills because he thought he would receive more praise and encouragement from her. She was, in his

opinion, an excellent artist and teacher who took great pride in discovering and developing young artists. He thought he was one of them. As an adult reflecting on this moment, he knows this still to be true. "I don't think she intentionally meant to kill my enthusiasm for art," he tells me. "She was not that kind of person." Nevertheless, she did, and twenty years later he marks it as the day he stopped seeing himself as an artist.

As a consequence as well, he subconsciously stopped pursuing activities at which he didn't already know he would be good. Gradually, the curiosity ended. The wonder faded. The play became work.

*I am not an artist.* This is the most common statement people make when they start. It is made with a lot of gravity behind it. Like Jackson, they are sharing with me, in part, that someone or something has killed their creativity. However, they are also warning me. They do not feel confident that they can make something meaningful in our session together. They are not artists, after all. They do not have "the gift" or "the talent." Therefore, I should lower my expectations about what they will create in our workshop before we even begin. This statement is laden with many unspoken fears, the chief of which is the fear of not being good enough. This fear often keeps them from trying to make anything in the first place, and if they do make something, it most definitely keeps them from sharing it with anyone. Sharing their "art" would make them feel like an imposter.

*I am an artist.* This statement is less frequently made. It carries with it a slightly different weight. While it is often still composed of fears that are not much different from those of non-artists, it is uniquely compounded by the pressure to make everything they create absolutely perfect. They may or may not announce their artistic ability in my workshops, and I find that it often depends on the confidence they have in achieving a laudable outcome before they begin. I know that to be true as an artist myself.

When I first started SketchPoetic, an unexpected dialogue be-

gan to take place inside me. It grew into more of an argument over what the meaning, purpose, place, and function of art was. The growth I was experiencing was challenged by the beliefs I had mindlessly adopted from childhood into adulthood without ever stopping to question them. I was curious and conflicted by the force with which these beliefs held me back. Thoughts like:

- "I should stop drawing and accomplish something. Creating is indulgent."
- "You need to focus more on school, work, and family. Art is just a hobby."
- "You can't show this to anyone. It doesn't look perfect."
- "Argh. I should not have drawn that line. It ruins everything."
- "Unless I'm making money on my art, I am not really an artist."
- "True artists are represented by galleries. Can I even call myself an artist?"
- "Art isn't going to pay the bills. Why am I wasting so much time on it?"
- "My type of art doesn't speak to everyone. Not enough people get it."

Every single one of these thoughts reveal a flaw in the paradigm upon which my entire life was constructed. When these thoughts surface, I am not actually wrestling with the meaning of art. I am wrestling with the meaning of love. Through sketching, I am sometimes recreating loveless experiences in my life. The action gives me the opportunity, safety, and space inside myself to actually wonder and play with certain questions or fears. By engaging those experiences, I am making something new out of them. Perfect love does that. It turns on the light and shows you the truth about your fears, then it allows you to live in knowledge of that love. It drives you to create more.

Creation is the purest expression of love. To become one with that love, you must also become a creator. I am encouraging you to leap into SketchPoetic with this mindset. You are love. If love cannot be divided or destroyed, neither can you. If love believes in all things, hopes in all things, endures all things—so do you. If it is long-suffering and kind, so are you. Love never fails. You never fail.

Even as you read these words, you have your doubts. Good. Bring them into your daily sketches. Embrace your conflicting thoughts, fears, and doubts as a starting point for exploring your emotions.

By engaging in creation regularly, you are turning on the lights inside your soul and allowing love to begin work in your life. You are returning to the childlike curiosity with the wisdom and mindfulness of an adult. You will see yourself as love soon enough and you will grow in love even if you seriously doubt it right now.

Before you move on to the sketching exercise, sketch some playful and expressive marks in the margins of this page. These marks can be a quick doodle of an image that comes to mind, a symbol of love that means something to you, or simply your signature. Trust yourself. Let these marks represent your commitment to this practice. Let them be your first leap into love—a visual way of saying, *"I am ready to explore the margins of love in my life."*

Now, let's recap. You don't have to be an artist to be a creator. You don't have to be perfect to create. You don't have to be fearless to take the leap.

# LOVE SKETCHES

Love recognizes that we are all creators. When we create, we make patterns in our own stories. When we create, we make the dotted lines into trails marking both the way we came and the way we are going. When we create, we make mindful marks in the margins of our lives. We make space. We make room. We make meaning, power, significance. The inner workings of our conscious and subconscious minds become evident in the marks that make us. We create love.

Love is the leap we must make. In the following sketching prompts, you will reflect on love as both an impulse and an instinct. It may be your impulse to reject parts of yourself that you have been taught to hate. Let's reconnect to those parts and find love in them. As you do, you will instinctively begin to respond with unconditional love for yourself and others. Thus, in shifting from impulse to instinct, you learn to create love.

To be creative means to be in love with life. You can be creative only if you love life enough that you want to enhance its beauty, you want to bring a little more music to it, a little more poetry to it, a little more dance to it.

—Osho

## SKETCHING THROUGH JUDGMENT

( 10 MINUTES )

### *OBSERVE*

One of the ways we express love to another is through compassion. Whenever someone falls or falters, we embrace them. We care for them. We support them. We know it is through love that the wounds of their pain can heal.

Yet, when it comes to self-love, having compassion for ourselves

can be difficult to find. More often, we extend unconditional love to everyone around us, but when we fall or when we falter, we are the first to judge, admonish, or punish ourselves.

Similarly, as you create, there is an opportunity for self-love and acceptance throughout the process. We can love ourselves in the thoughtful way we honor our space, commitment, and time. We can love ourselves in the gentle way we remove judgment and criticism as we create. We can love ourselves in recognizing and celebrating each creation as a gift.

Let yourself be seen in love and watch your creations transform in the image of it.

## *SKETCH*

Imagine your blank page as a mirror holding your reflection. Sketch through all of the ways you do not embody self-love or self-compassion. Do not focus on visualizing the metaphor perfectly. It does not have to look like a portrait or resemble any form.

If having a form does help you in sketching through this, then sketch an oval on top of a square and let it represent your face and body. It matters more that you allow yourself to feel the energy and emotions that flow through you as you reflect on the ways we reject self-love.

- Do you judge or criticize your looks or see only the things you don't like about yourself? Sketch arrows or crosses as a critical expression of pointing out flaws.
- Do you speak to yourself in negative or harmful ways? Sketch spirals or exclamation points that convey the damaging energy of these words.
- Do you physically hurt or punish yourself? Sketch the wounds or marks that express these painful actions.

Love many things, for therein lies the true strength, and whosoever loves much performs much, and can accomplish much, and what is done in love is done well.

—Vincent van Gogh

Use these guides as a starting point and welcome ideas that may arise as you connect your visual expression with your thoughts and emotions. As you sketch through this exercise, allow yourself to be curious about the why behind the thoughts and beliefs that led you there. Wherever your mind goes, allow yourself to drift with it. As with all of your daily sketches, do not put pressure in finding meaning or gaining insights from these thoughts. It is equally as powerful to be aware of our thoughts as it is to act on them.

The more comfortable you become in letting your thoughts pass, the more comfortable you will be in focusing on the process and not the outcome.

## REFLECT

When you are done, take a moment to reflect on what you sketched:

1. What patterns, themes, or images arose?
2. What emotion(s) did you feel during the sketch?
3. How did your body respond throughout?
4. Did any memories, thoughts, or insights surface?
5. Did you observe any shifts in energy or perspective?

# — SKETCH —

# SKETCHING WITH FREEDOM

( 30 MINUTES )

## *OBSERVE*

We are born to love unconditionally. We give without question and receive without hesitation. Never doubting the purity of its goodness.

In time and through circumstance, we learn to place conditions on love. We learn to see it as a measure of connection rather than an essence of who we are. We learn to contextualize and commoditize love as an act to be seen or a gesture to be appreciated. We learn to stop trusting what is in our hearts and seeing it through the eyes of another. Eventually, we become so conditioned to the conditions we place on love that we begin to lose touch with the ease and grace of being in the presence of unconditional love.

When did these conditions start? When did we inherit them as our own? How do we return home to love? Let's recall a time when creativity was seen in the same way as love. Limitless in possibilities. Boundless in imagination. Divine in its presence.

Imagine yourself as a young child sitting with a pen and paper in hand in the middle of your favorite place. It could be somewhere in your home, a park, a vacation spot, a place that holds fond memories. What if I told you to sketch this scene as accurately as possible with accurate dimensions and relational proportions and that the objects in the scene must be rendered as realistically as possible?

What thoughts and emotions did that provoke in you? Were you hesitant, intimidated, annoyed, confused? These are all natural emotions to feel when you are asked to create with rules in mind.

See the world as if for the first time; see it through the eyes of a child, and you will suddenly find that you are free.

—Deepak Chopra

## *SKETCH*

Harness your inner child once more. In this sketch, draw your favorite place. There are *no* rules or conditions. The proportions or relationship between objects does not have to be accurate. If a flower is bigger than a chair, then let it be so. The objects in your scene do not have to look like what they are meant to be. If the sun looks like a piece of fruit, okay. The scene can be as whimsical as van Gogh's *Starry Night* or as structured as you want it to be.

It doesn't matter what the scene is, do not hesitate to fill the page with marks that convey a sense of that place and the emotions it brings to you.

## *REFLECT*

When you are done, take a moment to reflect on what you sketched:

1. What patterns, themes, or images arose?
2. What emotion(s) did you feel during the sketch?
3. How did your body respond throughout?
4. Did any memories, thoughts, or insights surface?
5. Did you observe any shifts in energy or perspective?

Observe what you sketched and connect back to the feeling it is trying to convey. Acknowledge the inner child in you that has longed to create in this way. If you're fortunate, this is the way you have always created. For others, it is a remembrance of what it felt like to do so.

To create is to love. To be a creator is to be love.

This prompt isn't about harnessing the artist within or testing your ability to sketch a scene or landscape. It is an attempt to bring awareness to how much we lose ourselves in the doing that

we forget how it is to just be. To create from a place of unconditional love. To create because you are a creator.

Allow yourself to notice the comfort or discomfort of sketching from your wild imagination.

- Has it been a while since you've tapped into this side of yourself?
- Do you have certain beliefs that limit you from doing so?
- Are you worried about how silly or nonsensical it feels to do so?
- Was it difficult for you to let go or sketch from your imagination?

Whatever your thoughts or emotions, honor them. Do not judge or condemn whatever it is you are feeling. All of it is part of the process. All of it is intended to bring awareness.

We all need reminders of *why* we walk a certain path and to remember the spark we felt when it all began. Come back to this prompt when you need a gentle reminder of when new conditions are placed on yourself or on this practice. Do not let these conditions get in the way of doing what you love.

— SKETCH —

"I've been drawing and painting ever since I was a little girl. I've studied art and design and I coach people on creativity. I've always been too close to art and creativity. Studying art and making it into a career somehow took the fun and intuitive connection to it away mainly because you are taught how things are supposed to be, what is 'good' art. Then there is pressure to make it look perfect, have a certain meaning behind or attached to it. You no longer try things just for the sake of trying them. As a recovering perfectionist, that has always been a little too much pressure for me.

"To me, embracing the practice of SketchPoetic was like giving myself permission to just be. The practice of sketching poetic allowed me to embrace the process even more than the outcome. It took me back to my carefree childhood days where I drew, painted, and made a mess without putting any weight of expectations on my shoulders.

"One of the most amazing things that sketching poetic practice made me realize was that two contrasting emotions can be true at the same time. We can experience grief, anger, fear, loneliness, sadness, and uncertainty and experience joy, connection, presence, gratitude, and grounding at the same time. In this one particular sketch, you can feel the flow and stillness all in one. That is how I was feeling when I was making these marks on the paper. There is movement and entanglement. Then there is too much negative space. This negative space represents stillness and calm for me.

"One thing that I'd like to take a moment to emphasize is that it is a practice. The mere act of sitting down and putting pen to paper allows you to get curious about your inner world. Setting a few minutes aside to be in conversation with myself through art allowed me to process my thoughts and underlying

deep emotions that I potentially was finding too hard to put into words.

"Through daily sketching you learn to separate yourself from your emotions and create space for them to come to the surface. You are not your feelings, your thoughts, or your fears. You are not other people's ideas of you. You are more than all of it. You are wild, messy, and an incredible human being.

"In the beginning, it might feel uncomfortable but if you are willing to be uncomfortable, you get to see what you are capable of through this practice."

—Hira S. Ahmed, @hirasahmed

# 4

# SKETCH SILENCE

The only silence I ever really accepted in my life was the silence of my own voice. Surrounded by ambient sounds of chaos and chatter was comforting. Music was always on in the car. I'd fall asleep to the TV. Podcasts played on my walks. I'd read books in coffee shops. The clank of the dishwasher, whirl of the vacuum, thumping of the washing machine, and hum of the dryer competed with the whine and bark of my dog for my attention, but none of them ever demanded I speak up. It felt safe in the noise.

In the volume, proximity, and content of the noise, I could avoid the internal soundtrack playing in my mind—the cacophony of constant analysis, endless thoughts, and chronic anxiety. Perhaps, I thought silencing the endless clamor with louder clamor was the best approach. In some ways, it worked, but the cause of the roaring distress inside was never resolved.

Having grown up with an alcoholic father, my childhood conditioned me to be acutely aware of the sounds in someone's voice. Cuing into such nuances as inflection, volume, and tone, I gathered quickly how words were being said with their voice mattered infinitely more than what precise words the person was using. One slurred word, several escalating phrases, a sudden terrifying yell

> Within each of us, there is silence. A silence as vast as the universe. And when we experience that silence, we remember who we are.
> —Gunilla Norris

from my father could paralyze my mother and me. Moments later, an apology laced with shame and guilt would fall on deaf ears. Perhaps that is why I could not say anything honestly to myself or to him. I didn't want him to hear the disdain and disrespect in my voice, so I tuned out the voice inside that expressed it.

Even more terrifying than the sound of my true thoughts, though, was the sound of nothing. Dead silence. The kind of silence that came from me while my parents fought. The kind of silence that came in the dreadful moments after violence had ceased. In those moments, I would hold my breath, lean into the quiet while sitting perfectly still in the darkness of my room, and listen with my whole body for any sound that my mother was alive.

Until daily sketching, I didn't realize that my need for sound derived from these moments. I blocked them. Buried them. Built my life on top of them. I associated the sound of my voice with danger and silence with death. As a result, the quiet never felt peaceful. Silence revived the anxiety within. Reminding me that I was powerless. I remember wanting to scream "Stop!" when the violence began, but I could never get the words out of my mouth. I did not have the courage to speak up or understand my limitations as a child, only the shame, guilt, and despair for feeling powerless against all of it.

The conflict was an unresolvable paradox that left me in perpetual anxiety. I had to sketch my way back to the source in order to sketch my way through it and then my way out of it.

Change did not happen overnight. As the sources of my anxiety became clearer, I became more at peace with the silence. I could hear my own voice in the sketches. The sound of it was strange. It was happy and angry, loving and spiteful, caring and carefree, selfless and selfish, confident and insecure, calm and frenzied. *Who was this person?* I wondered.

In reflection, each sketch had the ability to convey multiple meanings about the complexity of each moment. The complexity

was much more difficult to express with words. The sound of the pen scratching, gliding, dotting, and moving across the page is its own language—my language. I speak into every curve of a line, dash, dot, and shape. They reveal the patterns in my life that could not have been heard or seen in any other way. The sketches became the way in which to express my truth, learn to draw boundaries, reframe experiences, manage conflict, and imagine my future. When I could feel anxious without being in a state of anxiety, it was then that music and sounds reentered my life. I was learning to listen and tune in. I didn't *need* sound. I needed to hear myself.

It is for this reason that I encourage you to begin in silence. No music. No TV. No background static. Just you, the pen, and the page. Let flow from you all that you have been listening to and all that you have actively avoided saying out loud. Tune in to what your body is feeling and the tone of your voice in your head. Pay attention to what conversations, experiences, and thoughts repeatedly enter your mind during this time. Be aware of what noises distract you. Incorporate them into your sketches. Listen with the intent to hear. Allow it to guide your pen across the page.

This is a big risk you are taking. You don't know what you will find in the silence. You will most certainly find conflict and paradox. This is natural. This is okay. This is normal. The world is conflict and paradox. You can feel it, acknowledge it, *and* be in a state of peace and love.

At thirty-five, Sandy came to the realization that she was not in control of her own life. As a single mom struggling to make ends meet, she felt a unique isolation. The isolation was difficult to speak about or share, not because she worried what people would think, but because it was hard for her to make sense of it. The isolation felt more like a void—a space in her life where her future used to be along with all the security, comfort, and intimate conversation that came with it. The void felt like freedom and

desertion. It felt loud and quiet. It felt chaotic and calm. It felt sad and relieved. She could sleep in the middle of her bed, but she didn't sleep. She could make her own plans, but she couldn't plan anything.

The hope she'd had in her youth had left her. The faith she'd had in her family had failed her. The love that she'd thought was real had only been a mirage. What could she dream of? What could she believe in? What could she trust was true? If she could not see it, hear it, taste it, touch it, or smell it anymore—how would she be sure anything was ever going to be right again? The thoughts plagued her. She didn't want to hear them. She threw herself into the chaos of her kids and work. She binged on TV shows, chips, and wine at night, then she would run herself into oblivion on the treadmill at the gym while her kids played at day care. Every minute of every day was filled with some noise, some distraction, some chaos to keep herself from hearing all of the worrisome thoughts she was having.

In the quiet, she couldn't escape the feeling that she was running away from something deeper. She felt she needed more quiet in her life to confront these feelings of despair. Without really thinking or planning, she asked her parents to take care of her kids and took a solo trip to the mountains for a weekend. Nature had always been a place of comfort. *Would it still be comforting?* she wondered. She set off for a trail that she had read about. It was supposed to lead to a waterfall.

The trailhead wasn't marked clearly, and it didn't look like a waterfall could be anywhere along this path, but she thought she was in the right place, so she set out on her hike. An hour into it, she thought, *This can't be right. There is no way a waterfall is out here.*

She knew the path she was on wasn't leading her to the place she wanted to be and something needed to change. She hadn't seen another hiker for a while. Her thoughts started to turn toward the way in which this hike was mirroring her own personal journey.

She came to a cliff where she could see the vast wide valley in front of her. She paused to drink some water and considered turning back. *If I keep going this way, I am going to run out of water and there is no sign of a waterfall. This is not what the trail is supposed to look like,* she thought. *If I go back, though . . . I may never find the waterfall.*

She looked around. She was all alone. No one was there to guide her. She couldn't get a WiFi signal to pull up the description of the trail to verify. She had to make a decision. From deep within her came an unbelievable urge to scream. It rose with such fierceness and fury that before she could stop it, she released the deepest, loudest, most primal roar from her soul out into the wild. From the bottom of her lungs, she emptied all of the frustrations, fear, anger, pain, disappointment, and confusion flooding inside her. The sound of her scream echoed in the valley below and floated above the rocks. She listened as the sound dissipated into the distance.

Then silence.

She wasn't sure how long she sat there in the silence that followed, and she can't remember what she thought about. She doesn't remember turning back or what she saw along the trail home. She just allowed the silence to surround her. She allowed her mind to empty. She allowed her feet to move along the ground.

At the bottom of the trail, as she was about to get into her car, she noticed a small, lush, green area farther up the road at the edge of the desert mountain she had just climbed. She hadn't noticed it when she first got there. She walked a quarter mile over to it and there, a sign marked the entrance to the waterfall trail she had been looking for and a half mile farther, along a raging, glorious, roaring river of water, she found her destination.

While Sandy's story isn't related to sketching, she shared it during one of my workshops. The release and clarity she felt in that moment paralleled her experience sketching and she made the connection in our discussion. Experiences with silence and sound

come up a great deal in our discussions post-sketching because similar to Sandy, the conflict and peace it provokes from us is sensory. It takes effort to listen. It takes patience to hear. We know the truth of what we experience in the awareness by its association to what we feel.

You can allow the static sounds of your life to fill you to the point where you can stop feeling, stop listening, stop experiencing the calling inside of you. You don't think it is possible, so you turn up the sounds of impossibility. You don't believe you are on the right path, so you turn up the volume until it sounds like the right path and you can ignore the still small voice saying, "Stop. Listen. Look." You know already. You don't want to hear. You don't want to take the time to travel back. They said it wouldn't be easy. You should keep going forward. "Backwards is defeat," you tell your-

self. You settle for a direction and a path that isn't what you said you wanted.

Tuning in to our internal dialogue is a critical part of the transformation process. How much are you aware of the sounds of community, work, school, family, friends, and others? How often do these sounds easily replace and drown out your own voice? How much do you listen to their external dialogue and let it define what you hear inside of you? When did you start to let it play as the soundtrack you live your life by? How do you change the playlist?

Let's listen into the silence and find out.

# SILENT SKETCHES

Silence can become your channel. It can amplify insights and make more evident the vibrations of truth you have long tried to ignore inside yourself. Allowing silence in your life invites the kind of authenticity and vulnerability that strengthens your voice. In silence, you can turn up the sound inside of you.

There can be a rich source of truth found in the absence and presence of sound. It can facilitate movements between our conscious and subconscious minds. It can create experiences that motivate us to move or transport us into a meditative state. It can imprint new memories or help us recall old ones. It can free us in its expression or imprison us in its recall. The multifaceted nature of sound is where the power of silence resides.

When the tip of the pen glides across the paper, it makes a sound. In the following experiences, you will follow the notes you are making and internally calibrate the vibrations you feel. Tune in to yourself. Find your frequency. You may not hear yourself at first, but sketch by sketch you will.

> Everything that's created comes out of silence. Thoughts emerge from the nothingness of silence. Words come out of the void. Your very essence emerged from emptiness. All creativity requires some stillness.
> —Wayne Dyer

# SKETCHING THROUGH NOISE

( 10 MINUTES )

## *OBSERVE*

Chatter can be deafening. It is in our home, at work, and in almost every public space. There is the chatter of talking, gossiping, deal-making, arguing, planning, celebrating . . . well, you get the idea. Whatever it is, we often choose to ignore it out of respect for people's privacy, but also for our own sanity. Whether we know

it or not, we unconsciously listen to it anyway, so today, let's be purposeful about it.

First, choose a place where you can sketch and listen (e.g., coffee shop, waiting room, train station, etc.) and with a pen in hand, close your eyes and listen to all of the sounds happening around you. As they start to come into focus, pay attention to the sounds farthest away. Depending on where you are, listen beyond walls, spaces, or in the immediate distance. Listen to the nuances you hear and visualize in your mind the source of them.

Now, start to listen as the sounds draw closer and closer to you. Take your time in doing this exercise. The slower you go, the more you will hear. As you are doing this, picture yourself as an explorer indexing the images or thoughts swirling in your mind as you hear each sound. Once you hear the sound closest to you or have exhausted every possibility, open your eyes.

Pay attention to what you're hearing and how it makes you feel. Are you amused? Stressed? Invested? Horrified? Whatever the case, allow yourself to notice it all.

*The quieter you become, the more you are able to hear.*

—Rumi

## *SKETCH*

As you continue listening to the chatter, begin to sketch along with it. Sketch the energy of what you're hearing. Is it repetitive? Make marks that repeat the rise and fall of sounds over and over again. Is it chaotic? Then make marks that reflect the chaos. Is it calm? Make marks that reflect the peace and serenity of what you are hearing.

Visualize the sounds. It is okay to jump from one sound to another as you hear it. Abandon one set of lines to start a new set if you need to. You can choose to focus on one sound intently or ebb and flow between different sounds.

Be curious about what sounds capture your imagination and which ones trigger thoughts. Notice the volume, texture, and

vibration of the sound. Observe how certain sounds please, while others repel.

Pay attention to the internal dialogue and external ambient sounds that fill the space and how you decide to convey the lines of internal sound or chatter. The idea is to explore both inner and outer noise, and the silence we can find throughout.

## *REFLECT*

When you are done, take a moment to reflect on what you sketched:

1. What patterns, themes, or images arose?
2. What emotion(s) did you feel during the sketch?
3. How did your body respond throughout?
4. Did any memories, thoughts, or insights surface?
5. Did you observe any shifts in energy or perspective?

— SKETCH —

# SKETCHING WITH VOICE

( 30 MINUTES )

## *OBSERVE*

Find a love that listens even when you're not saying anything, that knows the infinite ways you express yourself in silence, and can interpret the quiet as though you're screaming to be heard.

—Liz Newman

Your voice has resonance—a sound emoting a certain frequency, a certain knowing. It is an audible expression that has traveled from the belly of your breath to the passage of your mouth. The cadence and rhythm of its frequency mirrors that of the depth and urgency of what is spoken. However, when the resonance of our inner and outer self is not aligned, our expression becomes an amalgamation of conflicting narratives creating tension between what we say versus who we are.

## *SKETCH*

Imagine yourself standing on a cliff and the blank page as the valley of a mountain. In this valley, you will purge all of the unwanted emotions rising within. You will do so by visualizing a silent scream. You will use your pen as a vehicle to release it all onto the page.

Allow your shoulders, arms, and hands to move in harmony with the expression of it. Imagine your feet, legs, hips, and belly pulling from the earth and amplifying your scream even further. Use all of it to emphasize the weight of its expression. Let your strokes be wild, bold, and free. Use your lines to convey the uncontrolled, shaky vibration of its release. Play with the thickness of the lines, the motion the lines convey, and use your body to extend the energy of this release. Give your silent scream texture and imagine how good it would feel to release it.

As you sketch, pay attention to your breath. Allow it to mimic the forcefulness of its intention. Harness all of your senses including sight, sound, taste, and touch. Use your imagination and transport yourself to a time and place where this scream could be actualized.

When we scream, we are emptying ourselves from unwanted energy or signaling for help. In this exercise, I want you to think about both perspectives of what this silent scream means to you. Harness and reflect on the emotions you are trying to release.

As you release, sketch through the full energy of the scream. Do not stop at visualizing the scream, sketch through the silence afterward. What emotions does this silence hold? What energy are you still carrying after the scream is over?

It is not unusual when doing this sketching prompt for your body to move as an extension of this release. Listen to your body and allow yourself to let go. Here are some creative ways to physically release:

- Shake your body as if you are drying yourself off without a towel.
- Engage in a quick burst of rapid activity (i.e., jumping jacks, running in place, etc.).
- Dance like no one (or everyone) is watching.

## *REFLECT*

When you are done, take a moment to reflect on what you sketched:

1. What patterns, themes, or images arose?
2. What emotion(s) did you feel during the sketch?
3. How did your body respond throughout?
4. Did any memories, thoughts, or insights surface?
5. Did you observe any shifts in energy or perspective?

If, after the exercise, you want to follow through and give voice to your silent scream, do so in the safety and privacy of your own space. You can scream into a pillow, inside a closet, inside a car, while under water, or in the middle of nowhere. Whatever you choose, let go and release it all.

It is also okay to feel silly or uncomfortable while doing so. You do not have to project this façade of strength and perfection. Break free from the status quo. Even superheroes retire their capes from time to time. You have permission to do the same.

Escaping our daily life isn't always an option. If you are in search of a healthy alternative to expressing negativity in your life, this prompt is for you. Refer to it anytime you feel overwhelmed, stressed, or need permission to let go.

When you are able to sit inside the chaos and find a way to the stillness of your mind, you unlock the power of silence. More often than not, we do not have control over the external noise. All we can do is be present in all of it.

Breathe in the silence. Breathe out the stillness.

 SKETCH

## — TESTIMONIAL —

"SketchPoetic has given me a new language to connect with myself and others. For the first time in my life since I was a young child, I've been able to give shape to what is inside me—without expectations, without explanation, without the constraint of words—and know that I will be received. My sketches show me who I am and what I'm experiencing. They reflect my life in mysterious and surprising ways through the marks my hand creates.

"Since I started sketching daily, there is less noise in my mind. The images and messages I absorb from outside are balanced by the ones I create. In a quiet way SketchPoetic has moved the needle by bringing me back to myself. I am the same person I always was, only more so."

—Essie Martsinkovsky, @inked_sense

# 5

# SKETCH BREATH

Breathing is both essential and existential.

Essentially, it creates life. As you inhale oxygen into your lungs, your lungs deliver that oxygen to your bloodstream where it is exchanged for carbon dioxide. As your chest contracts you expel and eliminate the waste of carbon dioxide from your body. It keeps your heart pumping and your mind working. Thus, breath by breath, inhaling and exhaling is the definition of life.

Existentially, breathing creates the meaning of life. In fact, it is the most consistent meaningful act of creation that we are experiencing. The awareness of our breath connects us to our body, mind, and spirit. Each breath is change and exchange of the good for the greater good. It is growth. Conversely, the lack of awareness of your breath disconnects your spirit from your mind and body. When your spirit disconnects from your mind and body, you lose consciousness. Over time, if this continues, the disconnect widens and your mind and body eventually atrophy. Thus, maintaining the connection between our mind, body, and spirit is dependent on a regular, conscious exchange of inhaling and exhaling. Can we live our lives without this conscious exchange? Yes, for some time, but it is like holding your breath under water. Eventually,

Whatever truth we feel compelled to withhold, no matter how unthinkable it is to imagine ourselves telling it, not to is a way of spiritually holding our breath. You can only do it for so long.

—Mark Nepo

you have to come up for air. When you don't stop to consciously take a breath, you lose your sense of connection to yourself and the world around you. You lose the meaning of life.

SketchPoetic is an exercise of creative expression that teaches us to breathe with depth, awareness, purpose, and intention. It fuels the meaning of your life with every inhale and exhale you take. Your breath centers you on the rise and fall of the here and now. When we are centered on the here and now, our senses are heightened, and our body is operating with intention. We are more aware of the universe working in harmony with us and are more able to work in harmony with the universe.

When we are intentionally using our breath in an exercise, we are expanding the capacity of our bodies for the possibilities of life. We are expanding our potential for growth. We are increasing our endurance and strength. Even though growth happens in every breath, the possibilities expand when we are intentionally exercising it. Likewise, our possibilities collapse when we don't intentionally engage our breath.

Every emotion we have is experienced in our bodies and expressed in our breathing—love, anger, anxiety, anticipation, empathy, jealousy, passion, compassion, patience, impatience, hate, joy, pain, celebration, grief. Whatever the emotion, our breath guides us to the precious nature of its existence. Hence, the pace of our breath is also an indicator of truth. The speed at which it is taking place is a reaction to every action. We hold our breath when we are afraid, anxious, or anticipating a surprise. When we're upset, our blood boils, our hearts pound, and our breath is expelled in huffs and puffs of rage. When we are in love, our breathing speeds up and slows down. When we slowly and deeply inhale the beauty of a sunset, our lungs exchange the joy of that moment cell by cell for grief we were carrying in the unoxygenated blood fueling our mind and body. Whether consciously or unconsciously, breathing is relative to our mental and emotional state.

Returning to our breath also heightens our awareness of time. Time is one of those precious illusions we hold sacred in our lives. We never think we have enough time to stop and take a second and breathe. Seconds can seem like hours when we are intentionally holding our breath under water, going for a long run, or attempting to meditate. While taking a moment to consciously breathe is valuable, I would be lying if I didn't say that all too often, the moment feels indulgent, expensive, and unproductive. I have to purposefully give myself permission and space to feel that way about it and still engage in the exercise of it.

How do I use my breath in the process of sketching? I condition myself to breathe while sketching as if I was running. When I run, I am teaching my body to rapidly eliminate the waste. The exercise conditions my body to efficiently make this exchange. When I sketch and consciously engage my breathing, I am teaching my body how to efficiently eliminate the emotional waste. It may seem daunting to begin with, but over time, you realize the power of it vibrating in concert with every cell of your being. Your breath wants to be acknowledged and activated. It wants to expand your potential, grow possibilities for you, realize opportunities, heal you from injury, transform experiences, and release you to live.

The phone rang early one morning when Simon was on his way out the front door to his job as a lead software engineer for one of the biggest tech startups in Silicon Valley. In his late twenties, Simon was the definition of success. He was healthy. He had a vibrant social life, steady income, retirement accounts, and a handsome bachelor pad. It was like breathing. He didn't have to think about it. Life came naturally to him.

Years earlier his mother had passed away, and perhaps, the resilience he learned from losing his mother when he was young is the reason why he was so successful. He hadn't taken the time to think about it or consider it. There wasn't a reason to pause and breathe.

*Bzzzz.* His phone rang. It was an unknown number. *Bzzzz.* He wasn't going to answer it, but something felt off. He picked up the call.

"Hi. My name is Jennifer calling from Mission Hospital. I am calling on behalf of Mr. Andrew Zhou. May I speak with Simon Zhou?"

"Speaking," Simon answered. "Is my father okay?"

"Unfortunately, Simon, I am sorry to tell you that he is in the hospital here. He's had a heart attack and is now in a coma. You are listed as his emergency contact and we need you to come in to speak with the doctors."

Simon's heart began beating rapidly as he got off the phone with the hospital. He immediately called in to work and drove over to his father's bedside. *What is happening? Why now? What will I do?* He wasn't prepared to lose his father. The memories of his mother's passing surfaced and flashed in front of his eyes as he listened to the doctors explain the gravity of his father's condition. Everything moved in slow motion.

It's interesting what details people remember in these moments: the sound of the doctor's voice, the vibration from the heart monitors, the bright white tiles on the floor. All of his senses were heightened but he couldn't process the meaning of any of it. He just held his breath waiting for them to say the words that he did not want to hear, but those words never came.

After weeks of being in the hospital, his father finally awoke from his coma. A flood of relief was soon met with another round of concern. His dad was entirely unable to care for himself or to communicate. He needed full-time care, and Simon had no additional family on whom he could rely. Panic rose inside of him. *How can I manage it?*

*Inhale. Exhale.* Simon accepted his responsibility without knowing how long he would need to do it or what it would evolve into. He was in crisis. In a crisis, you don't think. You decide. You triage. You rally your strength and endure it. He had no way of

processing the financial, emotional, or mental stress of this change to his life. Overnight, he became the primary caregiver to his father, moving him into his one-bedroom bachelor pad. He hired an in-home nurse to take care of him while he worked. When he came home, he took over the care of his father—feeding him, bathing him, and dressing him. His days were excruciatingly long and occupied with someone to whom he couldn't really talk. He stopped seeing friends and exercising. As this situation became the new normal, Simon began to feel the isolation he was experiencing. His ability to relate with himself, with his father, and with others was deteriorating. It impacted his work. He felt panicked as if the four walls were closing in on him. *Will I be able to breathe again?* In his eyes, his life was no longer his own and no amount of air could fill his lungs enough to escape the suffocating nature of it all.

Simon shared all this as we sketched together. As I asked the group of participants to take a moment to inhale and exhale before we started the group sketch, he noticed his own shallow breathing. He had grown so accustomed to the panicked breathing he engaged in while treading the waters of his new life that he hadn't consciously noticed the way it was affecting him. As he took a deep inhale, tears instantly flooded his eyes. He hadn't given himself permission to feel any of the feelings he had collected—fear, anger, resentment, guilt, grief; it all exhaled from his body into the sketch. Simon had accepted his responsibility, he told me, verklempt with emotion, but in the aftermath of the trauma, he couldn't breathe. He couldn't allow himself to feel. He thought he would sink under the weight of it all, but in fighting to tread water, he was slowly exhausting himself. If he kept at it in the way he was doing it, he would drown. His only thought was to survive. He couldn't see how to lean back and float to get the air he needed to care for himself and carry his father. His spirit was disconnected from his mind and body. Sketching brought his spirit back to his mind and body.

When a person is drowning, they panic. They lose all sense of reason. The only way to safely help someone is to remind them to float. It helps them catch their breath so they can navigate to safety. If they can't rescue themselves, then lifeguards are trained to notify others that they are going in for a rescue then to approach swimmers with a flotation device from behind to support the victim's ability to lean back and breathe as they guide them to shore. In Simon's attempt to rescue his father, he didn't take stock of his own safety. Most of us don't. We leap into action without preparation or planning and get stuck. When we finally realize we are in trouble, no one knows we are drowning in our attempt to rescue another person. Every breath becomes a struggle to survive.

For caregivers, self-care is a paradox. It feels wrong to be concerned with our own care when someone else close to us is in dire need of it. We aren't taught to properly care for ourselves when caring for someone else. As a result, we don't allow ourselves the time to breathe. We don't feel the negative emotions that come with the responsibility of sustaining life for another person who can't care for themselves. The situation becomes untenable. You can't sustain it. You have to breathe. You have to take care of yourself. You *need* to breathe for the sake of those for whom you are caring.

Rest is also needed for renewal. We can exhaust our imagination in this process and sometimes lose our vision or motivation to create; the scarcity of our imagination is as dry as an arid desert.

Part of sketching daily involves bringing awareness to your breath as a way to connect or reconnect you with your mind, body, and spirit. Sketching in cadence with your breathing allows you to lean back and float above the waters threatening to drown you. It brings peace and sanity to war and chaos. It can function as your floatation device when you are rescuing someone else. Each line, dot, or mark consciously centers you above and below

the surface of your life. Through each mark you make, you are creating a way to live each moment of your life instead of simply surviving it.

Inhale. Exhale. Listen. Breathe into it.

# BREATH SKETCHES

In meditation, breathing is a spiritual practice. To inhale is to allow the positive energy to flow inside you, and to exhale is to allow the negative energy to flow out. The energy is changed and exchanged inside of us. Breathing creates its own cadence and produces its own lyrics. When you sketch, there is a similar change and exchange of energies. In fact, you can use your breath to learn about this exchange.

When you sketch through the following experience, notice the negative space you create on the paper. Negative space is what exists between the lines. It constructs and frames the images. Positive space is the image. As you stare into the negative space and breathe, notice the shape it takes. Not everything labeled "negative" is bad. Not everything that is labeled "positive" is good.

As you engage in the following experiences, notice the depth and pace of your breath. Imagine that the rise and fall of your breath is a lyrical backdrop that you can use to guide your sketches. When it is rapid or shallow, your lines may convey a restlessness and unease. When it is slow and deep, your lines may embody a keen sense of direction and purpose.

- How often do you pay attention to your breath?
- When you do, what thoughts or emotions arise in this mindful act?
- In what situations do you find yourself most aware of your breath?

Breathing is a lot like creativity. Like an inhale, you receive an inspiration, you let it run through the unique magnificence of who you are, and then you release it into the world, letting it go, unattached to the way it needs to look.

—Jill Badonsky

# SKETCHING THROUGH INTENSITY

( 10 MINUTES )

## *OBSERVE*

There is a synchronous connection between our breath and our emotions with our body serving as the bridge between both. Breathing allows us to express those emotions and learn to manage them. When we are afraid, our breath can take hold and release us in an instant. When we are confronted with the vitality and necessity of breath, we become consciously aware of its presence. Breath is life.

Bring awareness to your breath right now by sketching spirals at the same pace, frequency, and intensity as you feel yourself breathing.

## *SKETCH*

Starting with a dot at the center, take a deep breath in and sketch a spiral going clockwise out to mimic the rate and length of the breath. Then, when you're ready, exhale out and repeat the same spiral, but this time going counterclockwise.

Create a new spiral for every breath and notice whether the spiral changes in rate or length as you continue.

In the middle of this sketch, pause and hold one breath in for as long as reasonably possible. Do not overdo it. Hold it long enough to bring awareness to your body. Now exhale and continue breathing at your normal place.

For the remainder of the ten minutes, continue sketching spirals in synchronicity with your breath. Pay attention to the thoughts

A piece of art comes to life when we can feel it is breathing, when it talks to us and starts raising questions. It may dispel biased perceptions or make us recognize ignored fragments and remember forsaken episodes of our life story. Art may sometimes even be nasty and disturbing, if we don't want to consent to its philosophy or concept, but it might, in the end, perhaps reconcile us with ourselves.

—Erik Pevernagie

that pass along with any physical or emotional shifts that occur throughout.

## *REFLECT*

When you are done, take a moment to reflect on what you sketched:

1. What patterns, themes, or images arose?
2. What emotion(s) did you feel during the sketch?
3. How did your body respond throughout?
4. Did any memories, thoughts, or insights surface?
5. Did you observe any shifts in energy or perspective?

 SKETCH

# SKETCHING WITH STILLNESS

( 30 MINUTES )

## *OBSERVE*

For the human soul is virtually indestructible, and its ability to rise from the ashes remains as long as the body draws breath.

—Alice Miller

Imagine the blank page as the surface of a glassy lake. The water of the lake is calm and undisturbed. Let's connect how your breath and sketches can work together in synchronicity to bring you to the present moment.

Through sketching, you are going to visually "disturb" the page by imagining what happens when your breath hits the surface of the water. Here are some visual examples as a starting point:

- Imagine your breath as raindrops leaving circular ripples on the page. Think about the weight of the raindrop and the size of the ripples it creates to mirror the depth and length of your breath.
- Picture your exhale as wind blowing on the surface of the water, creating arched ripples across the page. Consider how wide the ripples go based on the length of your exhale.
- Picture your inhale creating a mini typhoon or whirlpool on the lake. Consider the size and width of the typhoon to mimic the depth of your inhale.

Do you have a visual in your mind? Good. Stare into the image. Inhale deeply. Exhale slowly. Bring awareness to the way in which your breath gives life to each part of your body. Now, begin.

## *SKETCH*

Sketch the marks or patterns you envision as you exhale on the surface of the page. Allow your pen to respond to the rise and fall of your breath.

If your breath is steady, let your lines be even and controlled. If your breath is forceful, let your marks be bold and strong. If it is shaky, shake the pen. If it is calm, keep the lines straight. If it flows like a stream, let your pen roll with the movement. Do you feel yourself breathing onto the page? Outline where your breath falls.

Engage and activate all of your senses. Let your hands rest against the page and allow the tactile experience of touch to deepen the connection between your breath and your sketches. Tune in to the sound of your breath and let the rhythm or richness of its sound intensify your focus. Breathe in the aroma of what is around you and let it enrich the fullness of this visual experience.

Connect with the power of your breath and its ability to transform the energy of your blank page. Allow your sketch to be in harmony with your breath. Let the negative spaces in between serve as the space for your emotions to breathe.

## *REFLECT*

When you are done, take a moment to reflect on what you sketched:

1. What patterns, themes, or images arose?
2. What emotion(s) did you feel during the sketch?
3. How did your body respond throughout?
4. Did any memories, thoughts, or insights surface?
5. Did you observe any shifts in energy or perspective?

Anytime you need to be present with your breath, repeat this exercise. Take notice of how breathing impacts you and how you can use your breath to transform your reactions.

- How did your mind and body respond after you held your breath?
- Did you see a change in your spirals after you held your breath?
- Do you ever hold your breath? If so, are you aware of it when it happens?
- What causes you to hold your breath?
- Did the rate and depth of your breath change as you sketched?
- What other observations did you have when you focused on your breath?

Let the visual metaphor evolve to be whatever you want it to be. Let the surface of the page change. Let your breath be something new in how it engages with it. Over time, the awareness of your breath will ignite truths that reside in your life.

— SKETCH —

— TESTIMONIAL —

"Breath and breathing are a key part of daily sketching. The body scan, requiring a deep breath and feeling where the energy—and what energy—is in the body, initiates every sketching occasion.

"One of my favorite prompts from Sheila was 'the yarn' exercise: the idea was to imagine a ball of yarn inside that unwinds as life unfolds; there are knots and tangles along the way, which represent challenges, lessons, or tension. I was asked to sketch the yarn as a representation of my current state, showing how much of the ball of yarn remains, how many tangles and knots still need unraveling, whether they're tightly knotted, etc.

"Breathing was a critical part of this prompt—both to set my intention for the sketch and also throughout the sketching process, as I unwound and unknotted my past and future challenges, lessons, and life experiences. I loved the simplicity of the prompt and sketching through this allowed me to realize how far I've come and how many knots and tangles I've conquered. It reminded me that there are knots and tangles ahead but I have lots of experience handling them now, so I don't fear them. There's one knot that I've been struggling with for a while and haven't sorted out yet, but that's okay—I'll keep working on it.

"I see the yarn—crinkles and dents and all—as a perfect metaphor for life. Patience and many deep breaths are required along the way."

—Amy Stanton, @amykstanton

# 6

# SKETCH TRUTH

Personal growth involves various forms of acceptance. Truth, for example, involves accepting that both the positive and the negative actions and reactions you have experienced in life work together for some good. *What good?* you wonder. Well, that isn't for me to tell you. It is for you to discover. What I can share with you is this—the anger, hate, shame, or regret you may feel from any given action or reaction is only temporary. You can choose to relive it and stay in that moment. Or you can choose to express it and grow from it.

My entire life has been built with goodness at the core of my being. Being a proud Filipino, I was inspired by the selfless, caring, and generous nature of my people. I made no room for disobedience or rebelliousness. Conformity and belonging mattered more than anything. It was safe. I molded myself into the "good girl" standards of what I was told and conditioned to believe was good. I never demonstrated my anger or displeasure. I put the needs of others before my own. I never complained and only expressed gratitude. I was the consummate daughter, friend, partner, wife, and mother. All of it tied neatly in a contained box with a pretty bow.

The truth has legs; it always stands. When everything else in the room has blown up or dissolved away, the only thing left standing will always be the truth. Since that's where you're gonna end up anyway, you might as well just start there.

—Rayya Elias

I constantly sought affirmation for my goodness. I was not secure in it. I knew it. When it came time to immerse myself in my career, it was not surprising that I felt drawn to corporate environments with strong, demanding cultures with passionate, driven individuals striving to create impact. That was how I saw myself. That was who I wanted to be. While this type of environment felt kindred, it also highlighted my underlying insecurity—*Would I ever be good enough?* I wondered as I admired my peers. Would I ever feel the confidence and self-assurance that they have?

There is a line between caring about what people think and defining yourself through their eyes. I put on a mask of confidence and certainty. The mask was made of small mirrors that I had collected over the years. It reflected back the characteristics of people I aspired to be. This mask gave me superpowers. It made me feel bold and fearless. It could harness all the incredible things I idolized in others.

However, it was not me. Underneath my mask of a good woman—strong, resilient, courageous, I was truthfully uncomfortable in the light. I felt exposed in the light. However, there came a point as I was engaging with my morning sketches when I realized I wanted to be confident in the light. I didn't want to hide in the shadows anymore. I wanted to strip away the mask I had made and be the person whom I always admired.

I had used the mask to climb higher and higher rungs on the ladder of success but as I reached each rung, I was faced with a definition of success that was not my own. *How could I live my life in a more purposeful and meaningful way?* I didn't know but I kept sketching through. As I did, gradually, the mask began to fade until I was no longer hiding behind it. I stood for the truth I wanted to live and the truth stood for me.

Every time an art student passed me in the halls at the University of Memphis, my stomach would sink. It was like bumping into someone I used to know, then losing her in the crowd. *No, I*

would say to myself, *that wasn't her. It isn't you.* Computer science seemed like a logical choice as my major in college. I mean, why not? The Internet seemed like it was about to boom, and I excelled in math and engineering. But it was predictable. I was on autopilot, studying hard, making good grades, and working full-time to pay for my tuition.

I knew I was a "good girl." I knew my internal compass rested solidly on that direction already. Being good reinforced my childhood silence. I hid from decisions that I thought would detract from the great honor I attributed to the sacrifices my mother had made. My mother's sacrifices lay as a blueprint for my life. Her hopes and dreams had become an extension of my own. As a dutiful daughter, it was my honor and goal to make her proud. Every day, my mother would express just that and for a long time, it was my personal measure of acceptance and worth. Good girls are obedient, respectful, kind. They know to be seen but not heard. They know to reject the wildness within themselves. This good path was safe. It didn't encourage exploration or require taking any risks. It gave me a false sense of safety and control. I innocently believed it was a path that could almost guarantee success as long as I didn't challenge it. But it wasn't my truth.

The more I saw myself in every art student, the more I realized I had to find out who she was. She appeared to be going somewhere I wanted to go. *Could I follow her? Could I choose her? Could I choose to stay on the pre-drawn, straight and narrow path? Could I color within the lines? But what if I sketched a way that led outside the lines—or what if I perhaps sketched a way that would lead to my own greater good?* The more curious I gave myself permission to be, the more purposefully I began to let myself wander. Without a doubt, I found myself wandering after the art student I saw in the hallway. The insatiable curiosity within demanded I follow her.

Eventually, I followed her into the academic office of fine arts and changed majors. When I found the courage to make this move,

my biggest fear was my mother's opinion. *Would I bring her dishonor? Would she think I was being foolish? Was I rebelling?* None of those questions were real fears. At lunch one afternoon, I shared with her my decision and while she was initially shocked, she did not have the hyperbolized reaction I thought she would have. She didn't disown or belittle my decision at all. She stood by me as she always had and demanded the same excellence in this path as she did in the last. Her love never wavered. Being a "good girl" was not the currency that determined her love for me. It wasn't the only way to receive love either.

I became aware of my truth in this decision to change majors, and it sounded a lot like love. The kind of love that has always existed inside, the kind of love that can't be created or destroyed, the kind of love that has been and always will be. Although the truth found in this experience was still very shy and unsure of itself, it lit up an awareness inside. It was shining a light on a way to love myself and for others to love me even more than they had been able to before. It revealed the truth about the existence of love inside and outside me. With this light and liberation came a world of questions, choices, and possibilities.

That is the way with truth.

How often do we project an external identity not aligned with our internal truth? Why do we feel the need to protect ourselves and others from it? It's like projecting a lifestyle of rich opulence, but being in overwhelming debt in order to live it. Eventually, if we are not living in awareness of truth, our lies become our truth. The false brand we have made of ourselves to make ourselves appear more marketable to friends, family, coworkers, and partners also keeps us at a distance from them. The façade we create of our perfect life choices, which we have accepted in place of truth, eventually decays. It's not sustainable. It's not real. It's fake, and the energy it takes to maintain it could be spent on activities that create a more authentic, durable structure in which to live.

Engaging in SketchPoetic is a practice that reveals your truth. It provides you with the opportunity to evaluate the rhythms and repetitions that exist in your life. The cadence of it allows you to become aware of the truth in the patterns you find, and it also allows you to expand the truth that you see until it takes up the whole page of your life. As the momentum builds, the truth expands wider and wider. It bubbles and boils over page after page.

Listen to the truth that sets you free.

# TRUTH SKETCHES

In the search for ourselves, we often lose the path to our own self-worth. Worthiness can be elusive and layered with great expectations. We fixate on what the end state looks like and forget why we were searching in the first place. Living in our truth takes courage. Becoming aware of our truth involves repetition and reflection. These characteristics of strength are also malleable like water. They take the form of whatever they are poured into. Engaging in daily sketching trains you to flow forward and over the lies or partial truths that no longer serve your growth.

There is power in challenging your beliefs and letting your curiosity override what is hardwired in your brain. To unleash your truth, you must choose to bring your shadowed self into the light. You must follow that person to the place where you decide to make the changes you know you need to make. What you will find when you get to that place, is that you have already transformed. You've been making small changes daily and now you are simply recording the transformation.

In the following prompts, you will begin marking your truth and recording your change.

- Do you stand in the truth of your being?
- Do you mask the truth of who you are to others?
- What emotions do you find yourself masking?
- How is your external self different from your internal self?
- Are there any parts of yourself you're afraid to reveal?

*Should you shield the valleys from the wind storms, you would never see the beauty of their canyons.*

—Elisabeth Kübler-Ross

# SKETCHING THROUGH FRACTURE

## ( 10 MINUTES )

## *OBSERVE*

Whatever path or detour led you here, honor it as a gift. You are choosing to remember. To see yourself as a creator and the divine work in progress you have always been.

Some days you will flow, you will blossom, you will grow toward your full self. And some days you will feel discarded, found in the torn, crumpled pages of your forgotten self. This dismissive act is not one of rebellion or disgust, it is an act of avoidance—an avoidance of the truths you may not want to see or to feel the love you do not believe you deserve.

The purity of creation will guide you to detach from the outcome, no matter how magnificent or destructive it may be. It invites you to move beyond your mistakes and embrace the wondrous joy of your unique imperfections.

There is a Japanese art called *kintsugi,* also known as *kintsukuroi,* which brings together pieces of broken pottery using liquid gold. The gold enhances the breaks and celebrates its scars. The art of healing manifests in this wondrous expression of art.

Dear reader, are your cracks faint or noticeable? Do you have short or long ones? Are they jagged or smooth? How many cracks are there? Are there pieces of you missing? Through creation, make peace with this part of yourself and remember, you are not broken. You are worthy. You are glorious in all of your golden imperfections.

I know exactly where my cracks are and how deep they run. I don't pretend to not be a broken person and therein lies the big difference. Because the truth is, we are all broken in places, but it is those who know exactly where and how they are broken, who also know exactly where and how they are whole! And we may not be whole in all places and in all ways, but we take whatever wholeness that we do have, and we make good of it. And we try hard to work on the broken parts, and we ask for help when we need it.

—C. JoyBell C.

## *SKETCH*

Embodying the philosophy and mindset of *kintsugi,* sketch a basic shape representing you. It can be a circle, square, or an organic shape like a silhouette or a portrait. Think of it as your essence only and create an outline.

Once you have made the outline, spend the next ten minutes sketching cracks in your shape. Let each crack represent the wounds or brokenness you feel within.

As you sketch the cracks within the shape of you, connect to the thoughts and emotions that arise as you remember how it originated. If the memory is too painful, do not linger on the experience. Rather, allow yourself to feel the uncomfortable emotions and release them on paper. Retrace the cracks lightly, if needed, and continue until you are ready to move on.

## *REFLECT*

When you are done, take a moment to reflect on what you sketched:

1. What patterns, themes, or images arose?
2. What emotion(s) did you feel during the sketch?
3. How did your body respond throughout?
4. Did any memories, thoughts, or insights surface?
5. Did you observe any shifts in energy or perspective?

 SKETCH

# SKETCHING WITH PROTECTION

( 30 MINUTES )

## *OBSERVE*

Do you remember the day you put on your first mask? Not a literal one, but a figurative, metaphorical one? Perhaps it was the first time you pretended to be someone you were not? Maybe it was a projection of someone you wanted to be? Or the only way you knew how to fit in? Whatever the reason, we all wear masks to conceal what we do not want to feel.

## *SKETCH*

Sketch the mask you wear, or have worn in the past, by expressing what it represents to you. You can choose to visualize it as an actual mask with eyes, a nose, and a mouth. Or you can explore an abstract expression using patterns, textures, or lines to convey the energy of it.

As always, do not focus on what it looks like. Focus on the truth of what these masks mean to you. Visually explore the concept of it on paper. Use your imagination and have fun with it.

As you sketch, pay attention to any memories or experiences that come to pass. Observe with curiosity and wonder how your face distorts when you sketch the different parts of your mask. If you notice yourself fixating on what the mask looks like or whether it truly represents you, then take a moment to pause, breathe, and reflect on the why.

The goal of this prompt is not to design a mask, but rather to express how it feels to know you are wearing one.

You may never know how many masks you have worn or

> The most important kind of freedom is to be what you really are. You trade in your reality for a role. You trade in your sense for an act. You give up your ability to feel, and in exchange, put on a mask. There can't be any large-scale revolution until there's a personal revolution, on an individual level. It's got to happen inside first.
>
> —Jim Morrison

whether you still do. You may even discover that you have worn your mask for so long, you don't even realize you are still wearing it. What matters in this moment is to sketch through the why and to slowly reveal the truth of who you are beneath it.

## *REFLECT*

When you are done, take a moment to reflect on what you sketched:

1. What patterns, themes, or images arose?
2. What emotion(s) did you feel during the sketch?
3. How did your body respond throughout?
4. Did any memories, thoughts, or insights surface?
5. Did you observe any shifts in energy or perspective?

Hidden within the process of creation are universal truths we often seek to find in the world around us. The magic of creation is the illumination that so much of what we seek is already within us.

- Do you wear an emotional mask to project a mood or comfort yourself?
- Do you wear a physical mask to project an image or style that isn't really you?
- Do you wear a relational mask to project belonging or a way to blend in?
- Do you wear a protective mask to hide how you truly feel inside?
- Do you wear a costume mask to pretend to be someone you are not?

If you choose to do so, you can also use this prompt to sketch the mask of another. Someone who may be triggering a response

in you that is not favorable. Sketch their mask and allow yourself to find compassion in why they may be wearing one too.

Anytime you catch yourself avoiding an emotion or shielding yourself from the world, use this sketch as a way to explore the why. In visualizing your armor, you will remember the battles it has fought and the grace you deserve in seeing it.

 SKETCH

## — TESTIMONIAL —

"The concept of a Renaissance person who excelled in both art and science drew me to art at first, but it was the first impressionists that fascinated me later. The fact that one can express one's inner world and impression through art is awesome. When I realized after a few years of practice that I do not have the emotional connection to my work, I left the practice of art behind me.

"Twenty years later, I am a PhD student in particle physics, and my emotional world is turbulent. I stumbled onto a post by a friend regarding emotional drawing and I contacted her, searching for a way to channel my emotion onto paper. She sent me a message about the pioneering group called SketchPoetic hosted by Sheila.

"The practice awakened the artist in me. My dormant creative side was unleashed. I wanted to create nonstop, and new ways of expression came naturally to me. In addition to sketching, poetry emerged from me. I was able to connect to myself better and to be more empathetic to others. Our small group of strangers transformed fast into a community of companions on a spiritual and emotional journey.

"The practice takes an important part of my day. This is a time that I religiously take to myself. It is

an important tool for me to connect to the conscious and sub-conscious parts of myself. I am grateful for the opportunity to learn the practice and be a part of a wonderful group of amazing, insightful friends."

Finishing with a haiku:

Colorful black ink

extracts the best out of us

forms a family.

—Dan Shaked-Renous, @tunnelledpoetic

# 7

# SKETCH BELIEF

Not the world, not
what's outside of us,
but what we hold inside
traps us. We may not
be responsible for the
world that created our
minds, but we can take
responsibility for the
mind with which we
create our world.

—Gabor Maté

Staring at the blank page of my sketchbook, expectation looms. I expect myself to produce something of value. I expect the page to reflect my worth. During the "stare down," I expect what it produces to be perfect and to perfectly represent me. I am a creator. I must create and will create, but the evidence of my creative identity has not yet happened. Belief is the only way it can be realized.

Believing in myself always gives me pause. I am innately loyal to the false ideals of perfectionism, paradoxically committed to an unattainable sense of achievement, and overprotective of my need for validation and approval. *What if I make mistakes? What if the sketch represents nothing of value? What does the sketch say about me? What ugliness will it reveal in me? What insecurity will it expose?* Once the sketch is realized on the page, I have to let it live, breathe, and exist. It cannot be denied. Each sketch is a risk that exposes my imperfections.

Thus, the stare down between me and the page is intense. The expectations are high.

In the beginning, I intuitively chose to use a pen rather than a pencil. Not for artistic reasons, but in recognition of my unhealthy attachment to perfectionism. I was certain using ink would be

an insurmountable challenge. There would be no opportunities to erase or rework the piece over and over again. In committing to it, the pen did what I feared most it would do. It prevented me from revising the proof of my imperfections. There they were—shaky lines, incongruent shapes, thoughtless designs, overworked sections, incomprehensible compositions—a whole journal full of them.

Pause.

Read that again. I completed an *entire journal of imperfect sketches*. To my surprise, I didn't abandon the practice or the pen. Instead, I made daily peace with each mark being made and gently, over time, began to dismantle the negative, external beliefs internalized. Using the pen gave me permission to make mistakes, incorporate failures, utilize errors, and create chaos. It forced me to believe in the good that could be made from whatever appeared on the page and as a result, it provided proof of the real good that existed within me—imperfectly perfect kind of good. Finishing an entire journal had never happened before. There was a true sense of accomplishment and achievement in it. In those moments and the many completed journals that have followed, the critical parts of myself were given new value and worth.

"I started taking watercolor classes with my daughter," an accountant shared with me one day. "I am not an artist, but that's not why I took the class or continue to take them."

"Why did you take it?" I asked.

"At first, it was simply to spend time with my daughter. It was what she was in to doing and I thought it would be a great way for us to bond together. It was and still is, but secondarily, I began learning something about myself as we sat in silence and painted. I found myself frustrated and bothered that my paintings looked bad. We kept going, and I began to lose my need for accuracy and my expectations of perfection. As I did, the paintings looked better. They felt better. Instead of accounting for something, I was making something. I lost

myself in the flow of the water and the pigment and let it become. My paintings aren't fine art, but I feel progress and peace. In fact, it is even changing the way I look at my work."

"How so?" I wondered with curiosity.

"I have always been so focused on formulas and calculations that follow rules, procedures, and steps to arrive at results, answers, savings, and growth that I didn't realize that I was living my entire life this way. In all my relationships and in my leadership, I was especially rule-driven. It was procedural and transactional. Sitting with my daughter, following our curiosities together and simply making something without attachment to the result. It simply clicked a light on inside that accounting is not a paradigm for which I want to live my entire life. I was missing greater meaning—a qualitative meaning, not quantitative meaning. I was missing context."

One of the greatest challenges people face when they first begin to sketch daily is overcoming their own set of limiting beliefs. They have preconceived notions about art, the process, the value, the worth, the outcome, whether or not they are good at it. The list goes on. Every expectation is piled one on top of another like mental and emotional blocks cemented into place. Because belief is like an invisible frame, we don't realize how trapped we are in our view of the world. You can see outside of the frame, so you believe you are free. However, you can't leave the place you are in. You don't see what is restricting you. In turn, you run in place. It feels like progress because you are exercising, but you are going nowhere. Every runner knows that running a mile on the treadmill is a different experience from running a mile on the road, but until you are on the road, you can't know the similarities and differences. Until you see the frame you are in and the structure of the house built around you, you won't find a window or doorway out.

As you engage in your own practice, acknowledge the various types of beliefs you encounter. Make note of them in your

sketches. Allow them to exist in the moment. Be aware of the way in which your beliefs empower you and disempower you. Release your certainty in them. Question them. As we learn to detach from expectations or accurate representations and still continue to produce, we tap into the power of creative expression as a tool for self-care, transformation, and healing.

You do not need to have all the answers. It is okay if you don't know how to start or complete a sketch. It is okay to leave a sketch unfinished. It is okay if your sketches look terrible and you don't perceive any meaning to them right away. Release your expectations and beliefs that are disabling one by one. Each can be and will be transformed through the frequency and consistency of your practice. You create a believer in yourself.

Believe you can fall. Believe you can fail. Believe you remain unfinished.

Examine and release.

# BELIEF SKETCHES

In mastering the art of staying busy, we believe stillness is tantamount to laziness. In the pursuit of productivity, awareness is a distraction. Achievement is measured by the product rather than the process. Thus, we live in unawareness as we are focused on the destination or outcome.

Activity comforts us. To be silent and to be still unnerves us. To be curious feels like a waste of time. In fact, these activities often represent speed bumps rather than progress, and with that mindset, we do not take time to pause or take scenic detours. We are conditioned to feel that it is imperative in life to know at all times what our destination is and be marching toward it. In the following prompts, identify the ways in which you feel pressure to achieve and allow yourself to reframe and rethink them. Explore your fears. Question your reasons. Allow yourself to release your idea of perfection.

Most big transformations come about from the hundreds of tiny, almost imperceptible, steps we take along the way.

—Lori Gottlieb

## SKETCHING THROUGH CONSTRAINT

( 10 MINUTES )

### *OBSERVE*

We often hold on to beliefs that hurt us or no longer serve a purpose in our lives. These beliefs anchor us in place and prevent us from experiencing anything more than what we know to be true around us.

Imagine yourself as a boat being anchored. You want to set sail, but this heavy weight holds you back. Think about your answers to the following questions:

- How big is this boat? Is it a rowboat, sailboat, yacht, or ship?
- Is there anyone or anything on the boat that holds significance?
- Where is the boat? Is it on a lake, river, or ocean?
- Is the boat free or anchored?

## *SKETCH*

Using this visual metaphor, begin to draw what you see in your mind. Think of your circumstances today and how your vessel has changed or evolved over time. Begin with the shapes and the lines of your boat. How does it represent you?

Now imagine the scene it is in. Are the waters calm or rocky? Vast or contained? Allow your mind to explore the details of the image or scene unfolding in your mind. Let your pen wander around the outlines and shapes it wants to create. Repeat them over and over as you feel necessary.

You don't need to draw a realistic boat or scene. Sketch the feeling of the boat you are imagining. Think about the size and scale of this vessel and the type of anchor that is needed to keep it in place. Consider how long it has been anchored. How deep is the anchor that is weighing it down?

Let the anchor serve as a metaphor for something (or someone) that is holding you back. Visualize the heaviness or attachment in a way that you can understand. You can do so by adding symbols, marks, or even words. Integrate them into your sketch.

You may encounter many defeats, but you must not be defeated. In fact, it may be necessary to encounter the defeats, so you can know who you are, what you can rise from, how you can still come out of it.

—Maya Angelou

113

## *REFLECT*

When you are done, take a moment to reflect on what you sketched:

1. What patterns, themes, or images arose?
2. What emotion(s) did you feel during the sketch?
3. How did your body respond throughout?
4. Did any memories, thoughts, or insights surface?
5. Did you observe any shifts in energy or perspective?

— SKETCH —

# SKETCHING WITH FREEDOM

( 30 MINUTES )

## *OBSERVE*

When we take risks in life, failure is an inevitability. It is not enough to succeed. Learning from errors and converting them into fuel is part of our growth process. As you sketch through what you go through, you will begin to observe the marks you see as failures or guideposts inviting you to look deeper within yourself.

Every sketch you want to destroy or throw away is challenging you to see its worth. It desires to be seen and not discarded for its perceived imperfections or missed expectations. Reflect on the truth that these "mistakes" reveal in you. Take action to incorporate them into your design. In doing so, you consider what new meaning that gives to viewing yourself as a creator.

As long as the mind is enslaved the body can never be free. Psychological freedom and a firm sense of self-esteem is the most powerful weapon against the long night of physical slavery.

—Martin Luther King Jr.

## *SKETCH*

For this exercise, I want you to take a piece of paper and crumple it. If the page is in your sketchbook, do not tear it. Crumple it within your journal or make enough creases to give it a similar look and feel. Once you're done, flatten out the page.

Pause for a moment and stare at this crumpled blank page. Observe how it feels to see it damaged and visually discarded before a mark has even been made.

Using all of the folds, creases, and shadows as inspiration for your sketch, follow the lines like a roadmap. You can outline all the creases and folds or just some. You can create designs using dots, crosshatching, or parallel lines within the folds or none at

all. Interact within lines and shapes as you sketch and see what images or patterns arise.

As you engage with the uneven and bumpy terrain of the page, observe how playing with it makes you feel. Pay attention to your senses, especially touch, as you navigate your way around the crumpled page.

## *REFLECT*

When you are done, take a moment to reflect on what you sketched:

1. What patterns, themes, or images arose?
2. What emotion(s) did you feel during the sketch?
3. How did your body respond throughout?
4. Did any memories, thoughts, or insights surface?
5. Did you observe any shifts in energy or perspective?

Whether this page is in your journal or outside of it, refer to it anytime you desire to judge or discard one of your creations. You may be tempted on occasion to do so, out of fear of what others may think or from your own unwillingness to associate yourself with it. These emotions are here to shine a light on a part of your creative self that is seeking to be freed.

Imagine each sketch as an embodiment of your inner child expressing itself on paper.

- How does it feel to create on top of something that was initially discarded?
- Would you hide or discard this creation from the world?
- Or would you love, honor, or cherish it for its purity and joy?
- How does it feel to engage with the texture and terrain of this page?

- What are you noticing in the patterns or lines you are following?
- What thoughts or memories arose as you sketched through it?
- What did you observe about yourself in this experience?

Release regret and any errors you perceive as you make your way through this sketch. You will likely see something you could have done differently or wish you could erase. Embrace that feeling. Become curious about it and ask yourself, how can I incorporate it? What new idea can it spark?

Learning to sketch with growth in mind is to embrace the healing power of the unintended or unwelcomed lines. It is a catalyst for self-acceptance and love.

As you return to these prompts, allow yourself to fall further and further into a state of belief. Lean fully forward into the essence of who you are. Relax into all of it—the guilt, the shame, the disappointment, the ugliness, the desire for control and clarity. Let your imagination fuel these negative emotions and rather than resist them, embrace them fully. Comfort them. Let your inner critic emerge with its fiery stare and biting tongue and welcome it warmly. Let your eyes open to the world that existed before trophies, awards, degrees, money, and things were the evidence of your worth. Invite the failures and the judgments to sit with you. They do not define you as a creator. They do not define your creation. Your success is not outlined by perfection, but a collection of imperfect experiences leading you there.

As you begin to believe that nothing in life is perfect, it is then that you understand exactly how everything is perfect.

Examine your beliefs.

— SKETCH —

## — TESTIMONIAL —

"SketchPoetic has been an uncomfortable experience, which is how I know it's exactly where I need to be. As a type A woman, I'm constantly holding myself to a pedestal of perfection that I thought simply couldn't be reached with my lack of artistic language.

"I've so truly appreciated the community providing me with an opportunity to be perfectly imperfect as I continue to discover myself through my sketches. I've found my own language, an ability to not only express how I feel but also an outlet to remember those emotions and memories days and even weeks later when I look back at them.

"I've been provided a home within this platform. One that accepts my darkness, my light, and my unwillingness to stick to one single way of doing things. A home that truly lets me be me with no judgment or you-should-do's attached. I'm forever appreciative of the community, and will carry this practice close to my heart always."

—Victoria Myers-Lopez,
@_cultivatingcreativity_

# 8

# SKETCH TRUST

There will be moments when your pen glides from sketch to sketch sailing through the imaginary skies without fear or hesitation. It will seem effortless and divinely guided. You will be in awe at the ease in which you flow into it. You no longer question what will happen, because you know it is already happening. You have fought against the resistance and moved past the shadows cast from judgment or expectations. You've surrendered to the expression of what you can create. You have tasted the richness of your potent energy. You are now free to create in love. This is trust.

Then there are moments when your mind is vacant, your emotions stalled, your senses numb. Every part of you is frozen in place, fixed by the weight of this nagging feeling of *"Now what?"* and *"What's next?"* You were not prepared for this feeling. Up until this moment, daily sketching has led you to curiosity, wonder, growth, and transformation. Now, the luster and shine are fading. The habit is starting to feel like work. And this tool, which was once sharp and pointed in its insights, now feels dull and less revealing.

Your sketches begin to look the same, so you question the value of what you are doing. You skip more days than originally

Transformative art must express something beyond where you are. It demands that you grow beyond your current self. This is where an artist's angst and the pain of transformation coincide. You reach toward the true, the good, and the beautiful and become a better person through the struggle.

—Alex Grey

planned, so you question your commitment to the practice. You believe you have explored every facet of yourself, so your insights seem superficial and meaningless. This wall is real. You have hit a plateau. But it is not what you think.

This is a different type of discomfort. The type of discomfort that happens when we become attached to the intensity of growth or the newness of an experience. It is a natural part of any process to plateau or experience what I call the "blahs." The blah moments where it seems like you are going through the motions. Where your sketches seem to blend from one to the other. When the process has now become all too easy.

What is it about easy that we mistrust? And what is it about the simplest or lightest of expressions that we question as less worthy than a breakthrough or profound expression?

It is in these moments that trust becomes even more imperative. It is counterintuitive to think of sketching through comfort, when most of your journey has been sketching through discomfort.

When we leap into a process of self-discovery, our appetite for change can be insatiable. It is not uncommon to become prolific in your expressions. However, it is also common after an accelerated start to question the steadiness of the ground below when things level off and stillness becomes your new normal. This is the process of creative expression. The learning and unlearning of truths we once held to be true and the unhealthy behaviors that support them.

As you continue the path of self-discovery, you will begin to trust in all of the ebbs and flows, curves and straight lines your journey will go through. You will learn to value every part as a necessary and divine step in your evolution. You will learn that every sketch is an invitation to trust in *all* of it.

Tilting her head to the side, Stephanie stared at her self-portrait on the easel. "That looks nothing like me," she grumbled to herself. She had been working on the painting of herself for over two weeks and every time she looked at it she could only see the faults

it had. The proportions weren't balanced. One feature had more detail than the other. The values were off. The color was muddy. A relentless spiral of criticism and judgment consumed her.

Staring into her own eyes in the mirror, she hated this assignment. Nothing is more unnerving than completing a self-portrait, especially when you don't believe yourself to be a subject worth painting. The depth of pain she felt, she couldn't capture. There wasn't a value she could add to her image on the canvas that would represent how inept she felt. What was the point?

She doesn't remember when art became all about the outcome. It used to be something she leapt into without reservation. The process felt wild and free. She felt alive and pure in its innocence. The shift in perspective didn't happen overnight. It happened slowly. What once was an audience of one became a crowded room made up of people who she sought for affirmation and validation. She no longer trusted herself to decide whether or not her work was good. Trust shifts in that way. It is easily transferred. In placing her trust in the opinions of others, she gradually stopped listening to her own voice.

Second-guessing and questioning every aspect of her work, she felt an ever-present critic sitting on her shoulder directing, correcting each brush stroke. During the 2020 pandemic, she was forced to study from home and class critiques were canceled. The assignment was postponed. Frustrated and isolated from others, she decided to scrap the painting and paint herself in the way she felt about herself in that moment. She globbed on paint and pushed it around the canvas furiously. She moved with anger, disappointment, and deep frustration as she facilitated between looking at her reflection and constructing her portrait.

A conversation between her and the image on the canvas began to take place as she painted. Little snippets of criticism her mother had said about her nose. The time her boyfriend held her face and looked into her eyes before kissing her. Faint wrinkles around her eyes. A memory of her grandmother by the water. A song from

childhood she used to dance to. An imaginary argument with one of her teachers that she wished she had the nerve to start. Thoughts about her future.

When Stephanie was finished, she saw herself on the canvas. Contentment and peace washed over her. It was a mess of brush strokes, color, and paint, but it was her. That was her image. That was her soul. She had tuned in to herself and found the frequency inside herself to which she could listen and express herself. As she turned up the volume and clicked play, she found sounds of hope and faith returning to her. She could trust these sounds more than any other because they were made of love.

When trust becomes distrust, it loses faith and hope. Distrust breeds fear, resentment, and contempt. It kills the creative spirit. Discerning where, when, and in whom to place your trust is a moment-by-moment decision. Trust is not permanent. It is temporary. After all, nothing in life is certain.

Your hands may shake and your fears may surface. You may say to yourself, *It's dark in here, I don't know the way, I have no talent for this,* as you weave in and out of your daily sketches. You may even question the value of doing it. You may want to stop, to give up and turn back once more especially if it does not reap immediate rewards or satisfaction.

Examine all of it. Extend your discomfort and express the frustration you feel. Soon, the critical light that once existed outside of you will pale in comparison to the light of truth that comes from within you.

As you plunge headlong into the magical, curious places of your inner world, release the reservations, criticisms, and judgments holding you back. Trust the process of creation.

# TRUST SKETCHES

If I lean back and trust someone or something to catch me and it doesn't, I learn two things from the experience: 1) discernment and 2) judgment. I could use that discernment and judgment to distrust everyone and everything for the rest of my life, or I can use it to calibrate who and what I can trust. I grieve the pain and accept the loss of that person, place, or thing in my life because it is not part of the possibilities with which I can design. It's a crayon I have tried and it doesn't serve a purpose in my box. I can appreciate it, but not use it. I can enjoy it in another way or get rid of it.

From a young age, we observe the importance of belonging. We pay attention to the actions and behaviors of others. We actively choose to mirror or adapt in order to fit in. At first, these choices seem innocuous. Playing video games because everyone is playing them. Buying a pair of expensive shoes because it's what the cool kids in school are wearing. Listening to certain music because it's what everyone your age is into.

While these examples may seem innocent, it shows the slow and quiet progression of how belonging can turn into longing. The longing to be seen, to be heard, to be liked. When our basic needs aren't met, we either choose to disconnect and survive on our own or we spend our lives forcing these connections and adapting to the people around us. We start to blend in and give in. Before long, the mirror we look into no longer reflects our image, but rather, the image we see through the eyes of others.

When we have no boundaries or allow others to consistently cross them, the disease to please is usually at the foundation of our discontent. If boundaries are there to teach others how to treat us, then having no boundaries teaches others to ignore us. This cycle is a reflection of our inner and outer selves working together to reflect what we think of ourselves and how others may see us.

No boundary or barrier surrounds the heart of a person that loves their self and others.

—Shannon L. Alder

We ignore our inner compass and expect the outer world to guide us. We train our mind to disobey our innate desires and obey the external rules that govern our way of being.

To please is to act on someone else's pleasure, but what if their pleasure is in conflict with our own? When we decide that the possibility of disappointing, challenging, or hurting another person's feelings is more important than honoring our own, we give up on the opportunity to trust and be trusted.

In the following sketching experiences, consider the way in which trust blossoms in your life and the way in which it is heavily guarded. Which characteristics and values facilitate your trust? Which ones do not?

# SKETCHING THROUGH INSECURITY

( 10 MINUTES )

## OBSERVE

There is a fine balance between selflessness and self-love. All of it exists in collaboration with the greater good. We are wired to give and receive the full bounty of what this world has to offer. There is no path saying we should give of ourselves fully and not give that same love and compassion to ourselves. Both exist to serve each other.

When we become one for everyone, we become nothing for ourselves. Our time and energy are depleted, and we leave no room for growth or reflection. We do not feel grounded in this imbalanced scenario. Instead, our legs dangle in midair like our body on a seesaw striving to find footing and connection with the ground below.

Self-care is a loving act and doesn't require you to abandon the

> In art and dream, may you proceed with abandon. In life may you proceed with balance and stealth.
>
> —Patti Smith

parts that make us feel whole. We can be fulfilled while filling our own well. We can be passionate about a cause and discover our own passions. We can be busy in meaningful ways and find meaning in the stillness.

When we allow our worth to run on empty, the smell of the toxic fumes will eventually wake us to the truth of who we are. It will demand that we replenish our own well, so we can quench our own thirst for life.

## *SKETCH*

For this exercise, you will sketch a symmetrical image using both hands at the same time. Think of one side being the dominant one and the other being the non-dominant one. If you are right-handed, that would be your dominant hand.

Starting on the top of the page and working your way down, let your dominant hand lead by starting with simple and easy lines. Ease into this prompt and take your time. Let your non-dominant hand sketch the mirror image of what your dominant hand is doing.

As you sketch your way down the page, begin to get more comfortable sketching with both hands at the same time. Explore the imbalance of both hands by adding more complexity and detail to your sketch. Play with the speed of how fast you are sketching. Notice if it is easier to mirror both sides when you are sketching faster or slower. Consider why the pace at which you sketch matters.

Pay attention to the sensations in your body as you try to find balance between both the dominant and non-dominant sides. Consider the metaphor of how two sides of a whole can be imbalanced, but still connected. Where does this show up in your life and what actions do you take today to find balance in it?

If you prefer, you can choose a symmetrical object as a starting

point such as a vase, butterfly, heart, etc. You can also sketch one on top of another. Explore and have fun with it.

## REFLECT

When you are done, take a moment to reflect on what you sketched:

1. What patterns, themes, or images arose?
2. What emotion(s) did you feel during the sketch?
3. How did your body respond throughout?
4. Did any memories, thoughts, or insights surface?
5. Did you observe any shifts in energy or perspective?

— SKETCH —

# SKETCHING WITH CONFIDENCE

( 30 MINUTES )

## *OBSERVE*

In visual art, perfectionism relies heavily on what your eyes see rather than what your heart feels. It is your critical eye that notices the nuanced lines, imperfect circles, undesired marks, or unintentional forms. You observe the areas that fall short and measure them against a preconceived outcome.

But what if you harnessed this critical eye and coupled it with intuition and insight? To use your keen sense of direction and knowing to dive deeper inward. Invite yourself to move beyond the struggle of getting it right and instead ask yourself, what is right?

Harness your passion for details and use it to empower rather than overpower your creations. You may just find the liberation you have been seeking in the perfect imperfections you've been staring at all along. The truth is in you only if you choose to see it.

Have no fear of perfection—you'll never reach it.

—Salvador Dalí

## *SKETCH*

Sketch the largest eye you can on the page. This could mean turning the page horizontally. At first, it should look more like an outline with very little detail. Once the outline is done, I want you to spend the next twenty minutes adding as much detail as you can, trying to make it the most perfect eye you can.

Even if you do not consider yourself an artist, think about ways you can add more details to it such as coloring the pupils, adding eyelids, eyelashes, tear ducts, reflections, etc. If it helps, look in the

131

mirror and stare at your eye or zoom into a photo of an eye and see what other details you can add.

As you are perfecting the sketch, pay attention to your breathing and how you're feeling as you work on it.

Once you're done, take a moment to stare at it and appreciate everything you've done to enhance it. Recognize how each mark gave it texture, depth, and meaning. After you've taken the time to recognize the work you've done, switch gears and think about all the ways your sketch isn't perfect in your eyes, pun intended.

Either show arrows pointing to the flaws within your sketch or write words or observations in or around it to highlight why it isn't perfect. Here are some suggestions to get you started:

I don't like how . . .
I wish it were . . .
This is too . . .
It's not quite . . .
It doesn't seem . . .
I'm not sure of . . .

To close out this exercise, do any or all of the following:

- Turn the page upside down and ask yourself, "Does it look like an eye?"
- Stand ten feet away from your sketch and ask yourself, "Does it look like an eye?"
- Show your sketch to someone and ask them, "Does it look like an eye?"

If any or all of the answers is "Yes, it looks like an eye," then you have achieved the outcome.

## *REFLECT*

When you are done, take a moment to reflect on what you sketched:

1. What patterns, themes, or images arose?
2. What emotion(s) did you feel during the sketch?
3. How did your body respond throughout?
4. Did any memories, thoughts, or insights surface?
5. Did you observe any shifts in energy or perspective?

The purpose of these sketch prompts is not the outcome, but rather to bring awareness of how much energy we expend in criticizing and judging our creations. Even when the outcome is exactly what you had intended it to be, in this case a sketch of an eye, we still obsess, edit, and rework it to perfection.

This focus on perfection pulls us further from the pure and simple joy of creating. You are both the creator and creation itself. Just as you, as a human, are not perfect, no expression, creative or not, should hold the same expectation.

Whenever you need a reminder to enjoy the process or give yourself permission to make mistakes, come back to this exercise.

SKETCH

— TESTIMONIAL —

"The time of quarantining at home forced many of us to look inward. Originally, I was just looking to do an art workshop for my birthday, but this twenty-one-day sketch challenge turned out to be so much more. Sheila guided me to trust the process and focus on the release. Sometimes it's an emotional release. Sometimes it's a mental release due to world or life events. Sometimes it's a sketch of a dream I've had. Other times, I have no idea what I'm putting on paper and it ends up being a subconscious dump. Analyzing what I've sketched with the help of others has been healing and revealing for me. I didn't realize what I had going on deep down.

"The others in my group are like family now. Sheila has created a safe space for us to be our unedited selves, unleashing what we have inside, nurturing and healing our inner children. I'm really thankful to have gone through this experience. I've never been through anything like this. The format has really accelerated my growth and healing. I hope many others can experience this.

"A world filled with hate is a world full of hurt. When people stop hurting and start healing, they are more able to give and receive love."

—Gail Batac, @flow.doodle

# 9

# SKETCH COURAGE

Art is a personal act of courage, something one human does that creates change in another.

—Seth Godin

It is natural to fear change and what it represents. But what if I told you, the very change you fear is already happening inside of you? All of the thoughts and emotions you have vibrating inside of you are evidence of it. And what if I told you, the cocoon you instinctually have made around you for protection was not meant to be permanent? It was meant to protect you as you became what you needed to become.

You already know that what I am saying is true. The rumbling and shaking inside of you is awaiting a release. There is a frenetic, nervous, and creative energy that is agitating you. You have difficulty relaxing or being present. You find you cannot sit still, and yet, you remain cocooned in a perpetual stillness, a holding pattern. What is it? You want both safety and freedom. You want consistency and change. How can you have both? Good question.

Let's examine what is changing.

*How did I get here?* Desmond lay on the ground in a pitch-dark tent in Afghanistan trying to sleep in the cold. Clenching his teeth to keep from chattering, his whole body was tense. He listened intently to the distant sound of gunfire. Riddled with anxiety, his

thoughts hopscotched from one random thought to the next until his mind settled on an image of his brother, Jack, fearlessly standing on the front lawn of their childhood home, audaciously standing up to a neighborhood boy who had attempted to steal his bike.

When Desmond was a kid, he wanted to be just like his brother. In Desmond's mind, Jack was the definition of courage. He defended people he cared about, confronted bullies with bravado, and never backed down from a challenge. Jack was also the de facto "man of the house." Their dad had left the family years prior and his single mom was working two jobs to make ends meet. Desmond and his brother practically raised themselves.

Desmond tells me that he was the opposite of Jack. He was a quiet kid who liked to read books and solve puzzles. He was a daydreamer and didn't have a lot of friends. He watched Jack lead with a type of courage that didn't come easily to Desmond. After high school, he decided to sign up for the army. He thought that this was the type of structure he needed to become the man he wanted to be. Secretly, he hoped a father figure would emerge in the ranks to take the place of the father he never knew.

Desmond shifted uncomfortably in his tent. It was so cold. *Why am I not more like my brother?* he wondered. The sound of gunfire ended. Desmond tensed. He knew they were not in immediate danger, but they always could be. The uncertainty made sleep scarce.

Nothing about joining the army was what Desmond had thought it would be. The training. The war. The integration back into society when he got back. Everything was different. He found himself "always on," scanning the room for any signs of immediate danger. He could assess a place in minutes, finding exit strategies and entry points that could be blind spots. Nothing could get past him. Even the manholes on the street were marked as targets ready for ambush.

"Do you know how many manholes there are in one city block?" he asked as he shared his story. He didn't wait for my response. "I do." Even though he returned home from deployment years ago,

the war in his mind was still present. "I'm not the same man," he said to me. "I no longer feel at ease in life. To be honest, I am not sure if I ever felt at ease, but now, I feel like a bomb is set to explode inside me."

When Desmond would go on dates, he never felt any sense of real connection. He only half listened out of courtesy. He was always tuned in to his surroundings, ready to fight, ready for battle. This constant state of alertness made it impossible for him to simply be in the room with anyone. While his hypervigilance gave him a sense of control over his surroundings, his inner world was in turmoil. He grew increasingly anxious and found social interactions to be more and more challenging. He didn't open up to civilians, because he didn't think they could understand what he'd gone through. Instead, he became even more closed off.

He was conditioned to repress his emotions as a way to survive and cope within an intensely stressful environment.

As he was searching for ways to slowly release the pressure he felt mounting, he went to therapy and eventually found solace in making art. He could lose himself in the process of creating and could release the tangle of emotions he felt knotted up inside of him.

"It takes more courage to make art than I feel it ever took to go to war . . ." he shared with me. "I had to face fears of dying and watch others lose their lives and limbs, but coming home, I have to learn to live and love. That is hard to do when you can't live with yourself or love yourself. I may always wrestle with these feelings, but when I draw, I find a way to live and love."

Change involves vulnerability, but vulnerability is the antithesis of survival. It is the definition of risk.

Should you move out of state where you have no friends or family to take a job offer that excites you? Would you try to rekindle a relationship that has begun to burn out? Could you start the business you have always dreamed of making? Should you try again

to have a baby even if you've lost previous pregnancies to miscarriage? Why don't you reach out to that friend or family member from whom you are estranged? Could you get remarried again after a failed marriage or two? No matter how innocuous or serious the context of the threat we perceive, we avoid being vulnerable at all costs.

Many of us desire to stay cocooned in our protective layers for this reason. We think we are being circumspect and wise, but really, we have simply decided that the hypothetical costs outweigh any imagined benefits. Unless something breaks us open by force, why intentionally disrupt the peace?

Because we aren't actually at peace. We are in an incubator. It is a self-built, temporary structure of safety that serves a purpose for a season until it doesn't anymore. The cocoon's purpose is to develop us into creators. However, if we stay too long in this space, eventually the creative, kinetic energy rumbling inside of us subsides and wanes. If we don't follow our curiosity, growth ceases. If we don't wonder at the world in which we are cocooned and wander outside of it, our mindset fixates on limits, atrophying our imaginations and calcifying the cannon of our experiences. Atrophy and calcification restrict what good we envision our lives can offer and curbs all possibility for the greater good our lives could produce. In short, it is why we feel stuck.

How do you break out, though? How do you face your fears and do the very thing you are afraid to do? I do not have a twelve-step guide for you that outlines how to become unstuck, but I do believe there is a way out that is built inside us all.

The very nature of sketching lends itself to the change each of us are seeking. In the art world, sketching is a rough drawing, usually completed quickly with little detail. Its purpose is to assist the artist in making a larger piece of art. It is the artist's way of trying out an idea without committing to it. Artists use sketching to practice, experiment, and explore ideas much like writers compose essays. In fact, the word "essay" comes from the French

word *essais,* which means "attempts" or "tests." A sketch has a similar denotation. It is a visual attempt at expressing an idea. For the non-artist, the way I am guiding you to sketch isn't art. It is a mind map through which you are able to visualize and compose a larger, more authentic, and meaningful portrait of yourself and narrative in your life.

As you follow your curiosity with sketching, you will see patterns emerge. It may not be immediately evident what these patterns mean, but when you recognize them, pay attention. These images are the first evidence of change taking place. Emotions are there to serve you in the process as well. The therapeutic nature of sketching takes shape through the transient emotions you experience. Thus, draw upon them. Express them. Acknowledge them. Explore them. As you continue sketching daily, the patterns will evolve. They will begin to represent the stages and states of awareness, growth, and transformation you will experience.

All that remains for now is to take a moment and listen to the voice of love circling around you—"*Courage, dear heart.* Courage."*

---

* The Chronicles of Narnia

# COURAGE SKETCHES

When I began my daily practice, I wanted my sketches to honor and confront challenges I felt were weighing me down. I wanted to "look fear in the face" as Eleanor Roosevelt once said, and "do the thing" I felt I could not do. Symbolically, it was with this intention I chose to use a pen versus a pencil to make my sketches. This choice gave the sketches a sense of permanence and forced me to forgive and incorporate mistakes I made in the design of each sketch.

As I eased into this choice with courage, the fluidity with which the pen moved across the paper became meaningful. I started to visualize each dot or line as tiny pebbles or a sign pointing in the direction I was to go next. I was connecting with my fear of making mistakes in a visual and visceral way. If I was constantly stopping my sketch to correct and restart, I could never have been able to flow through sketches with the rhythm and repetition I needed to experience. In this way, using ink to complete my sketches now represents the flow in and around obstacles and troubles, which I previously was unable to reconcile.

How often do we let our fear stop us from trying out an idea? Translating the invisible to something visible is where we can find the courage to face our fears and reveal the most profound insight and healing. Before beginning the following sketches, choose one of the following questions to ponder:

- What changes are you most afraid to make?
- What would you try if money, time, and opportunity were not factors?
- What things have you not done because of the fear of how you look doing it?
- What would you change about your life if you could change anything?

> You gain strength, courage, and confidence by every experience in which you really stop to look fear in the face. You are able to say to yourself, "I have lived through this horror. I can take the next thing that comes along." You must do the thing you think you cannot do.
>
> —Eleanor Roosevelt

- Where do you feel you have courage in your life?
- Where do you feel you need courage in your life?

# SKETCHING THROUGH FEAR

( 10 MINUTES )

## *OBSERVE*

I am not a courageous person by nature. I have simply discovered that, at certain key moments in this life, you must find courage in yourself, in order to move forward and live. It is like a muscle and it must be exercised, first a little, and then more and more. All the really exciting things possible during the course of a lifetime require a little more courage than we currently have. A deep breath and a leap.

—John Patrick Shanley

Do you remember connect-the-dots coloring books you used to color in as a child? The idea is that if you followed the numbered dots in order from one to fifty with your crayon, you would reveal a picture. In this exercise, you will create your own connect-the-dots, only without numbers, order, or rules.

## *SKETCH*

First draw one hundred dots on your paper. Have fun with the placement of each dot and pay attention to where the dots gather, keep their distance, or both.

Once complete, connect the dots by letting your line move from one dot to the next in any direction it desires. Your lines can overlap and connect to the same dot more than once. You can leave some dots without a connection. You can even add lines around your page that aren't connected to dots at all. After you're done, feel free to add details, images, or patterns to build upon the final piece.

As you engage in this experience, visualize what the future holds for you and how the patterns in your life will shift with it. Even if you don't know what it looks like, have fun with the possibilities of what it can be. It is more important to connect to the idea of what you are doing than focusing on what the sketch looks like. Have fun and be fearless in your exploration.

## *REFLECT*

When you are done, take a moment to reflect on what you sketched:

1. What patterns, themes, or images arose?
2. What emotion(s) did you feel during the sketch?
3. How did your body respond throughout?
4. Did any memories, thoughts, or insights surface?
5. Did you observe any shifts in energy or perspective?

— SKETCH —

# SKETCHING WITH BRAVERY

( 30 MINUTES )

## *OBSERVE*

Imagine yourself dancing alone in a room with no one watching. Only you and the dance floor. This is your time to let go. Letting go of everything that is in your heart and mind. What music is playing? Would you dance in silence? What movements would you make? Are those movements jerky, smooth, fast, slow, rehearsed, or freestyle? Would you be able to begin dancing quickly or would it take some time to get warmed up? Are you thinking of anyone? Or only yourself? Would you be serious, casual, laughing, or crying?

To create one's world in any of the arts takes courage.

—Georgia O'Keeffe

## *SKETCH*

In this experience, your pen is an extension of your body and the paper is your dance floor. Move the pen across the page as if it were dancing. Make lines and shapes that imitate the movements you see in your mind. You may even want to play some music to inspire your lines.

Using your imagination, sketch your movements on the blank page and allow your thoughts to move with you. Even if dancing feels unnatural, invite the opportunity to explore this side of yourself. Let the awkward, scattered parts of yourself be expressed.

Find the courage to tap into this unpolished expression and have fun with it. Let go in spirit and observe how your mind and body follow suit.

## *REFLECT*

When you are done, take a moment to reflect on what you sketched:

1. What patterns, themes, or images arose?
2. What emotion(s) did you feel during the sketch?
3. How did your body respond throughout?
4. Did any memories, thoughts, or insights surface?
5. Did you observe any shifts in energy or perspective?

After you have completed your sketch, reflect on the difference between your experience with fear and bravery. What are the inner sources of your strength? Who are you when no one is looking? What is the difference between your fears and freedoms?

Read the following words in affirmation of your courage. Commit them to your mind and heart. Repeat them like a refrain when you feel you lack the courage to continue. Let them serve as comfort. Allow them to override the voice of your inner critic. Turn up the volume to them so that they become louder and bolder than your fears.

"I am a creator."
"I can. I will."
"I am enough."

Sketching breeds courage. It fosters confidence. As you sketch and repeat these prompts, allow each of them to guide you to the inner sources of your strength and activate your capacity to convert your fear into courage.

Use this prompt to celebrate your wins. Observe how far you've come and how it becomes easier to dance when no one is watching.

 SKETCH

## — TESTIMONIAL —

"Although I don't consider myself an artist, in the same way most identify or define an artist, I am learning how to channel my emotions through the practice of daily sketching. This practice teaches me every day how to be more reflective, more aware and mindful of internal and external noise that affect my thoughts and emotions. It teaches me to be vulnerable, to dig deep into my soul and slowly heal the pain of the past.

"Conversely it teaches me how to play and have fun with art. To not be attached to the outcome and trust the process. It is with this newfound expression that I choose to define as an artist in my own right."

—Tricia Delgallego, @illuminate_her

# 10

# SKETCH PERCEPTION

SketchPoetic is an exercise of staring into the impossible and perceiving possibilities. Close your eyes and think about your wishes and dreams. Are they expansive and wide with large open fields? Or are they tight and thin within a small confined space? Do you believe your wishes and dreams are possible or do you doubt they will ever be more than a fantasy?

Dreaming shows us what we want. When we dream or use our imagination, we perceive no limits. Anything is possible. Our mind isn't restricted by reality when we dream. It doesn't matter how far we can actually see in front of us. Instead, we imagine the vast possibilities and suspend all disbelief in order to imagine it could be true. Size doesn't exist when we dream unless we allow doubts into the dreamscape. Size doesn't make sense because dreams are abstractions of reality. In the abstraction of rules, we become more aware of our presence, our thoughts, our emotions, and capabilities. We are not limited by dimension or spatial relationships. We simply exist.

Ultimately, the difference between a dream and reality is perception. A dream is evidence of your desire to create something meaningful. It is the evidence of that desire growing inside of you.

Your vision will become clear only when you can look into your own heart. Who looks outside, dreams; who looks inside, awakes.

—Carl Jung

You perceive that there has to be a way, and thus a way will make itself known. In reality, though, it is difficult to physically *see* the way. There are physical complexities of depth, peripheral visibility, blind spots, and focus that are not accounted for in dreams.

When you open your eyes, you become instantly aware of your limits. You can't consider all perspectives in one picture. You must choose. How do you choose? How do you make dreams become reality?

You must create them. You must walk around the perceived limitations. Examine them from above, below, from afar, close up, and at different times of day. Consider and test the rules that make it appear to be a limitation. What would you do if you knew you couldn't fail? What would you do if the limitation was not there? Begin with the end in mind. Which perspective fuels your engagement with possibilities?

How purposeful do you consider your limitations? How purposefully do you perceive possibilities? When you suspend disbelief for a moment, you can perceive alternate realities. You can incorporate other vantage points. You can allow yourself to let go of certainty, if only for a moment, and embrace uncertainty just long enough to take action. Little by little, these actions add up to significant results. Sketching helps you get results because it is an act of visualizing.

When we can perceive through our heart and not only with our eyes, we open ourselves to the gift of seeing things wholly and as holy. Perceiving is believing.

During a SketchPoetic workshop, I noticed Leah was growing increasingly frustrated.

There was a mental and physical exhaustion on her face as she sketched layers upon layers of long, undulating lines. As an observer, it was as if her pen was expressing her body's desire to surrender to the exhaustion that I perceived she felt.

After the thirty minutes, she found herself staring at a cross section of lines, and she was intrigued by a figure that she saw

forming in it. She was so intrigued by it that she continued on for another fifteen minutes while the rest of us moved on. I watched her demeanor change and soften. She didn't want to share what was happening with anyone in her sketch group. She was too embarrassed to admit it. She knew once the time was up to sketch a new piece each time, but for some reason, this one was bothering her. She was not ready yet.

She didn't say much about it at the time, but she kept working on this sketch for the next three days. Something in her wanted to make the image come to life. Each day, she would see something new about the figure she perceived in the lines and continue in the same cycle of revising and reworking. It became an obsession. It activated her. She felt the energy pulsing in her to continue.

*What was it? Was it desire? Was it passion? Was it curiosity? What was she looking for?*

"It started with this feeling of not having enough time and eventually progressed to something deeper," she told me later. By day three, Leah realized this piece was provoking an internal dialogue she had been silencing for years.

"I thought I was breaking the rules of SketchPoetic by revisiting and working on this sketch after the thirty minutes had passed. The feeling of breaking the rules—like I was doing it wrong—was compounded by the fact that it didn't look good.

"My brother is an artist, you know. Every time I sketch, I feel the presence of my brother as my own internal critic. He's the voice in my head. There are other critical voices in there as well. So many voices, in fact, I cannot tell the difference between their voice and mine. I think in this sketch, I was looking for validation.

"When I saw the image of the man and I kept going with it, I felt peace. I felt a release. I felt I had a direction to draw into and I wanted to go with it. As I did, I was seeking my own approval, not yours on how to correctly SketchPoetic and not my brother's on what art is. I wasn't seeking approval from anyone but me. I started following my own thoughts and hearing my own voice speak."

As she reflected on the sketch with me, she knew the answers she was seeking were within and she was excited at the possibility that sketching would help her process them in her own time and in her own way.

There is always a new day and a new page that gives you permission to perceive possibilities.

Time is an integral component of this practice, but it should not be a limitation. In addition to it being part of building the habit of mindfulness, it is also inviting you to become familiar or embrace the continuous process of awareness and release. When you stop sketching after thirty minutes, you have to allow the sketch to remain unfinished sometimes. It can leave you unsettled and that feeling reveals your expectations, your desires, your inner voice, and your conflict. While daily sketching is a tool and time is a component, the process of awareness and release is all yours. If a sketch calls you back, answer the call. Show up to it. Allow yourself to calibrate your sketch toward what you see appearing on the page. Be patient and take the time to see every part of the experience in every way you can. You will find the clarity and perspective that may have eluded you. If you find yourself returning to sketches over and over again, ask yourself why that is. What is your attachment to the design? Why can't you leave it unfinished?

If your perception of sketching is rooted in improving your drawing skills, then it is natural for you to focus on the outcome. If your perception of sketching is about transformation and gaining insights, then you will be questioning when these insights do not happen. If your perception is anything other than feeling your emotions and releasing them on paper, then your perceptions are likely based on what you see with your eyes and not with your heart, which is only a part and not the sum of the whole.

It is important to remember these guidelines are here to provide structure. They are not fixed or immovable. If the winds of change occur, it is okay to bend them to your will. This could

mean changing the time of day, decreasing the duration, or moving the location of where you sketch. All of it is okay. It is more important to focus on consistency and the why, so it becomes part of your daily life and not another box on your to-do list. If daily sketching becomes a task to complete, this is your immediate cue to check in with yourself and realign with the why.

This is a process of awareness and release, awareness and release. Stare into the possibilities you can create.

# PERCEPTION SKETCHES

To perceive the change we need to make in our lives or the way forward, we must look inside of ourselves and perceive it first. We must look at the way in which we have come to the question, to the problem, to the moment we are standing in front of. Have we been here before? Then, we must move around inside ourselves and look at the issue from other angles to gather perspective. Can we perceive our way forward?

When we limit the possibilities of our own happiness, our world diminishes in size and we become small. We also resign ourselves to a life of smallness. Our mind restricts the view of what lies ahead and our body contorts itself to fit inside the limits we've set.

When we look inside of ourselves for possibilities, purpose, and permission—we are free to live our lives with joy. We expand to the potential of what we can be, and we grow to the size of our imagination.

As you sketch through the following experiences, ask yourself the following questions:

- Do you feel you are perceived mostly in a positive or negative light?
- How do you respond when others' perceptions are misaligned with who you are?
- How much weight do you put on other people's opinions of you?
- How much weight do you put on how you view yourself?

> What looks inevitable in hindsight is often invisible with foresight.
>
> —Steven Kotler

# SKETCHING THROUGH DISTORTION

( 10 MINUTES )

## *OBSERVE*

When you sketch, you will move between being a creator and an observer. Both roles are necessary to extend the process of expression and release to sight and insight.

As a creator, you will move with the flow of creation. You will perceive things through the lens of your unconscious mind, active imagination, and artistic spirit. As you immerse yourself in your sketch, the perspective of space and time will be skewed. The two-dimensional space will become multidimensional. You will get lost in the curious wonder of what is happening and surrender to it all.

As an observer, you will evoke and engage all of your senses. You will be aware of the physical, emotional, mental, and intuitive responses. You will notice the passing thoughts and narratives playing. You will make peace with their presence, because you know the observer is the witness and the key to your unfolding. Your observer will be the bridge from past to present, present to future, connecting your felt experiences.

> Since everything is a reflection of our minds... everything can be changed by our minds.
> —Buddha

## *SKETCH*

Imagine if your mind, body, and spirit were represented by three shapes. Consider what shapes come to mind as you think about all three. On the center of the page, draw these three different shapes as basic and simple as possible.

Now, draw these three shapes again in the same way, but this

time, purposefully distort them. You can distort shapes in some of the following ways:

- Changing the proportions of it by exaggerating its relative size or weight to the other shapes around it.
- Breaking up the lines that create the shape to show the fragility of it.
- Emphasize or minimize the weight of the lines to give it depth or boldness in appearance.
- Bend or stretch your shape to the point where you can no longer tell what shape it is.

With the outline of all six shapes on the page, begin sketching by drawing around them, inside them, or designing patterns incorporating them.

Pay attention to your thoughts as you play around with each shape representing the mind, body, spirit. Explore each shape more than once. What do you perceive in the perfection and imperfection of these shapes?

## *REFLECT*

When you are done, take a moment to reflect on what you sketched:

1. What patterns, themes, or images arose?
2. What emotion(s) did you feel during the sketch?
3. How did your body respond throughout?
4. Did any memories, thoughts, or insights surface?
5. Did you observe any shifts in energy or perspective?

— SKETCH —

# SKETCHING WITH PERSPECTIVE

## ( 30 MINUTES )

### *OBSERVE*

In the egoic state, your sense of self, your identity, is derived from your thinking mind—in other words, what your mind tells you about yourself: the storyline of you, the memories, the expectations, all the thoughts that go through your head continuously and the emotions that reflect those thoughts. All those things make up your sense of self.

—Eckhart Tolle

Think about the experiences you have had that have caused you to feel misinterpreted or misunderstood. How do you perceive your character and actions in these experiences? How do you perceive the character and actions of others?

### *SKETCH*

The purpose of this exploration is to see things from a new perspective. For the next thirty minutes, you will observe your sketch from different rotations.

For the first ten minutes, set a timer. Begin by taking a deep breath. Exhale and begin expressing the emotions you are feeling about the experience on paper for the next ten minutes.

After the initial ten-minute sketch, rotate your page 90 degrees to view it from a new angle. Take a moment to look at your sketch from this perspective. Does it change what you see or the way you see it? Are you feeling challenged by this rotation or is it a welcome change?

With each rotation, pay attention to how your mind and body responds. Keep rotating the page every five minutes until thirty minutes have passed.

Remember, you do not need to focus on what it looks like. Focus on the thoughts that come to mind as you skew the perception of it through different lenses.

## *REFLECT*

When you are done, take a moment to reflect on what you sketched:

1. What patterns, themes, or images arose?
2. What emotion(s) did you feel during the sketch?
3. How did your body respond throughout?
4. Did any memories, thoughts, or insights surface?
5. Did you observe any shifts in energy or perspective?

As you take a moment to sit with both sketches, consider the following:

- What factors in your life influence the way you are perceived?
- When was the last time you saw yourself from varying perspectives?
- Are you able to step away from a situation and perceive it from a distance?
- Are you able to look closely at a situation and perceive it objectively?
- When are you naturally open to varying perspectives? And when are you not?

This sketching experience is a helpful one to revisit when you are questioning or doubting yourself. It is also an illuminating one to repeat when you need to see a situation in a new light. Use it to create awareness of how the energy or thoughts of others can skew our perception of self.

It is in the honest reflection of who you perceive yourself to be that you can expand the good you can become.

SKETCH

## — TESTIMONIAL —

"I almost didn't sign up for SketchPoetic because I'm not an artist. But I soon realized this isn't an art class, it isn't a tutorial. I didn't know what I was walking into but what I found was a magical space of connection and adventure into inner wisdom, the creative flow. It is a space where there is no right or wrong, no goal to attain, just an invitation to allow whatever wants to be expressed to be expressed.

"A recurring theme for me throughout the weeks was perfection and completion, wanting to fill in the space because it was empty and not necessarily because I was being called to create something. In one piece, I found myself wanting to add more

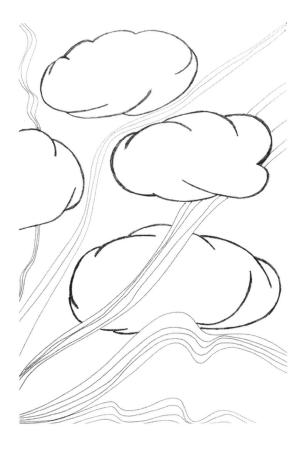

but instead asked myself, 'Will it improve the page or just add noise?' How often do we do that in life, say something just to fill in a void without actually adding meaning? In yet another piece, I was in a state of flow but kept getting caught up in the 'this doesn't look right, it doesn't feel done.' Uncomfortable feelings came up but in the end, I resisted the urge to 'fix it.' I could feel that the sketch did not want to be disturbed with additional lines. Sheila pointed out my desire to 'frame' everything so that it feels finished and her words really struck a chord with me.

"Where in my life do I struggle with trying to reach perfection? Why does everything have to be tied up with a pretty bow? What a relief to know that we don't have to do any of that, that we can live each day in freedom and beautiful imperfection.

"SketchPoetic nudged me away from the space of habit—of intellect—and into the space of spontaneity and wisdom. I am infinitely grateful."

—Venu Alagh, @heartsketches28

# || SKETCH INSIGHT

Art schools teach artists to see the world around them in terms of shape, form, value, contrast, and color. First the artist learns to see—to observe the room, to be in the moment, and pay attention, then it is up to them to create insights from what they see. Once they have learned to see, they can't unsee it. They are charged with harnessing that power to then create and re-create various ways for the rest of us to see. It is both sight and insight.

If you have ever stared at someone intensely, then you know how awkward it can be to stare and how much awareness, attention, and patience it takes to vividly transcribe what you are looking at. You always know that you have to revisit it many times to make sure you are recording what you see precisely as it is. Staring takes you into the nebulous space that exists between creators and creation. This space is where thoughts and ideas collide and intersect. Entering it allows you to see something as it is and take inventory of its details.

SketchPoetic invites you to stare inside yourself with the same intensity an artist would stare at you to draw your portrait. You must stare until you see beyond what is in front of you or around you; to view your circumstances, your past, your present, your future, and

We're not on our journey to save the world but to save ourselves. But in doing that you save the world.

—Joseph Campbell

your relationships with perspective. You are here, now. When you accept the invitation that sketching extends to you, and regularly sit and stare into that space on the page long enough, your mind's eye begins to see what it could not see before.

You have to give permission to stare, though. You have been conditioned to avoid staring because it is considered rude. To be the object of someone's stare without permission feels invasive. It feels vulnerable.

When you stare at the page, something wondrous happens as your mind wanders beyond what is physically present. You disappear into a world of free association and thought. Sometimes you are reviewing and revising conversations in your head. Sometimes you are reliving experiences. Sometimes you are imagining new experiences. Thoughts overlap, collide, revise, turn, flip, change, and evolve. You can see details you had previously overlooked. You can find answers to the questions your soul is posing. You can interpret the abstractions inside your memories with the light of love, grace, and forgiveness.

While sketching, your pen becomes a tool that traces your steps. It maps your way into and your way out of the space. It translates what you see. It makes sense of the senseless thoughts in your mind. It provides reason for those thoughts to exist. They can no longer appear and disappear with little significance. As you follow them deeper and deeper into your mind each day, you will see patterns emerge. These patterns lead to the substance and eventually the truth is realized. Sight becomes insight.

By regularly entering this state, the truth of who we were, who we are, and who we want to be are reconciled. We can create the world in which we want to live. We become both an active participant and a witness to our own transformation. Each sketch serves as a record of that change. In a world that is keen on taking *selfies* as a way to record our existence and change, this practice is familiar. The difference is that regular, daily sketching requires

no filter and collectively reveals the connections between the moments in which you are living.

No amount of warning could have prepared Chris for the day he realized he had lost his mother—especially not while she was still alive.

Chris had always loved going home to visit his parents. He fondly remembers the smell of his favorite pecan pie baking in the kitchen, the feel of his mother's hug tight around him as he walked in the door, the sound of his parents laughing as they teased each other endlessly, the wordless looks of love they shared that came from sharing forty years of marriage. They had weathered a great deal in life together.

When his mother was first diagnosed with Alzheimer's a few years prior, it was a strange relief. She had been struggling with her memory for years and knowing what was causing the memory loss helped them cognitively prepare for it, but they had no way of really knowing how fast it would happen.

Over a few months her condition quickly declined. As Chris walked into his parents' home with more frequency due to his mother's decline, the change was rapidly becoming more and more noticeable. The house began to smell stale. His mother did not greet him with warm recognition anymore. Her loving, tightly squeezed hug was gradually replaced with a slightly confused limp embrace. She was devolving into a shell of her former self, despondent and closed off. The familiar exchanges of looks and laughter between his parents faded until it was as if his father was someone that his mother used to know. The silence between them was deafening.

He often wondered what his mother thought when she looked around. He would try hard to put himself in her shoes—the overwhelming fear she must be experiencing, the confusion she must feel, the loneliness inside her own head it was creating for her. It was almost too unbearable to consider for too much time.

It hurt. It was uncomfortable. It was sad. It was infuriating. He could barely look at her. So instead, he tried his best to put on a strong face. He would keep things light and playful, sometimes creating scenarios like packing a car to go to Disneyland or planning a visit for his mother to go see her sister, Pat. He did anything he could to help anchor her in this world and not let her slip into the darkness her mind was creating.

But no escape could take away the feeling of loss he was already experiencing. He avoided feeling the loss as much as he could. She was still alive. He could not pretend she was no longer here. There was no doubt that Chris loved his mother dearly. He would be there for her and his dad as they had been there for him, but at the same time, he slowly began to dread the time they spent together. Chris did not want to see his mother leave him like this. He kept as busy as he could, filling up his social calendar and doing his best to avoid truly staring at what he was losing.

The unexpressed grief that Chris felt took a toll on him. He grew increasingly frustrated and angry about her condition, knowing that none of them had any control over it. He became claustrophobic and had difficulty relaxing. He was racked with guilt for feeling this way. He also felt his anger rising above his usually calm and collected self. *Why her?* he would ask the universe. *Why her?* He could not find an answer in what he was seeing, but he could find a way to express his grief in sketching.

Daily he began to take the pen to paper and see into the experience he was having. Daily he could see his mother for who she was, who she is, and say goodbye. Daily he could wrestle with the tangled web of emotions he felt and let the ugly sight of some of those emotions become insight into the person he wanted to be for his family.

Seeing goes beyond what our eyes allow us to witness. It also requires a willingness to look within and to allow the natural forces of our unconscious and subconscious to guide us. It is like a current

flowing through us and around us: a current containing life and the debris collected from our life experiences and the surrounding energy. This debris contains messages of pain, insights, suffering, and wisdom. They are a part of our learning. As it composts, it becomes fertilizer for what we are meant to cultivate and create in our lives.

It may seem philosophical or spiritual to think of sketching in this way. However, if you take a step back and look at it in the simplest terms, there is an invisible loop happening between the lines we make on paper and the thoughts flowing through our mind in response to it. In the intricacies of the marks you make lies the collective wisdom that connects us all to each other. You are amassing a visual vocabulary. The marks you create are the evidence of your learning. There is an ethos at work. The deeper you stare into yourself, the more universal the truth you find becomes. This feedback loop is where the magic of this practice lives. Once we can observe without judgment and with pure curiosity the inner workings of our being, we unlock the healing powers of the things we are avoiding.

As you hold that stare, you will see that the energy you spend avoiding the power of observation is greater than the energy it takes to surrender to it. Look. Observe. See.

Stare into your life. Sight will become insight.

# INSIGHT SKETCHES

Through the power of visual art, we can tell countless stories without saying a word. Each mark is a part of that story's development. As one line flows into another, it begins to sync with an internal cadence—a melody rising within us. The melody harmonizes with a collective wisdom and our thoughts begin to dance, like pirouettes in swirling rotation. The swirl of thoughts takes us deeper into the theater of our lives. We stare at the actions taking place as if we are watching a foreign film. We don't have the language to translate what we see so we observe the actions with intensity and record them in marks and lines on our paper. We interpret our thoughts and dreams in shapes, lines, and patterns.

To really change the world, we have to help people change the way they see things.

—Suzy Kassem

## SKETCHING THROUGH BLINDNESS

( 10 MINUTES )

### *OBSERVE*

It is counterintuitive to stare when we are confronted with the truths we are not ready to see. Instead of tightening our hold, making peace with the shards buried within is a critical part of our healing. These challenging emotions, once paralyzing, can serve as a connective tissue to shared pain and purpose with the people around us. We are not alone in our struggles. We are a community of embattled souls giving ourselves permission to be seen.

As you learn to see yourself in all of your Technicolor ways, you may observe the people in your lives resisting this new you. Have compassion for them and yourself in this process. It can take

a while before the winds of change become the status quo. This same perspective applies as you create.

As you shed parts of yourself that no longer serve you, you will observe a shift in your sketches. You will move with a keener sense of confidence and certainty. Your lines may become more purposeful and more detailed in the process. No matter what happens, embrace the change for what it is, an evolution of sight turning into insight.

Take a moment to reflect on someone in your life who may not see you in the way you want to be seen. Think about the way it makes you feel, how your body responds, and what thoughts arise when you do.

> You are the faint line between faith and blindly waiting.
> —Rupi Kaur

## *SKETCH*

For this exercise, you will complete two five-minute sketches, but this time with your eyes closed.

In the first five minutes, sketch a general expression of how you see yourself. Think of it as less of a self-portrait, but more of the energy you embody. For example, if you see yourself as fun or outgoing, let your lines convey this energy. If you see yourself as quiet or stoic, let your lines mimic the same.

For the next five minutes, sketch another expression of self, but this time through the eyes of another person. A person you feel doesn't see you in the same light as you see yourself. Take a moment to express how you think they see you. Remember, close your eyes and allow your hands to move in synchronicity with these thoughts.

Once you are done with both sketches, notice the visual differences. Is it subtle or is it vastly different? Did it change the way you saw yourself when you stared through another person's eyes? If so, why?

As you continue on this path of healing, it is important to

remember that your evolution will create a ripple effect on the people and the world around you. You can choose to let their responses or reactions influence the work you have done, or you can choose to have compassion for their discomfort.

Give yourself permission to be seen.

## *REFLECT*

When you are done, take a moment to reflect on what you sketched:

1. What patterns, themes, or images arose?
2. What emotion(s) did you feel during the sketch?
3. How did your body respond throughout?
4. Did any memories, thoughts, or insights surface?
5. Did you observe any shifts in energy or perspective?

— SKETCH —

# SKETCHING WITH OBSERVATION

( 30 MINUTES )

## *OBSERVE*

How often do we take for granted the spaces and people all around us? The scenic views to and from work. The neighborhood and neighbors nearby. The restaurants and stores we frequent. The errands we run. The people we see each day. Even the spaces, objects, and people inside our homes hiding in plain sight.

Stare at the space around you. Take the time to investigate every nook and cranny. See it through exploratory eyes and pay attention to what captivates you.

- What do you see in the room you are in?
- What do you notice for the first time?
- What or who does it remind you of?
- What sensory details do you notice about it?
- What feelings does it provoke?
- What questions do you have?

As you scan the room, make a mental note of your emotions, thoughts, musings, or ideas that pass. Use it as inspiration for your sketch.

## *SKETCH*

Once you've taken the time to scan the space around you, sketch the first thing that comes up for you as you look at the blank page. Look at it. Stare into it. It could be an object, a person, a section of the space around you. It could be the emotions or

Art does not reproduce what we see. It makes us see.

—Paul Klee

172

thoughts this moment evoked. It could be a vision, image, or idea sparked by what you saw. Begin by re-creating the shape of it, but let go of it as soon as you see yourself trying too hard to make it look like the object, idea, or thing. Look at what it is becoming and go with it.

Let all of it serve as inspiration. You might find that you start one way and end in another. You may notice your forms changing shape or your lines suddenly changing direction midway through. Do not be attached to an idea. Let your hands move fluidly and organically on the page.

The key to this prompt is to focus on what you feel and not what you can recall or remember. Let your intuition guide you.

As you sketch, connect with the everyday moments of life. How would you evaluate your presence of mind, body, and spirit? Are you keenly aware? Or are you mostly unaware? What is it about these everyday occurrences that makes it easy to take for granted? Is it because we take comfort in knowing they are always there? Is it because they fade into the backdrop as something we do not deem important enough to notice? Is it because we are so consumed by the world around us that paying attention to everything would feel too overwhelming?

Ask yourself, what is it that you choose to see and what is it that you don't? Then ask, why?

## REFLECT

When you are done, take a moment to reflect on what you sketched:

1. What patterns, themes, or images arose?
2. What emotion(s) did you feel during the sketch?
3. How did your body respond throughout?
4. Did any memories, thoughts, or insights surface?
5. Did you observe any shifts in energy or perspective?

Use this prompt to be mindful or as an invitation to slow down. You can dedicate pages upon pages to this one by changing the spaces to explore, the times of day you engage with it, or the change of people or scenery around you.

Incorporate this prompt into your daily life. Scan a room as if you were about to do this prompt again. Watch how others observe you as you do. They may even ask what you are doing. Invite them to join you.

Let yourself be in a state of wonder at the world around you. You may find that the world you were certain of has changed. The question is—how have you? A dialogue will begin to form in the two-dimensional lines when you begin to sketch what you see onto paper. Bear witness to where it wants to take you.

 — SKETCH —

## — TESTIMONIAL —

"I can't even begin to understand how this practice is changing me, but changing me it is. It's been complicated. Mostly, I have no idea what I'm doing (with sketching, as well as life), but putting pen to paper every single day is its own reward.

"And then, there are days when something shines through from beyond the silly, awkward squiggles. Some bubbles are safer after they break. I can't unsee, untouch, unfeel, but it's up to me what I do with this legacy. I am the raw sum of everything that ever touched me and I wouldn't have it any other way.

"Life really is like a box of chocolates (or every flavor of beans) and sometimes I binge to fill a void (less and less so), but most times I am just hungry for life. There's a time and place to grieve all the versions of me that could have known better, but then I have to let them rest in peace. Arms that hold on cannot hold properly. The self-stuck version of stuck is the worst, no harder chains to break than the ones in my mind.

"If it's a choice between feeling too much and staying safe, take out the boxes of tissues, I'm feeling. The trick is to ask the questions my fear doesn't want answered. Shards can cut me, but they can also cut through to me. Absence hurts, but I choose to hold dear the shape of it.

"Shards came up pretty early in my explorations, at least theoretically. I've been exploring in therapy the shards of my father abandoning me and my sister as young kids and I desperately wanted to sketch a shard, but kept putting it off because I didn't know how to. It showed up, out of nowhere, when trying to draw a second wing to a ball of feelings. This sketch was supposed to be in landscape, but then it made so much sense in portrait orientation, seeing the shard as a pedestal for whatever my flight may finally look like."

—Anca Pandrea, @ancapandrea

# 12

# SKETCH REFLECTION

Our ancient experience confirms at every point that everything is linked together, everything is inseparable.

—the Dalai Lama

Have you ever stared at a flower and marveled at the magic of its bloom? Have you ever watched a child take their first step and seen the sparkle of joy in their eyes? Have you ever been a witness to someone's transformation and basked in the light of their self-love and self-acceptance? This is the visual manifestation and power of connection.

One of the greatest insights SketchPoetic has illuminated in this journey is the many permutations of how I can connect with myself and with others. Human connection is one of the many reasons why it is so important to perceive what your emotions are trying to tell you, stare into what you are presently experiencing, and reflect on the connections you have made.

As you stare further into your imagination and mind, you connect with the memories. You reflect. When you reflect, you awaken your senses. You become aware of what you have experienced. You see it differently, sometimes with more clarity than ever before. Staring illuminates vision. It calibrates you into the frequency and patterns of your life. SketchPoetic brings your experience and intuition together and provides them an opportunity to dialogue.

It is here you will activate your feelings. Up until this point, I

have not asked you to look back at all your sketches. You need to produce a body of work in order to truly reflect and see your image on the surface of the pages. Reflect on the repetitive lines, shapes, and patterns that you can identify. What are the waves of emotion that you experience? What do each of them represent to you?

In the front of this book is a Visual Library with examples of repetitive lines and blank boxes for you to add your own. Reflection is where you begin to recognize the shift from codependence to independence. You are beginning to take on this practice for yourself. You are beginning to make it your own by identifying what makes your lines unique to you. What experiences give them meaning?

As you look back on your sketches and see patterns emerge, you can use them more intentionally. You will let your pen move from one place to another with experience, with knowledge. You will also be activating your intuition, which allows you to trust the process rather than control it. The ebb and flow of experience and intuition will deepen the understanding you have of yourself. Each mark will inch you forward, support the change happening inside of you, and sustain your personal healing and growth.

Reflection leads to revelation. Whenever ideas, thoughts, and images arise, let them swirl and give them time to settle. Some thoughts are intended to exist only for a moment, while others connect to more complex issues and a larger unfolding of your ability to understand. When the visual representation connects with clarity, waves of awareness roll over you. You can see connections you had never seen before you, behind you, and right there with you.

These epiphanies can be met with an accompanying shiver, recurring vision, harmonic resonance, memorable scent, or familial touch. Each sense magnifying the potency of your awakening. Trust that your mind, body, and spirit are orchestrating a melody that is so pleasing to listen to that it will all seem so easy and isn't that the uncomfortable truth we may not be ready to hear?

This is the way I want you to reflect on the previous sketches before you stare at the next blank page. Stare at your sketches with an intense curiosity and with an expansive heart. Let your eyes see where your pen is leading you and let your heart feel what it has experienced. Then, go the way of the pen.

Before daily sketching. I lived with a foreboding sense of uncertainty. There was a change happening in terms of my relationship with self, my family, my career, and my faith. In reflection, it all seems so clear. In the moment, nothing about it was certain.

Art has always been my safe space. It felt organic to turn to it when anxiety had reached such heights. At the time it wasn't an epiphany. It was a response. My first sketches were shaky. The lines were uncertain. In looking at them, I see how I was trying to control them. It is struggle, hesitation, and fear. I also see the first marks of faith, hope, and love returning to me. There are swirls of anger and sadness. Moments where I made connections to experiences I had long delayed resolving. My husband Micah calls those marks "emotional residue."

I love that phrasing because it is exactly how it feels to sketch through experiences. It's icky and sticky. It's wet with tears of joy and pain. It's a hot beautiful mess of trial and error. It's dirty and deep, simple and panoramic. There on the page I am making my way. Flipping through the pages one by one, my reflection experience is like cartography. I am studying the map of my emotional, spiritual, and physical growth. That is where I came from. This is where I am going. This is where I am now.

With the first sketchbook open, I am instantly taken back. *A tsunami is coming.* That was the thought that lingered one morning as I woke up from a restless sleep. I couldn't recall having had a dream about it. It wasn't a literal tsunami. It was more like a massive wave of energy coming toward me. This wave appears in many of my sketches. I couldn't fight this feeling that whatever it was, the landscape of my life was about to change. The question

was, how? I had a compelling urge to get to higher ground emotionally. The intensity of the anxiety is expressed in the pressure of the pen on paper and lack of control in making lines.

*Remember, Sheila* . . . the sketches speak to me. *You didn't want to fight. You didn't want to leave that job. You didn't know what was next. You thought you'd ruined that friendship. You felt you needed to stay silent.* Each of those sketches show me how far I have come. In my current sketches, there is an ease I feel with anxiety. It is as if my enemy has become my friend.

In later sketchbooks, I see myself getting lost in the meandering of my thoughts. Working through forgiveness, the uncertainty of my lines becomes more certain and more playful. Light, fragile, delicate strokes float through a number of pages. I am resolving childhood trauma. Lines are being made with less and less fear. I hear my own voice vibrating from the pages. This voice is standing up for herself and others. The woman I am is locking eyes with my inner child once more, and in solidarity with that child, I am finding the strength to bear the burdens and stress of trials my family faced. I see that strength in the boldness with which I began to branch out and experiment with others. I see myself learning to connect with people in true and genuine ways.

My sketchbooks say: *You are not alone. You are safe.* Hearing those words in this transformative moment right now, I can initiate faith, activate my courage, release my fear, activate my trust in the process, release myself to create, and elevate hope and love in my life. The word "safe" was the key that unlocked a secret. Every thought, every action, every path led to this clear and present truth: I had never felt safe until now. The most ironic realization in contemplating this truth is that in taking the risk to create, I have found the most safety.

As I sketch this feeling of safety, a symbolic union of blank ink on a white page works together to express a poetic narrative. When the external world around me is in chaos, my inner world flows purposefully and steadily in a course of peaceful surrender. I crack

wide open and let my emotions serve as the through line, while my pen serves as my lifeline. The inner safety forging in the current of my veins finds its release in every sketch and every expression. When I create, there are no boundaries. I am the instrument, the canvas, and the expression. I am the expression of all the possibilities in this universe. It is my nature and my nurture to be a creator.

Are you avoiding the stillness of reflection? What if deep down, pausing to reflect brings a sobering realization that the path you are on is vacant of the joy and meaning you desire? What if you have spent years or decades pursuing this path, only to realize that it no longer fulfills you as it did before? The impact of what this pause can represent becomes so terrifying, you choose to avoid it instead. You continue forward, reach for the next flag, the next mile marker, until you cross the finish line. It is then that you ask, "Am I the person I thought I'd be once at the finish line?"

It is more common to hear about the fear of failure than it is to hear about the fear of success. Our world is filled with messages celebrating awards and wins, but rarely talking about the pitfalls many face when they achieve it. Emotions play a similar role in our lives. We tend not to face them until they are so far down the path that we don't have a choice but to address them. This practice asks you to express, to pause, and then reflect. It is through reflection, where you will transition from the certainty of thinking to knowing. It also makes room for pivots or shifts along the journey rather than huge, sweeping changes required to course correct when you've gone too far.

Take the time to really reflect on each sketch. It is here to help open a passageway into your inner world. It wants you to start a dialogue and find meaning in it. This is not to say that every day you will have this tremendous insight or epiphany that will unlock you. However, there will be days when a certain line, a certain mark, or a certain sketch resonates more deeply than another. But, if we don't take the time to revere each one with this core belief that it has something to say, then we may miss the different

vibrations and energy each one holds. These aren't labels or titles you are putting on what you are creating or expressing. Rather, it is your way to recognize that for every conscious action we take, our unconscious or subconscious is also at play.

Trust the process. Reflect on what you've learned so far. In the near future, you will look back and realize the answers were there all along.

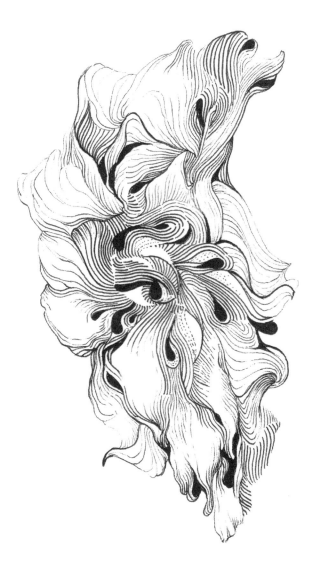

# REFLECTION SKETCHES

Accepting the opposing forces at play in our inner and outer worlds is to embrace every part of our whole self. The things we run away from become the walls we inevitably run into. Similarly, the emotions we repress or suppress are the same ones we are confronted with in situations that change us. This law of nature exists all around us. When we leap with the same abandon to challenges as we do to our desire to escape them, we grow into our full potential.

It takes enormous trust and courage to allow yourself to remember.
—Bessel van der Kolk

## SKETCHING THROUGH DISCOMFORT

( 10 MINUTES )

### *OBSERVE*

Standing up is an automatic response, so we don't often think about how we hold ourselves up. However, scanning and paying attention to our bodies is one of the quickest ways to connect back to ourselves both physically and mentally.

As you develop a habit of daily sketching, being aware of your body and its responses is a critical part of the process. Pay attention to where you may be feeling tension, aches, or pain. How your body shifts from comfort to discomfort. The way your emotions manifest in your physical self.

## *SKETCH*

To explore this further, I want you to sketch standing up. Make sure to find a space that allows you to sketch in this position. Once you are ready, stand in your natural and relaxed position and begin sketching this way. Let your mind drift to a place where you feel the most relaxed and at ease.

After a few minutes of sketching, change your position. This time stand up straight with your legs shoulder width apart. Adjust your posture to make sure it is completely upright, that is, spine straight, shoulders back, etc. Notice how this position creates more tension and awareness in your body. Now continue sketching.

The act of standing can be a physical expression or a symbolic one. Consider how your physical presence influences the way you feel or how others see you. How your posture or stance affects your mood or the boldness of your voice. Think about what you *stand for* and use it as inspiration for your sketch.

I'll tell you right now, the doors to the world of the wild self are few but precious. If you have a deep scar, that is a door; if you have an old, old story, that is a door. If you love the sky and the water so much that you almost cannot bear it, that is a door. If you yearn for a deeper life, a full life, a sane life, that is a door.

—Clarissa Pinkola Estés

## *REFLECT*

When you are done, take a moment to reflect on what you sketched:

1. What patterns, themes, or images arose?
2. What emotion(s) did you feel during the sketch?
3. How did your body respond throughout?
4. Did any memories, thoughts, or insights surface?
5. Did you observe any shifts in energy or perspective?

— SKETCH —

# SKETCHING WITH COMFORT

( 30 MINUTES )

## *OBSERVE*

You may find that as you evolve through self-reflection and healing, certain people or relationships will continue to hold a fixed view of who you are. This view may feel hurtful or unfair, but we cannot control how others see us. All we can do is to receive their fixed perspective of us with compassion and love. Not everyone is able or willing to challenge their own views. Instead, focus your energy on the connections that nourish and do not let the opinions of others hold more value than your opinion of yourself.

To expand on how certain connections can help or hurt you, you are going to invite another person to sketch with you for this experience. Ask someone in your life to help you get started. This can be a close connection or an acquaintance.

> We cannot live only for ourselves. A thousand fibers connect us with our fellow men; and among those fibers, as sympathetic threads, our actions run as causes, and they come back to us as effects.
> —Henry Melvill

## *SKETCH*

Start by giving this person your sketchbook or sheet of paper and have them create four playful marks on your blank page. These marks can be doodles, shapes, lines, anything their heart desires. They can be geometric, organic, playful, or serious. The lines or shapes can overlap or they can be separate. Make sure they don't spend too much time on it. The goal is simply to create a foundation for you to get started.

Look at the marks carefully. Turn the page to view it from different perspectives. Do you see anything emerging from these marks? If not, add your own four marks and connect with the four marks already made. Look again. Do you see anything emerging now?

187

Once you do, engage with this vision. Let your mind wander and your imagination take over. Let yourself play and see what arises when you do.

## *REFLECT*

When you are done, take a moment to reflect on what you sketched:

1. What patterns, themes, or images arose?
2. What emotion(s) did you feel during the sketch?
3. How did your body respond throughout?
4. Did any memories, thoughts, or insights surface?
5. Did you observe any shifts in energy or perspective?

As you reflect on the last two sketches, consider the ways in which you felt uncomfortable and comfortable. What shifted in you? Did you consider skipping this experience?

As you connect with this sketch your partner drew, pay attention to the feelings you have about the other person who made the original marks. Consider how their marks have influenced the direction and tone of this piece. Consider how their start became a foundation that connected back to you.

- Why did you choose this person?
- Did you have any expectations of the marks they made?
- What emotions surfaced when they made the marks on the page?
- What was it like to involve them in the process?

These experiences are designed to agitate and disrupt in order to create breathing room to grow. These are experiences you can do at any time, and a great way to introduce others into the process. It is also a great way to engage in meaningful dialogue viewed from the lens of art. I often use this prompt with family and friends.

— SKETCH —

## — TESTIMONIAL —

"When I dove into sketching this particular piece I remember being in Hawaii, in paradise, and yet I couldn't pinpoint the swirling confusion, sadness, and anger that was creating that dark cloud similar to Pig-Pen from Charlie Brown.

"To be clear, I didn't quite recognize two of the three emotions. I usually only see the sadness. I don't always tap into the others. So I started sketching. I looked out at the crystal blue Hawaiian water and just let the pen have its own run on

the paper. The water couldn't calm me, the smells around me, my husband, my gorgeous children—nothing was helping put a smile on my face.

"The intrusive thoughts were keeping me from enjoying the seemingly obvious moments of happiness around me.

"And so I sketched on. As I did, I continued to punish myself internally. Why aren't you being grateful? Why can't you enjoy the serenity and joy around you? But soon the dialogue started to just become thoughts and the thoughts started to be surrounded by sprinkles of compassion and by the time I finished my sketch I can't say I was fully feeling better. But what I can say is that I had worked through some emotions I didn't know I was feeling.

"You can see it in the sketch. The confusion, the moments of anger through the rapid pen strokes. And somehow I didn't even know I was fully experiencing that range of emotions because sketching in some ways put me in a trance. And in that trance, I could be more present in my thoughts. And through that experience, I could ultimately see my raw emotions play out and be expressed in an abstract sketch. If that's not its own poetry I don't know what is."

<div style="text-align: right">—Falguni Lakhani Adams, @producermama</div>

# 13

# SKETCH EXPRESSION

You are not supposed to be happy all the time. Life hurts and it's hard. Not because you're doing it wrong, but because it hurts for everybody. Don't avoid the pain. You need it. It's meant for you. Be still with it, let it come, let it go, let it leave you with the fuel you'll burn to get your work done on this earth.

—Glennon Doyle

Emotions can either control you or inform you. You can react or respond. Reacting is impulsive. Responding is constructive. Reacting leads to unresolved emotions while responding engages in an iterative problem-solving process.

To be clear, when I say "emotion," I don't mean "feelings." Feelings are singular and transient in nature and often easily resolved. I may feel angry, for example, when someone cuts me off on the freeway, but I am not defined by anger or led by anger. It is a moment. It passes. When a collection of feelings remains in a state of uncertainty for a length of time, they become emotions. Emotions are an amalgamation of unresolved feelings. They surface and overwhelm us whenever we are faced with circumstances that call attention to the reality of their irresolution. Part of the reason that the emotion is unresolved is because it is not simply one feeling. It is many conflicting feelings all felt at once.

When we are emotional, it is often too complicated to explain. The trigger for the emotion response isn't entirely about the present moment or circumstance. It is about more than the present moment. Instead of expressing it fully, we stifle it. *Don't cry. Don't cry. Don't cry,* we say to ourselves. *Get a grip. Relax. Ignore it.* We

dismiss the emotion as quickly as we can. Why? *It's not the right time to address it.* We rationalize. *This is too complicated. No one will understand. They will think I am crazy, unstable, weak ...* the list of adjectives goes on. If we try to let it blow over, we have to deal with it. Thus, we repress our unwanted emotions and believe that we can avoid addressing whatever it represents for the rest of our lives.

While you can definitely avoid addressing your emotions, you can't avoid having them. Additionally, the energy it takes to repress these emotions is the same it takes to confront them. The difference between repression and expression is growth. Repression stunts emotional growth. Healthy expression propels growth. As Newton's third law states, for every action, there is an equal and opposite reaction.

Emotions and feelings are tools we learn how to use in Sketch-Poetic. They are sources of information. Before you begin any sketch, you are encouraged to scan your body and identify the way you are feeling. Feelings trigger emotions. Heat, hunger, sounds, wind, pain, and medicine all contribute to feelings. This is why checking in with your body before you start sketching is important. It sources where the feeling is coming from and it helps you express the emotions it triggers.

In order to express emotion in a healthy way, we first have to acknowledge that inherent contradictions are a fundamental part of our emotional landscape. All at once we can feel gratitude for what we have, but still feel challenged in our current circumstance. We can experience joy, but still feel grief. We can love someone and hate their actions toward us. Acknowledging the inherent conflict is an essential part of expressing emotion in a constructive way. The exercise of expressing is a balancing act that takes time to develop and sustain.

Sketching through the tangled set of emotions as you experience them is a process that restores your sense of balance. It accepts the conflict for what it is and provides you a way to process

it. It doesn't eliminate emotion from your life. It digests the emotion and metabolizes it. Sketching turns the light on in the darkness and stimulates the growth of our character.

"I have no idea what the hell I am doing," Taylor muttered under his breath, flushed with embarrassment and frustration. He felt like a fool in front of his girlfriend and the other dancers. "I just want to watch and take a break," he declared as he retreated to the back of the studio. Dancing was not Taylor's idea of expressing himself. This dance class experiment his girlfriend had talked him into was simply more evidence of it.

I watched him slump into a corner.

Riffing on a guitar is more Taylor's way of creating. The improvisational melody and rhythm of chords and strumming together carries him into thoughtless, expressive places. When he is riffing, he doesn't care if it is good or if anyone hears it. He simply plays and lets the music carry him. For this reason, his girlfriend thought he would love the improvisational dance class that she was taking. "Hell no," was always his response. He wasn't a dancer, and the last thing he wanted to do was embarrass himself in front of an audience, but his girlfriend seemed certain that he would naturally pick it up.

After weeks and weeks of constant invitations, he finally gave in. However, it was clear from the minute he walked into the studio: he was filled with hesitation. He immediately took notice of those who were regular attendees and professional dancers. He saw them stretching so he began stretching as well. Mimicking the way others stretched made him feel less like an outsider, but he was clearly uncomfortable. The inner dialogue in his head kept on reminding him—*I am not a dancer. I look like a poseur, an imposter, a wannabe. Everyone can see that just by looking at me. How long is this class?*

The instructor came to the front of the studio and announced that there was no routine to learn. While that information brought

some relief to Taylor, it was quickly replaced with anxiety again when she asked everyone to begin dancing by making some playful movements. She encouraged the students to "explore their physical bodies" and "expand their comfort levels." Taylor didn't know where to start. *What is a "playful" movement anyway?* Even with step-by-step guidance from the instructor, Taylor felt ridiculous and his feelings grew exponentially stronger as the movements got more and more expressive. Each step irritated him, and as the instructor introduced yet another movement, he nearly collided with another dancer . . . nope. That was it. He was taking a break and politely migrated to the back of the studio where he would watch.

The instructor set the rest of the class in motion and dimmed the lights in the studio. She walked over to him and whispered, "No judgment. No mistakes. Just try. Just move the way you want to move. If the movement you feel is frustration, then express that with your body. Have fun with it." Eventually, he rejoined the group.

*Breathe,* the instructor told the class. *Relax into your body. Close your eyes if you need to. Move with the music. Forgive yourself. Honor the movements of those around you. Adapt. Create. Explore. Listen.* Before he knew it, her voice was replacing the one he was listening to in his head and his body followed suit.

After the two-hour session, Taylor couldn't believe the way his mindset had changed or how comfortable he now felt dancing. He went from an awkward, nervous participant to one who fully let go to the wonder of improvisation. He realized it wasn't so different from his music after all. In fact, there was a point where he felt his body become his instrument.

There are many walls we can build to keep the perceived threats from hurting us. We can avoid anger from the fear of it consuming us or embrace it with compassion for what it will teach. We can numb ourselves from overwhelming grief or feel the agony of its grace. It is in this complex and cathartic release of unwanted

emotions that we begin to actualize our fullest expression. By learning to embrace the nature of our own suffering, we make way for the cycle of expression and release to become one.

Over time, we will learn that avoiding pain only extends it. Everything we are trying to keep out is already in. Every emotion is swirling in and around us. It is natural to want to fold into our protective shell when we're afraid. This shell becomes an impenetrable shield keeping everything at bay. Eventually, your shield will become heavy and your body will grow weary from the weight of expectation. No longer will you see a shining veneer of perfection, but instead the tarnished truths will pierce through the cracks within the armor. These cracks are there to let the light in. The question is, are you ready to let it in?

The way of which I speak is free of judgments and mistakes. It is filled with permission to try, to experiment, to play, and invent. The way involves expressing emotion rather than repressing it. Sketching is my way. Riffing on the guitar was Taylor's way. Improvisational dancing was the way of Taylor's girlfriend. There are many ways, in truth, but all of them begin with the courage to follow your curiosities.

Curious what these emotions may become if you can express them? Breathe in. Breathe out. Release.

# EXPRESSION SKETCHES

Part of expressing our emotions in a healthy way involves identifying the limiting beliefs that prevent us. For example, when we label anger as negative, we are likely to repress our feelings of anger out of fear of being judged. Similarly, if we observe anger in others, we may consciously judge them based on past experiences. By contrast, if we view anger as a tool we can use to identify fears and resentment that we would like to resolve, the anger can be expressed for that purpose.

Emotions cannot be categorized as good or bad, positive or negative, shameful or glorified. These labels we place on emotions carry the judgment and weight of how we see ourselves when we feel the conflict rising within us. The labels hinder us from exploring our emotions and they skew our perception of the world. If we can stare at our emotions in context with the other conflicting feelings and experiences they are associated with, we can begin to parse them out and express each injury.

If you observed someone expressing anger through exercise, dance, or art, would you judge it in the same way as anger expressed in yelling or violence? Expressed creatively, anger is transformed into true empowerment. Expressed aggressively, it is threatening. Emotions in all of their complexity exist to agitate growth in us. Sketching through emotions on a regular basis is an opportunity to sit with the discomfort and messiness of learning and stare at it with curiosity. Curiosity allows us to interpret emotions as experiences that happen *for* our growth and development.

Allow the following sketches to express your emotions and as you do, stare into the light it gives to the darkest depths of your soul. Move slowly. There is no need to rush. Take your time to feel your way through with kindness and compassion.

> If you want to have a life that is worth living, a life that expresses your deepest feelings and emotions and cares and dreams, you have to fight for it.
>
> —Alice Walker

# SKETCHING THROUGH CONTRAST

## ( 10 MINUTES )

### *OBSERVE*

Think about your emotions as if they are part of a landscape you would find in nature.

Are your emotions like a desert, mountain, or seascape? What is the weather like in your emotional world? What is the season of your emotion? Are there roads, signs, buildings, or other indicators of life? Are your emotions static or do they seem more dynamic? How big do they feel? Can you identify individual feelings? Are they close or far away from you? Do the majority of these emotions and feelings feel high or low? How do they all overlap? Where do they overlap?

### *SKETCH*

In this exercise, you are going to briefly sketch your emotional landscape. Begin by outlining the terrain that represents the range of emotions you experience in any given week. Once you have outlined your landscape, begin to fill it in with various types of lines. Refer to the Visual Library for reference.

Remember, it doesn't have to look like a real landscape. You can use squiggly, jagged, swirling, or straight lines, or shapes or dots to visualize it. Represent your emotional world.

Take the time to reflect on the relationship between human nature versus Mother Earth. Explore what influences the highs and lows of your terrain. What shifts are happening in the tides or groundswell of your landscape? Play with the myriad of emotions

> Your emotions are the slaves to your thoughts, and you are the slave to your emotions.
>
> —Elizabeth Gilbert

you are feeling and challenge yourself by going deeper into each one.

For example, if you are feeling sad, what other emotions are attached or layered within it? Did something or someone disappoint, hurt, neglect, or abandon you? Did an event or situation create turmoil, dismay, anxiety, or hardship? Express the details of these connections in your sketch.

Let your emotions breathe life to the page in the passionate expression of its existence.

## *REFLECT*

When you are done, take a moment to reflect on what you sketched:

1. What patterns, themes, or images arose?
2. What emotion(s) did you feel during the sketch?
3. How did your body respond throughout?
4. Did any memories, thoughts, or insights surface?
5. Did you observe any shifts in energy or perspective?

— SKETCH —

# SKETCHING WITH HARMONY

( 30 MINUTES )

## *OBSERVE*

Let's experiment with the translucent and transparent medium of watercolor. The fluidity and texture of watercolor gives way to a new form of creative expression. It allows you to expand on the visual language of emotions you are already building upon. Whether it is the introduction of color or a paintbrush, let the joy of this new form of expression unlock your imagination and unique expression.

If you do not have access to watercolors, be resourceful and create your own by mixing water with colors found in nature such as flowers, leaves, fruits, soil, or liquids found at home such as wine, juice, tea, etc. Enjoy the creativity and playfulness of making your own.

Before you begin, close your eyes and inhale for a count of four and exhale for a count of four. Be mindful of the thoughts, sensations, emotions, stories, and memories that surface and allow yourself to feel it all.

> I learned that just beneath the surface there's another world, and still different worlds as you dig deeper. I knew it as a kid, but I couldn't find the proof. It was just a kind of feeling. There is goodness in blue skies and flowers, but another force—a wild pain and decay—also accompanies everything.
>
> —David Lynch

## *SKETCH*

After a moment of stillness, I want you to open your eyes and think about the first color that comes to mind. When it comes to your choice of color, there are no rules. For example, one day purple could be expressing happiness and on another day expressing sadness. Do not overthink it, let your intuition guide you.

Use this color as your starting point to express how you're feeling. Let your paintbrush move across the paper as you would your

pen. Notice how the brush feels in your hand. What do you notice about the tightness of your grip from pen to a paintbrush? How do the strokes look and feel different? Do you have more or less control? How does it make you feel?

As you are painting, be mindful of how water interacts with your paper. It is okay to let your paper distort in response to the liquid. If you prefer to use watercolor paper or a separate sheet of paper, that is okay too. All of it is part of the expansive dialogue between your thoughts, emotions, and what is being expressed.

Throughout this exercise, pay attention to your physical movements. Does it mimic the fluidity of the watercolor or are you rigid in response to your discomfort of using this new medium? How is your breath? Is it shallow or deep? Are you noticing it change as you progress?

Use these questions as a way to give your expression texture and dimension beyond its visual expression. Again, it does not have to be a masterpiece. It is more important to focus on which emotions you release and visually how you represent them.

## *REFLECT*

When you are done, take a moment to reflect on what you sketched:

1. What patterns, themes, or images arose?
2. What emotion(s) did you feel during the sketch?
3. How did your body respond throughout?
4. Did any memories, thoughts, or insights surface?
5. Did you observe any shifts in energy or perspective?

Watercolor is a wild, loose medium. Attempts to control it are often met with much frustration. This is because watercolor is responsive. Pigments react to water with immediacy. There is a natural, inviting beauty as the gentle release of color ignites

emotions and curiosity, engaging the painter's mind, body, and spirit.

Water by itself is symbolic of life, birth, and fertility. It is a transformative, life-giving element. Colors also have symbolic meanings and when considering color choices think about how certain colors make you feel. Listen to your inner voice and the physical response to your body engaging with this medium. Remember, all thoughts and emotions are valid. Whatever arises is meant to be for that moment.

Anytime you are feeling a complex set of emotions or unsure about what you're feeling at all, come back to this exercise. It will help you to give dimension to your emotions and add more visual content to the library of complex emotions you are feeling, and allow you to highlight patterns and trends that occur in your emotional landscape.

— SKETCH —

## — TESTIMONIAL —

"I met Sheila online when she kicked off the twenty-one days of daily sketching. I met people from different countries, who were leading different lives with a hint of similarity. That similarity was their struggle with life. When I started this venture I had no idea it would unfold multiple aspects of my personality and emotions that were unknown to me.

"I have been sketching daily and through this I am meeting with different emotions each day. I was never good at processing those emotions on my own. I would trouble myself and obsess over things for so long until I felt exhausted. The synchronization of mind and body was always lacking. Always looking for the 'how' and 'why.'

"That struggle is still on, but now the difference is I am able to contain the chaos that comes with it. I take the pen in my hand and use it as my biggest and strongest tool to cope with the overwhelming emotional episodes. The evolution is in the process. I am rooting for the growth that is long-awaited and crucial."

—Arfa Aizaz, @arfa_aizaz

# 14

# SKETCH SURRENDER

I am so grateful that surrender had taught me to willingly participate in life's dance with a quiet mind and an open heart.

—Michael A. Singer

In the many workshops I have facilitated, *surrender* brings to light how each person's unique experiences can change the meaning of how a word and its expression can vary over time.

For some, the commitment to daily sketching is a form of surrender. It requires a leap of faith and a conscious decision to embrace uncertainty and doubt. For others, the sanctity of surrender holds a deeper and more complex meaning. It can represent a plunge into the deep or an admission of a crisis of faith requiring further exploration.

Each interpretation is no more or less worthy than another. All interpretations are to be embraced as part of this process.

Walking the path of the unknown is not for the weary at heart. Trust and courage are an inherent part of surrender. Many participants have described it as floating in thin air or walking into a vast, open space of the unknown. It can be unnerving, even intimidating to feel the weightlessness of surrender. Yet, in the stillness of your daily expressions, you will find the incremental ways you let go of the tired constraints, or the recycled narratives you no longer claim as your own.

Every sketch is an invitation to surrender.

When I feel stuck, I have difficulty making decisions. My mind scatters in a hundred different directions. I wonder why I cannot focus. What is it my heart is trying to tell me? What is it that my mind is trying to avoid? I observe with curious wonder the answers to these questions. I surrender to sketching to see what develops.

Before I start, my hand begins to tremble. Not from fear, but from knowing that I am about to release the energy building up inside. The practice has become second nature. I know the experience intimately. My pen is the conduit. A signal fires to all of the cells, muscles, and organs.

As I plunge headfirst into the swirling, spiraling messiness of my chaotic mind, I notice my hands moving in the same direction and speed as the thoughts passing by. The movements are sudden, changing direction before they can find their flow. I do not question the lines being made.

After a while, my jumbled mind starts to settle. It begins to pay less attention to the thoughts. Instead, it becomes more curious about the textured markings on the page. My senses are activated as I get warmed up. *I see something,* I say to myself. An image forms in the directionless strokes filling the page. I pause. I wonder, *What does it mean? What is it trying to reveal?* I do not push myself to find the answer. These curious thoughts pass as the ink flows through my pen. *Surrender,* I tell myself. *Surrender.* I invite myself to let go of whatever it is I am holding on to.

What does it mean to "let go" in terms of SketchPoetic? What are we supposed to be letting go of?

As it turns out, the word "let" is an Old English word for an obstacle in a body of flowing water. The let operated like a dam, holding rushing water back from flowing. The water built up pressure against the let until it reached a point and breached

the barrier either by breaking it open or flowing over it. When the let goes, the water rushes over it, around it, and through it as if it was never there. That is what it means to "let go."

This phrase "let go" is a paradox. It is both the problem and the solution, just like transformation. It is both composition and decomposition. Your resistance and acceptance of the change process is relative to your tolerance for discomfort and your patience to endure the time it takes for positive and negative energy to build momentum. How long can you sit without reacting to feelings of anxiety, frustration, annoyance, or pain? It may not seem like you are fighting against growth, but you are simply eager for the release. When you react to the uncomfortable energy mounting inside of you, you create more problems that prolong the process of change. It's counterproductive to react.

Sketching provides a way to process those conflicting emotions in the way that I am guiding you to use it. It allows the energy to rise within so that you can let go, overcome, abound, release, and flow with the world. Sketching every day for a limited time conditions you to process change. It conditions you to breathe into the exchange of positive and negative energies as if it were a conversation. It harnesses the energy of that exchange and channels it toward a measured and timely response.

One of the ways this happens is when you leave your sketch unfinished. When the time is up, put the pen down. Not everything has to be resolved in one sitting. It is okay for it to remain unfinished because it is finished for that day. Rest. Breathe. Observe. Take it all in. Let it all out.

An image floats by like a cumulus cloud taking shape. It reminds me of my grandmother. Her memory begins to creep into my mind. I can feel my body protectively resist, then settle in as quickly as it arrived. It knows that this is what I was seeking when sitting down to sketch on one particular morning.

The anniversary of her passing was approaching. The anniver-

sary was a reminder of what I've lost and the remnants of guilt for not saying goodbye when I had the chance. A wave of knowing washes through me—it is grief I am feeling, not frustration, not anger, not exhaustion . . . but grief. Once more, my curious sketch becomes my permission slip to let go.

And . . . I did. I was able to cry. I apologized to her while I was sketching. I forgave myself. I said goodbye. I didn't know where my pen was guiding me. All I knew was the ink flowed to the most

curious of places as if it had visited this flat terrain before. With each mark, a new dimension was added.

I leapt into daily sketching with only one intention—to address my mental health. I never expected the healing, peace, forgiveness, or love I would experience. I had no idea the purity and simplicity of activating my creativity would lead to so many other evolutions of it. It seems that when we prioritize self-care as worthy of our time, we are rewarded in the ways we had always sought to find elsewhere.

Even as I write these words, it still brings a sense of awe and wonder of exactly how this all came to be. There was no yellow brick road to follow. Only a pen that I carried each day that transformed itself from a pair of ruby red slippers.

"There's no place like home."
"There's no place like home."

Home was not a physical place, but a destination. It was a return to self, to a pure state of knowing and unknowing, becoming and unbecoming—the paradox of my earthly existence with the spiritual one. Each sketch was a return home. A return to innocence. A return to the creator. A return to the divine perfection God intended me to be.

I invite you to return home and sit in the wild, wondrous unknowing of your purest self.

You are waiting. Surrender.

# SURRENDER SKETCHES

The blank page is our white flag of surrender. It meets us where we are. It finds us in exhaustion or exaltation. It invites us to create and enter the flow of weightless liberation. When we sketch, we create endless moments of surrender. It begins in the curious way we lose ourselves in the undulating lines. It continues in the magic of the images unfolding. It ends in our awestruck wonder of how it all came to be.

Creative expression is a continuous journey of letting go. It does not want or boast. It guides us to a place where freedom is an act and a destination. It is a divine call to shed our external attachments and fold inward. To look within and find the truths we've solemnly held as separate from who we project ourselves to be.

There may also be moments when this practice is met with skepticism or doubt. When the evolution of daily sketching slows to an unnoticeable place. While we may be moving, the feeling of inertia builds, and the restlessness leads to a search for the next new discovery.

In those moments, do not regard these emotions as any less worthy than the ones that inspire and move you to action. It is in the questioning and stuckness where old patterns and egoic protections reside. Use the feeling of restless unease as a gateway to sketch more. Push through the desire to give up and instead give into it further. Make peace with emotions such as apathy or resignation. Bow to it as you would any emotion and release the power of its hold over you.

This is your surrender.

> The first demand any work of art makes upon us is surrender. Look. Listen. Receive. Get yourself out of the way.
> —C. S. Lewis

# SKETCHING THROUGH TENSION

( 10 MINUTES )

## *OBSERVE*

As we begin to surrender, our body responds in reflexive tension. It holds in anticipation of change or tightens in the resistance of it. It can arise in the stiffness of our neck, the clenching of our jaw, even in the holding of our breath. Each part a symphony of tension and release. Tension and release.

For this sketch experience, I want you to explore the various ways tension can inspire your expression. Become aware of the ebb and flow of its intensity, observing how its presence influences the direction and movement of your piece.

If you have noticeable tension in your body, use it as inspiration for this exercise.

If not, follow the physical exercises below to create tension and release in your body. Pay attention to how you feel during and after each one. Hold each of these positions to the point of discomfort, but do not push it too far. The purpose of this prompt is not to create pain or injury. Rather, it is intended to bring conscious awareness of what it feels like when we hold tension.

*Hold your breath.*
*Clench your jaw.*
*Squeeze both hands.*
*Press your shoulders up to your ears.*
*Flex your feet by pointing your toes toward your shins.*

The history of physics has been the tension between the natural tendency to project our everyday experience on the universe and the universe's noncompliance.

—Carl Sagan

## *SKETCH*

Once you are done, sketch how it feels to hold tension in your body and the eventual release of it. If needed, do each physical exercise throughout the sketch as a way to connect back to your body. Use dots, lines, marks, or shapes to convey tension and let your pen be the conduit for its release.

There is a calm that will wash over you as you surrender to the process. Your grip on the pen will loosen, and your mind and body will relax into it in a way it never has before. When we commit to our own self-care and healing, our mind and body conspire to aid us in our transformation. It orchestrates an opening and brings awareness to new points of tension and release.

Whether you are on day one, twenty-one, or one hundred, your mind, body, and spirit will support you in your transformation. Trust and release yourself to it.

## *REFLECT*

When you are done, take a moment to reflect on what you sketched:

1. What patterns, themes, or images arose?
2. What emotion(s) did you feel during the sketch?
3. How did your body respond throughout?
4. Did any memories, thoughts, or insights surface?
5. Did you observe any shifts in energy or perspective?

— SKETCH —

# SKETCHING WITH RELIEF

( 30 MINUTES )

## OBSERVE

Part of the journey of SketchPoetic is finding our way to the truth of who we are. These truths may not be self-evident or easy to unearth, which means that different sketches may reveal more or less of what we need or don't need. Each lesson culminates in a reconciliation of our physical, mental, emotional, and spiritual being.

The beauty of each sketch is not in what it looks like, but rather in its ability to expose layered narratives that are toxic or dated. These layers can be made up of societal expectations, conditioned beliefs, comparative measures, or ingrained behaviors. We may never know how many layers or how deep each goes. All we can do is have compassion for ourselves and the patience to trust the process in getting there.

When we think about the true nature of our character, we aspire for our external selves to be in alignment with our internal one. Let's sketch through this visualization of how your inner and outer worlds are aligned or misaligned.

> To be fully alive, fully human, and completely awake is to be continually thrown out of the nest. To live fully is to be always in no-man's-land, to experience each moment as completely new and fresh. To live is to be willing to die over and over again.
>
> —Pema Chödrön

## SKETCH

The questions below are guides to help you sketch each of the three layers starting from the external one all the way to the internal one:

- For the first layer, that is, the border around the page, think about the external shell of your body, your clothing, your behaviors, etc. How does it reflect who you are or how you

want to be seen? Focus on the energy you convey or project in the outer layer.

- For the second layer, you are going more inward. Imagine the first layer being a veil protecting yourself and others from seeing what is below the surface. What are the things you are protecting them from? Focus on the emotions or truths you are afraid to reveal.

- For the third layer, sketch at the center of the page the very essence of who you are. Sketch your passions, the unique gifts you hold, the cherished parts of you. If you don't know exactly what that is yet, sketch a representation of yourself as a child radiating the light within.

As you explore all three layers, focus on the thoughts or insights they reveal. You can choose to sketch objects or images or move through this prompt in a more abstract way using the energy of the marks to speak for themselves.

You can also choose to sketch from the outside in or start at the center and work your way out. Trust your intuition on what makes the most sense for you.

## *REFLECT*

When you are done, take a moment to reflect on what you sketched:

1. What patterns, themes, or images arose?
2. What emotion(s) did you feel during the sketch?
3. How did your body respond throughout?
4. Did any memories, thoughts, or insights surface?
5. Did you observe any shifts in energy or perspective?

Once you're done, take a moment to reflect on the entire sketch. Connect with where there is alignment in the expression of your

inner and outer self and where there isn't. Ask yourself why this is the case.

If you so choose, start a new sketch and express what it would look like if you were in complete alignment with the core of who you are.

Come back to this prompt anytime you feel a misalignment in any of the layers you sketched. Let it serve as a reminder to let go of the shell, the veil, the protection keeping us from returning to our highest self.

SKETCH

## — TESTIMONIAL —

"At the beginning, my process involved scanning my body to identify how I was feeling in the moment. I thought I needed to label what I was feeling before sketching. This led me to attempt sketching the label(s) that I came up with. My conscious mind would then try to attach an image that I associated with the label(s). As an example, one day I was feeling grounded so I drew roots. I would get frustrated with this process because I felt like I had to draw labels and I don't have any arts training so I blocked a lot.

"Then after a one-on-one call with Sheila, she helped me

realize that I was turning the process into art by trying to draw labels and this is not about art. The sketches that followed our call were very different. My mindset and process changed.

"Since this shift, I don't put a label to what I am feeling in the moment of sketching anymore. Instead, I hold my awareness of the feeling until the feeling inspires my hand to move. I totally surrender to whatever it is my hand wants to do. It's only after surrendering that I recognize what I am feeling.

"Surrendering to the feeling allows me to connect with deeper emotions and become aware of what is going on emotionally beneath the surface of my conscious awareness."

—Alain Cormier, @dessinpoetic

# 15

# SKETCH WISDOM

As sight turns into insight, each sketch becomes a bloom representing your awakening. You make daily peace with the paradox, juxtaposition, and contradiction that comprise your expressions of faith, hope, love, sound, life, truth, belief, trust, and courage. Your perception expands to include and accept the conflict and mess as part of the design process.

Acceptance is the beginning of wisdom. It allows you to see on the page the parts of yourself that your ego will not allow you to see any other way. You are certain of uncertainty and uncertain of certainty. You know that you do not know. Acceptance is the mechanism of change.

When you move the pen on the paper, you are making sense of the senseless. You are thinking outside your senses while being present with your senses. The process iteratively forms new perceptions. Unconnected thoughts make connections with one another. The connections are both planned and unplanned, conscious and unconscious. Wisdom is both.

What you perceive is evil, works for your good. It is the compost that creates the fertile soil from which the greater good can blossom in your life. It renews the growth. It maximizes potential.

Yesterday I was clever, so I wanted to change the world. Today I am wise, so I am changing myself.

—Rumi

What you perceive as negative, makes possible the positive. The balance and exchange between what you consider to be negative and positive is the dynamic interaction that defines life.

In art classes, when you first learn to draw, one of the first exercises teachers engage you in is a negative space drawing. This is where you take an object like the wheel of a bicycle, and draw only the space in and around the wheel. You don't draw the wheel. The space that the wheel takes up is left blank.

Consider some of the objects around you right now and look at the negative space around them. As you look into that space and begin to see the way in which it shapes the positive space, there is more you will begin to see. The insight it brings to people, places, objects, and experiences is the next level of wisdom you are looking to experience.

Alice never viewed herself as a creative of any kind. Instead, she watched with curiosity how her father and sister would bond over their mutual love of painting. It came so easily to them. Her father encouraged her sister to paint from a young age, seeing her natural talent bloom before his eyes. They had an unspoken language in the way they communicated, and in the way they felt things that were not visible to the eye.

In some ways, this made her feel left out. Alice wanted the connection that she observed them sharing, but as she was explaining to those in the workshop, she "always needed evidence of things" before she could fully embrace it. She and her father shared their own deep and loving relationship. It wasn't with jealousy that Alice felt left out. It was more motivated by curiosity. Alice had always imagined what it would be like to explore her psyche through a creative lens. However, she assumed she had to be innately creative. She believed that because she was analytical, she couldn't be creative. The two types of thinking could not coexist.

Alice came to SketchPoetic with a built-in propensity to go

deep. When I asked her what kind of art she was drawn to, she was immediately taken with strong contrasts of shadow and light. She loved the stark nature of the images and minimal shades of gray. When she attended her first SketchPoetic workshop, Alice was following her curiosity. There was a physiological, psychological, and spiritual aspect to it that she had been observing in me and others who had started doing it. The sketches we produced seemed accessible to her and the depth of analysis resonated with her own growth mindset.

As she immersed herself in the process, she was struck by how quickly she could enter into the flow of simply making lines on the paper. She found it easy to embrace the abstract lines rather than trying to sketch an image of what she saw. She found herself exploring her subconscious and unconscious. There was an avenue developing inside of her. It revealed a path she had been walking parallel to her whole life, unable to cross over. She found that the act of sketching counterbalanced the way in which she overanalyzes, overthinks, and overevaluates her circumstances and emotions.

"I have the freedom to play and not to perfect," she explained in reflection during one session. The marks on her pages were expressions of herself in ways she hadn't experienced before. "Each sketch is an evolution and a revolution."

Within weeks, Alice became an impassioned practitioner. She would sketch with enthusiasm every morning, eager to see what insights she would gather. She approached it as she did her studies. She pored over all of the details, examining each line as a hieroglyph she wanted to decode. At first, the insights were flowing freely and frequently, to the point where it became an expectation for her. Day after day, and week after week, more insights came and more growth followed.

Until one day as quickly as she had started, she stopped. She felt an unexpected resistance she couldn't quite explain. She was

growing increasingly frustrated. "What happened?" she wondered. It was flowing so easily before, but now, it felt like work. Eventually, her frustration became impatience and her impatience became anger. This was an emotion she hadn't felt in a while. She didn't know where this emotion was coming from, but she knew she wanted to sketch through it. And, so she did.

"I think the anger started when I tried to make something of my sketches, rather than just make abstract lines. There were several days of sketches I didn't like and wanted to rip out of my sketchbook because they ruined the aesthetic I'd had in the previous pages, but in continuing to create, I found myself accepting the conflict, realizing the anger it was producing, evaluating the reasons why it was surfacing and allowing myself to feel stuck. In doing so, I returned to expressing."

One of the curious things that happens as you embrace this practice is resistance. You will shift from a sense of awareness and insight to a sudden sense of vacancy and blockage. It is not uncommon to become frustrated. Your sketches don't achieve what you expect them to achieve.

"I feel distracted. I can't seem to get into the same flow as before."
"I feel stuck. I don't think I'm going deep enough."
"It feels like I'm doodling. No more insights are coming."
"I really loved what was happening last week, but this week I'm not feeling it."

When you have seen, tasted, touched, and witnessed your whole self expressed in your sketches, you want to continue and sustain it. As with all emotions, doubt and frustration are here to serve us, too. It is asking you to sit in the discomfort and to ask why. Why am I doubting the process? Why am I frustrated when some days feel less impactful than others? Go beyond the reactive

response and look within. Ask yourself where in your life these same emotions arise. What is it about the swing of disconnection to connection, depth to surface that brings unease? And what if, instead of annoyance or frustration, you see it as an opportunity to pause and reflect?

Whenever participants go through this phase of the process, I emphasize the need to pause. Pause doesn't mean to stop. It means to freeze. Stare into this moment. Breathe into it. Hover over it. Relax into it. Pausing is a way to fully close out an exhale and marks the beginning of a new cycle for the next inhale. It can mean taking a day or two off from sketching, shortening your sketch times, or temporarily changing the time, place, and frequency of your sketches. It is up to you to decide what "pausing" means to you, but it is part of the process.

When Alice hit a plateau, it was her mind and body telling her it was time to pause. It was time to break from the energy and flurry of an intense season of growth and to stabilize. She wasn't aware of what was happening, only the emotions she was feeling because of it. It was the first bump in her journey where she finally understood the power of this practice. She hadn't really been aware of extreme emotions in a very long time. When she could sketch her frustrations and impatience, she could see how the visual language of her emotions was developing.

This is the wisdom found from shedding old ideas. You clean up and make room for the new. You put your house in order to make space for the next creative mess you are about to make. As we continue to evolve, it is an important part of our healing to make peace with the parts of ourselves that we have shed. To sit in gratitude for how our past has served us and how it informs

who we are today. This reflection does not have to be a reflection of years or decades. It could be recognition of who you were last month or last week. Every step of our journey is deserving of this grace. The grace that shines light on our truths, our beginnings, and sustains us for the long journey ahead.

You are here now. Accept the conflict. Release it.

# WISDOM SKETCHES

Part of the wisdom you gain from daily sketching comes from the ways in which you learn to accept change and how you respond to the comfort and discomfort of this process. While discomfort is always a good reminder to look inward, comfort can provide the same insights based on the context or questions asked. Both are needed in our evolution and healing. However, there is a difference between feeling comfort to heal versus avoiding discomfort to not feel.

Knowing yourself is the beginning of all wisdom.

—Aristotle

Ask yourself:

- Is my comfort coming from a place of complacency or obligation (i.e., are you sketching because you feel you have to, not because you desire to)? If so, ask yourself why.
- Is my comfort coming from a need to integrate new insights and learnings into my life (i.e., you recently went through growth or transformation and are enjoying the newness of it)?
- Is my comfort a way to stabilize and feel certain about something in my life when everything around me is uncertain (i.e., sketching is allowing you to grow through whatever you're going through even if it means not gaining new insights or going deeper within)?

# SKETCHING THROUGH CONFLICT

( 10 MINUTES )

## *OBSERVE*

At the end of the day, we can endure much more than we think we can.
—Frida Kahlo

One of the ways to think about our emotional highs and lows is to watch a pendulum in action. A pendulum swings back and forth like emotions in opposition and in harmony with one another. When we sketch daily, we swing from one emotion, gathering speed and momentum as we give in to the gravity and tension that arises. We become transfixed by the growth and learning, but we also forget about the critical nature of resting in between.

It is in this middle, in-between state where a pendulum holds the most energy and momentum. Similarly, it is in our stillness and resting place where the crossroads of transformation and healing meet. Giving ourselves permission to rest, to sketch for the sake of sketching, gives way to acceptance and a surrender to the process. Have faith that every part of it is intended. Some things will lead to change, while others will not.

It is the wisdom in knowing the difference that matters.

In this next sketch, consider what truth feels and looks like to you.

- Does it feel like waves crashing around you? How big or small are the waves?
- Does it feel like a light turning on within? What kind of light source is it?
- Does it feel like a resonance or vibration in harmony with your soul?
- Does it feel instantaneous or is it a slow reveal? What does that look like to you?

## SKETCH

Take an object lying around you and consider the space around it. Outline the negative space and create designs in the negative space you have created. This activity works well with objects that have a lot of holes in them, like bicycle wheels, cages, plants, a wood chair, or pencils in a jar.

Let go of the positive space. You may find yourself wanting to sketch the positive space like a still life or a portrait. Resist. Release the need to see the object. See around it like an outline or as if light was shining brightly behind it and all you could see was the shadow.

Allow yourself to struggle or feel challenged by holding this view. Seeing the negative spaces may not come naturally. Be patient with yourself as you learn to see things in a new way.

## REFLECT

When you are done, take a moment to reflect on what you sketched:

1. What patterns, themes, or images arose?
2. What emotion(s) did you feel during the sketch?
3. How did your body respond throughout?
4. Did any memories, thoughts, or insights surface?
5. Did you observe any shifts in energy or perspective?

— SKETCH —

# SKETCHING WITH ACCEPTANCE

( 30 MINUTES )

## *OBSERVE*

We all have a ball of yarn inside of us. A ball full of knots representing challenges, lessons, and/or traumas (experienced or passed down from generations before us). Some of us don't even know it exists. Some of us see it, but pack it away to hide its existence or wait to deal with it later. Others sit and stare, feeling overwhelmed and with uncertainty of where or when to begin.

Then one day you wake and say now is the time. So you start to unravel . . . knot by knot. Some knots are much larger and more challenging than others, while some are easy and take little effort. The distance from each knot can be few and far between, while others show up back-to-back with little to no space in between.

If you've ever untied knots, you'll know how frustrating and difficult it can be. It is natural to want to give up when the knot is too tight to loosen. But if you persist long enough, the satisfaction of its release gives you the energy to move on to the next.

Then there are the threads. The threads that unravel at the end of this ball of yarn. Each thread represents the many paths opening up to us. Each one reveals the magic and wonder of God and the universe.

- How much have you unraveled already?
- How big is the ball of yarn that remains?
- How knotted is your ball of yarn?
- How frequently do the knots show up?
- Are they big or small knots?

> Knowing others is intelligence; knowing yourself is true wisdom. Mastering others is strength; mastering yourself is true power.
>
> —Lao Tzu

## *SKETCH*

Sketch what your ball of yarn looks like today. Draw out the tangle of lines and flow with the direction they take you.

Breathe through any stress you may be feeling and think about how you approach the knots in your life. Have you ever had a knot so big you gave up? Did you ever return to it? Do you ever ask for help in untying the knots in your life? What are you most excited about in this new chapter of your life?

## *REFLECT*

When you are done, take a moment to reflect on what you sketched:

1. What shapes, patterns, and/or images do you see?
2. What emotions did you feel during the sketch?
3. How did your body respond throughout?
4. How do you feel after sketching versus before?
5. Did any memories, emotions, or insights surface?

As you sit patiently with your ball of yarn, do not be afraid of what it represents. You now have design tools with you to help you decide how to proceed. It is in the process of discovery that healing and transformation begin. You are here now. You are right where you need to be.

We are all in this together . . . connected by this thread and the wonder of the wisdom it will reveal in all of us.

— SKETCH —

## — TESTIMONIAL —

"SketchPoetic has been an extension of therapy for me. Going in to the root of my emotion and considering how the root got there, what physical feelings/emotions I get from that root. How do I work through it and heal from it? I've learned exactly how much I show in my expressions as an artist but also in everyday life. This experience has helped me see in a different way with all of the feedback I have received. It's helped me step out of my comfort zone while staying comfortable. Most importantly I have connected with other people that have some of the same experiences. It felt like going to a store, trying on a shirt that you are unsure of and it fits perfectly.

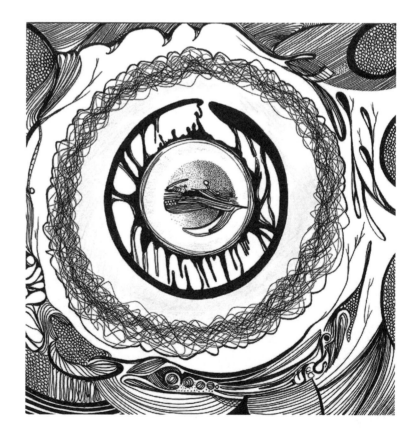

"When I created this piece I was still kind of thinking about what it meant to me and where my compass was taking me. While creating and reflecting upon it, I had thoughts about my compass possibly being broken like Jack Sparrow, but in the end it would take me where I needed to go or maybe it was led by love. The love I have for those on my path with me.

"I have come to the conclusion that my inner compass has been leading me to me. It is led by love but it is not the love for those close to me because that is already a given. It is being led by the love I need to have for myself. I was able to see all of my layers and see that there are a lot of layers I have to get through to get to me. This picture was a turning point because it made me see that while I have started to change and grow, I was still sort of hiding. I think realizing where my compass was trying to take me actually let me begin to work on loving myself again."

—Emily Gonzales, @emily_inks

# 16

# SKETCH INSPIRATION

As you become more accustomed to daily sketching, there will be a natural desire to want to share it with others. It can be a gradual shift or an early occurrence depending on your comfort level. The desire to share can originate from a spark to try something new or as an expansion of the creative energy flowing inward.

When you engage your creativity, you may have already noticed the way in which it activates inspiration. Inspiration is energy. It is motivation. It is joy and gratitude in abundance. It needs fuel to sustain it. You fuel it by giving it a witness. As it is seen, it also needs to be incubated. The ways in which you incubate your inspiration we will discuss in the next chapter, but while it is incubating, your inspiration becomes evidence of your hope, courage, beliefs—it becomes an expression. The more the expression grows, the more it naturally gets to a point where it wants to multiply. It desires to be experienced with another.

When I began collaborating with others on Instagram, it deepened my connection and appreciation for this community. It started in the most traditional of ways. Creators from around the world mailing each other unfinished pieces and completing them in their own style. I have dozens upon dozens of mementos to commemo-

rate this generosity of spirit. The results were inspiring, and more incredible than just the beauty of what was created was the hope it initiated, the courage it activated, and the perspective it gave to each of us. Collaboration is more than just fueling inspiration, it multiplies it.

When we co-create, we elevate. You not only consider how to bring out the best in yourself, but also how you can bring out the best in your collaborator. Instead of communicating through spoken words, facial expressions, or body language, you allow yourself to experience each other through what is expressed on the canvas. You remove external judgments or criticisms and simply see what they have expressed from their soul. You also are invited to acknowledge your own reflection in the eyes of another. We allow the ink to speak volumes to the unspoken words or feelings not being shared. It is a healthy way to explore uncomfortable feelings or tensions that may exist between you and your co-creator. It is also an incredible way to introduce intimacy and vulnerability that may not be organic in your connection with someone. It expands beyond merely sustaining the practice and opens another world of exploration.

Both reasons for sharing accountability and collaboration represent ways to expand our growth. Whether it is encouraging someone to take the leap for themselves or inviting them to collaborate on a piece with you, the internal pull to experience it with others is part of the healing process.

Ronen and I first met at Verve coffee shop in Los Angeles, a place where I frequented daily to sketch. Ronen, a successful music composer, had observed my sketches and found an opportunity to strike up a conversation.

Our conversation began with sharing the genesis and purpose of SketchPoetic. In our exchange, we made an immediate connection over our shared passion for creative expression, our shared belief in the importance of emotional expression, and our shared experience

in the power of improvisation. This connection inspired an idea in Ronen.

"We should collaborate. Your sketches with my sounds," he declared. I was curious. The project and process were simple for us to agree upon. Ronen would send me a playlist of different musical compositions he had curated, and I would creatively express the emotions his playlist had evoked.

Ronen had carefully selected each composition to follow one after the other to tell one cohesive story. However, when I went to listen to the playlist, it played alphabetically rather than in the order in which it was curated. As a result, his playlist took me on a journey quite different from the one he'd intended. What was meant to be a build-up of one composition following another became a succession of different tunes making me leap from one emotion to another. Some jarring and others flowing more smoothly. At the time, I had no idea this wasn't how it was meant to flow, thus I responded to it without expectation. I let my mind and body feel whatever came with the music.

As I listened, my original approach to this collaboration shifted as well. My original plan was to create one holistic piece from the entire playlist. However, after listening to the playlist in random order, I noticed three unique and definitive emotions coming through: fear, peace, and love. Whether Ronen intended to convey these emotions or not, I had no idea. It was simply what I felt coming from his expression. We chose to not influence the other by sharing the details of what we were feeling or thinking. Rather, we let the creation of music and art speak for themselves.

There were moments in this experience where I felt like I was inside Ronen's head imagining what he was thinking and feeling with the cadence of each note. I listened intently to the pacing and pauses in between, the way it would fade or become loud in an instant. I even embodied the feeling of the instruments as they were being played, keeping me present in the moment throughout.

Once my visual expressions were complete, Ronen took the

recorded time-lapse videos of my sketching process and decided to write an original score to capture the emotional idea he witnessed. He wanted to reflect it back through music. Similarly, he felt himself inside my head, responding to emotions he thought I was feeling as the sketch evolved on the page.

"Art is on a continuum," Ronen reflected on this process with me. "Art is on this loop." Thus, the title for our mixed-media album *Art on a Loop* was born. To date, it was one of the most exciting and sincere collaborations I have had. We both saw ourselves in a new light. We saw the process of creation in a new light along with a profoundly deep sense of abundance and satisfaction.

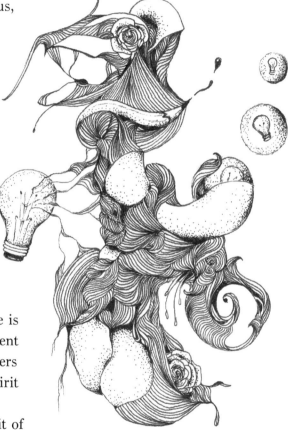

Creative collaboration is an orchestrated union where the flow of giving and receiving is reciprocated throughout the process of creation. We are giving equally of our time, energy, and vulnerable space to another. To collaborate is to create a safe and welcoming environment for generosity of spirit to exist. It engenders trust in the shared intention and selfless spirit in which it was born.

As you start to invite others in the spirit of co-creation or connection, there is a natural and organic flow that develops when you share a creative space or energy with another. Whether it is seen visually on the shared page or whether it is in the unspoken connection you will feel as you co-create, the healing occurs in the collaborative energy of the creating.

Elevate improvisation. Release expectations. Be aware of the

process and celebrate the outcome even if you do not entirely love the result. Each action and reaction you have reveals who you are, and it calibrates you toward the greater good you can become. This is the magic of collaboration. It is an opportunity to open our heart, mind, and spirit to the endless possibilities of creativity and the realization of our creative selves.

# INSPIRATION SKETCHES

Where does your inspiration come from? This question is hard for many creatives to answer because the answer always involves some amalgamation of experience, experimentation, and improvisation. I don't believe that inspiration is a light bulb that switches on over your head. Rather, inspiration begins as an internal vibration that gradually becomes more disruptive. There are two reactions I have when I am growing aware of inspiration: fear and wonder. I fear what will change and I wonder what will become. This is the most fragile moment for inspiration. It lingers between initiation and activation.

> Picture your brain forming new connections as you meet the challenge and learn. Keep on going.
> —Carol S. Dweck

Doubts consume inspiration:

- What if I am not good enough?
- What if my experience is meaningless or ridiculous?
- What if I can't finish?
- What if it turns out to be a waste of time, energy, and resources?
- What if I can't make it what I want it to be?
- What if no one else values it?

Creatives often hover over the deepness of these conflicting feelings until they start iterating on the awareness they have. When you act on awareness and begin creating, that is when the experimentation and improvisation take place. It is where the abundant source of inspiration flows. Elevate this source and allow the following experiences to lift you.

# SKETCHING THROUGH SCARCITY

( 10 MINUTES )

## *OBSERVE*

It's possible to distract ourselves to such a degree that we avoid dealing with anything difficult—even when our lives would be improved by facing reality and doing something about it.

—Marc Brackett

Scarcity is an emotion that breeds intense sorrow, insecurity, and selfishness. When we feel our resources are scarce or exhaustible, we are less inclined to share.

In contrast, abundance is an emotion that fills us with immense joy and gratitude. When we feel our resources are abundant and renewable, we are more inclined to share. For me, the key is renewability. When you create, you both exhaust and create energy.

Have you opened a sketchbook recently and been paralyzed by your vacant stare? Where do you start? In these vacant moments, we search for the semblance of inspiration to spark the embers of creativity. We feel a sense of longing, and sometimes desperation for what others have and the power they possess. We look at their prolific work and imagine the abundance of source fueling their existence. We wonder what magic they behold and whether we can ever hold such magic for ourselves.

This measure of what we have or don't have in relation to another keeps us from seeing the gifts which we possess. Our mind restricts and creates scarcity, while our soul expands and craves the freedom to express its abundance. It is the focus on the outcome and not the process that limits our view of the gifts we possess.

In this next experience, let's sketch through the feelings of scarcity and abundance and notice how they show up in all aspects of your life—spiritually, mentally, physically or at work, at home, at play.

## *SKETCH*

For this exercise, I want you to express what scarcity means to you. Think of a symbol, analogy, or metaphor that represents scarcity. It can be an object that personifies the word or an experience that embodies the feeling of it.

Whatever thoughts arise, let them serve as a starting point. Allow your lines and marks to convey the complexity of this emotion. Consider the visual space your sketch takes up on the page or how the ink of your pen flows with the expression of it. Feel your fears. Feel your reasons. Feel all of the emotions scarcity evokes in you.

Once you have sketched through this experience, consider the perspective of transforming this scarcity to abundance. Sketch through the emotions this opportunity presents and what thoughts surface as you think about what those things can be.

Focus less on the image in your head and more on how scarcity and abundance inspire your creative expression.

## *REFLECT*

When you are done, take a moment to reflect on what you sketched:

1. What patterns, themes, or images arose?
2. What emotion(s) did you feel during the sketch?
3. How did your body respond throughout?
4. Did any memories, thoughts, or insights surface?
5. Did you observe any shifts in energy or perspective?

SKETCH

# SKETCHING WITH ABUNDANCE

( 30 MINUTES )

## *OBSERVE*

The healing power of creative expression can ripple into the hearts and minds of those around you. It can be felt in the passive experience of a curious observer or in an engaged experience of a co-creator. Both experiences guide you to honor your presence in the presence of others.

In creative collaborations, we extend the dynamic of creator and observer by introducing a safe, shared space for two or more to engage. This vulnerable exchange creates intimacy and connection within the limitations of personal space. You will engage with each other's marks and lose the sense of where one began and the other finished.

It is the union of improvised and unpredictable lines where the magic of collaboration begins.

> Pure generosity emerges when we give without the need for our offering to be received in a certain way. That's why the best kind of generosity comes from inner abundance, rather than from feeling deficient and hollow, starved for validation.
>
> —Sharon Salzberg

## *SKETCH*

Before you begin, take the time to discuss with your partner an emotion you are both feeling or an intention you want to set. It is important to have a foundation for what you are expressing, so you are on the same "page."

When you're ready, have each person start on opposite sides of the page. Start sketching, allowing yourself to engage in whatever way is natural. For example, if one person prefers to do larger, more expressive strokes, let them. And if another prefers to do small, more controlled strokes, that is okay, too. What may occur

is a natural dialogue, sharing how another person's expression is affecting you.

When engaging in a collaborative piece, I recommend doing so in silence. Silence is an important part of this practice because sounds impact our emotions, they can distract or help us concentrate. Before we can determine sound's impact on us, we first need to connect with the sound of our inner voice. Silence supports that connection. After a solid period of silence, it is okay to allow for dialogue, as long as the focus is about creating and not talking. The dialogue should enhance the experience and not distract from it.

Express your thoughts through the lens of what is on the paper rather than directing it as a personal comment. For example:

- I noticed you really enjoy taking up a lot of space on the page, can you tell me what you're feeling when you do that?
- I noticed you like interacting with the marks I make on the page. What is it about my lines that makes you want to connect with them?
- Is there anything coming up for you as you see the lines you are (or I am) making?

Note that these questions are simply here to guide you. Find your own language to connect, but remember, focus on the marks being made and not the person. We want to create a safe space for vulnerability and connection by staying curious and removing the critic from this exercise.

Another way to enhance this collaboration is to rotate the paper 90 degrees every five minutes. As you rotate the paper, pause and take the time to look at what your partner has created. Then take the time to enhance or expand on what they have done rather than covering up what already exists. The goal of this prompt is to show how a person can honor another by taking the time to see what they have created and adding to it.

At the end of this collaboration, you will forget where one person

started and another stopped. The goal is to have one cohesive piece, so interacting and playing with each other's creations is welcomed.

## *REFLECT*

When you are done, take a moment to reflect on what you sketched:

1. What patterns, themes, or images arose?
2. What emotion(s) did you feel during the sketch?
3. How did your body respond throughout?
4. Did any memories, thoughts, or insights surface?
5. Did you observe any shifts in energy or perspective?

Bring awareness to how the energy and emotions of another person can influence you and vice versa. Explore creative expression as a catalyst to create your own collaborations.

- Have someone read an original poem, essay, or story they have written. Listen to each word intently. Pay attention to the visuals and emotions they are expressing, as well as how you respond to what is being said. Sketch alongside as they creatively express, or sketch after they have shared their written piece.
- Have an improvised jam session with a musician or singer and ask them to play or sing while you sketch. Listen intently to the nuances of how they express themselves creatively and emotionally. Consider how their musical expressions can interact and influence your visual one as you co-create.
- Watch someone perform or dance to a piece of music and observe the subtlety of their movements and the emotions they are expressing as they move. Pay attention to your response to it all and let it inspire your sketch once they are finished.

If you are looking for a fun way to connect with someone, this is a great prompt to introduce. It is a portable and easy way to invite someone to play. It also makes room for vulnerability as it doesn't trigger unspoken communication such as eye contact, body language, or facial movements.

Let the page open the door for inspiration and allow yourselves to get lost in it.

— SKETCH —

— TESTIMONIAL —

"I started sketching daily as a therapeutic outlet to help work though some PTSD and trauma. My trust had been broken, which unfortunately led to a catastrophic, irreversible, life-altering event. I needed a way to heal this wound and feel inspired again.

"The sketches in the beginning were more like doodles. Admittedly, I didn't do it daily, nor record them all but I still kept on going. Eventually, with new-found strength and resilience I became more focused and started the journey again. I am loving the results!

"I like to think of my sketches as a 'visual arc of recovery.' From the start of this endeavor until now, you can see the change in me, I can see the change in me. I have used this platform of creative expression, thanks to Sheila, as a method to heal. The sketches are my emotions. They're raw, they're real, and they come from a place deep inside that needed to be released and so they have. I'm not the best artist (nor the worst!), I just am and that's all right with me.

"From my heart, thank you so much for introducing me to an incredibly positive way to get back to my true self. I plan to keep going with this forever. Looking forward to what my mind will reveal and how it will be expressed on paper."

—Angel Reed, @aingealism

# 17
# SKETCH PROGRESS

We naturally resist that which makes us uncomfortable. Discomfort isn't a threat to our well-being, but an intuitive call to pay attention. It is a sign asking us to slow down. The conditions for transformation and growth are rooted in a sense of security, but that does not mean we are comfortable. Security and comfort are two different experiences. I can be uncomfortable and secure. I can be comfortable and insecure. We need some sense of security to allow ourselves to feel both.

Accountability creates the space and security you need to feel both. It incubates inspiration. This is why, as we have discussed previously, sharing is so important for inspiration to flourish. Sharing breeds accountability and sustainability. It gives audience to your experience and opportunity for inspiration to flourish. How do you share your sketches?

There are a number of ways. I chose social media, but you can share them also in a small group. It can be one or more friends, acquaintances, or strangers who have decided to begin together. It can be in an online group or at face-to-face meetings at a coffee shop. Whatever way you decide, the important part is to allow yourself to share. Discuss what you see in your sketches. Ask what others see.

Every day you may make progress. Every step may be fruitful. Yet there will stretch out before you an ever-lengthening, ever-ascending, ever-improving path. You know you will never get to the end of the journey. But this, so far from discouraging, only adds to the joy and glory of the climb.

—Winston Churchill

Reflect out loud what you are learning and thinking about. The experience of sharing reveals insight and encourages inspiration.

Inspiration is part of the ongoing experience that actively sustains this practice. When you start looking inward, it will reveal the parts of yourself that you do not want others to see. It is much more comfortable to look at beauty. Intuitively and maybe even consciously, you wrestle with your own contradictions and the way in which those contradictions may come into the light. Creating exposes your pride and ego while also humbling you and empowering you.

The invitation to sketch each morning is an experience of contradictions. If you sit with them and endure them, you will never sustain a practice. If you always stop when it gets uncomfortable, then you won't progress. Progress is why you came to this practice. Growth and transformation are the experiences you desire. Uncomfortable is part of the experience. Agitation is part of the growth. Broken open is part of the change. It is all good.

"Keep it together," Terence told himself. "You shouldn't let it get to you. It is not going to get to you."

The idea of sketching without a plan was not the way Terence normally approached anything. He always had a plan. "I am more comfortable with a protractor and ruler than I am a sketchbook and pen," he declared stoically. Sketching agitated him, but he wasn't going to tell me or admit to it. He joined the virtual workshop because he wanted to explore a new side of himself, so when the invitation to sketch daily arose, he thought, *Why not?*

*This is why not,* he thought as he tried to "just go with the flow of his pen" as I had been telling him. The line was not straight. The next one was not parallel. The circle was wonky. He had listened intently as the process of SketchPoetic was explained to him. Scan your body and observe any tension, pain, or discomfort. Bring awareness to your emotions and sketch for thirty minutes. Feel and express it all. It seemed so simple, yet so foreign. "Creativity, emotions, expression," he heard me say. Three words that

did not resonate with him in the slightest. The crisp white page at first had felt comfortable. It reminded him of the pristine white sheets with tightly tucked corners that marked his morning each day. It seemed perfect as-is, beautiful in its minimalism and constraint. *Why am I screwing it up with my marks?* he wondered.

Terence had difficulty discussing his emotions. He was taught how he should feel and that dictated what he allowed himself to say. Relationship after relationship ended and each person left citing an inability to open up as the cause. Talking about emotions, let alone feeling them, was not what men do. Terence could feel his body tighten as he made mark after mark. He knew this wasn't about the strength of his mind or body, but giving himself permission to feel. For some reason, this ask was more intimidating than others he's had to face. *Why is it this hard to feel?*

But he was *feeling* and as he was feeling, his lines became bolder and more playful with each stroke. He was still unsure about what he was doing, but sensing his emotions come out of him onto paper made him feel different. There was something shifting inside. He couldn't quite place it, but he knew something was happening.

As he began to fill the page with what seemed like random and chaotic marks, he noticed his mind and body relaxing into it. Within thirty minutes, he had become lost in the meandering lines of his own creation. He also noticed the agitation that had gripped him had now relaxed.

For the next few days, Terence surrendered to the process. His mind was filled with possibility. He realized how much he longed to play in the playground of his imagination. He felt an indescribable peace at witnessing his body be in tune with his thoughts. Sketching created a pathway for discovery and exploration. This new way of seeing his emotions gave him hope for a new way of living. It was the oasis in the sparse land he had been craving, and he couldn't wait to see the treasures that lay buried within.

As with any emotion, the extreme or persistent expression of comfort or discomfort is also an alarm we should listen to. Whenever our lives become too comfortable, we limit the possibility of expanding the boundaries of our comfort zone. When we live a life of constant discomfort, we lose the remembrance of what it feels like to be in the stillness of comfort. There is a dance that is necessary for growth. It pushes us beyond our boundaries, but also tells us when we need to step back and breathe. It is telling us when it is time to let go and asks us to question the why when we're not ready to do so.

When we face a situation we do not expect, we assume we will respond in certain ways. When our mind or body betrays us, we turn to emotions of guilt, shame, anger, or frustration. We feel stuck. However, if we can learn to allow our emotions to pass us as nature does, we let go of the attachments we have with it.

Every day you sketch, you are drawing a map, marking a path, creating a way for your mind to navigate through discomfort. As you sketch, you become an agent of change rather than a victim of it. You become the creator.

Renew the spirit of curiosity. Elevate your agency as a creator. Endure your growth.

# PROGRESS SKETCHES

Nature in many ways resembles and represents the range of our human emotions. Like Mother Earth, we are made up of mental terrain, emotional landscapes, and spiritual backdrops. We have seasons and changes. We experience highs and lows.

As you evolve your sketching practice, you will begin to enter unexplored spaces of your inner world. You may feel curious and terrified at what visual images may arise from this territory inside you. Your reactions will filter through a range of judgments or criticisms. Navigating through those feelings may take time. Allow yourself the time. Mark it. As you do, ask yourself the following questions:

- How do you respond when the momentum of life slows or screeches to a halt?
- Have you ever felt stuck? What led you there and how did you get unstuck?
- Has your mind or body ever failed to respond the way you thought it would?
- What emotions do you feel when you are stuck? How does it feel to let go?

*The appearance of things changes according to the emotions; and thus we see magic and beauty in them, while the magic and beauty are really in ourselves.*
—Kahlil Gibran

## SKETCHING THROUGH CHANGE

( 30 MINUTES )

### *OBSERVE*

As you become more comfortable with your creative expression, you will start to notice certain techniques or styles emerging. It is wonderful when this happens as it conveys a message of "this is me" and a strengthening of your inner voice.

However, it is also good to continue to challenge yourself and purposefully create opportunities to be uncomfortable.

## *SKETCH*

For this exercise, I ask that you use a different kind of pen or paintbrush to mix things up. The key is finding a variation of tool that departs from the one you are used to.

- If you are used to using a bold, thick pen, try using the finest tip or vice versa.
- If you already experiment with different tips, then try a paintbrush.
- If you have been sketching with ink for a while, now try using a pencil.

If you are experimenting with a paintbrush, feel free to use a different sheet of paper or canvas. You can also apply the paint lightly on the page, so it doesn't affect the other pages of your sketchbook.

Once you've selected a new tool, begin this sketch at the borders of the page and work your way toward the center. Most of us intuitively start somewhere inside the page, but this time, I want you to consider the visual representation of sketching from the outside in. Pay attention to what it means to you.

The goal is to mix things up and sketch through the discomfort of a new tool and your approach to your daily sketching. When you get into a routine, there is a comfort in knowing what to expect. It's often only in the forced disruption of that routine that you give yourself permission to experiment with new ideas. If it is meaningful enough for you to continue, you adapt and incorporate fresh perspectives. If it is not meaningful, disruptions give you reason to end the practice.

When we make progress quickly, it feeds our emotions. Then, when there's a period of waiting or we hit a plateau, we find out how committed we really are and whether we're going to see things through to the finish or quit.

—Joyce Meyer

Anytime you are looking for ways to shake up your practice, come back to this exercise. Change pens. Change starting points. Always be open to trying something new, especially when the practice begins to feel forced or redundant.

## *REFLECT*

When you are done, take a moment to reflect on what you sketched:

1. What patterns, themes, or images arose?
2. What emotion(s) did you feel during the sketch?
3. How did your body respond throughout?
4. Did any memories, thoughts, or insights surface?
5. Did you observe any shifts in energy or perspective?

SKETCH

# SKETCHING WITH GROWTH

( 30 MINUTES )

## *OBSERVE*

When we begin to remember who we truly are, we uncover how many answers we held without knowing. Answers to the doors unlocking the secrets hidden within. Answers to questions that have weighed us down or have kept us fixed in one place. Answers to why and who we are today and what led us astray.

Almost all paths of healing lead back to our childhood. A time in our lives when questioning was a way of being and answers didn't mark the end, but a beginning. It led us down a winding path of unknowns. As children, we met this uncertainty with purity and innocence, coming from a place of wonder and curiosity. We had more questions than answers. A limitless capacity to imagine the vast possibilities of what life has to offer.

This path toward healing and self-love is like a meandering river with each turn bringing new adventures and unknowns.

> The real voyage of discovery consists not in seeking new landscapes, but in having new eyes.
> —Marcel Proust

## *SKETCH*

Imagine your life as a river. Starting from the top left of your page, start sketching a river flowing through the blank page. This river represents a timeline of your life beginning with your earlier memories and moving to the more recent ones. Start slowly and purposefully. Think about how your life flowed in your childhood.

Was it calm and peaceful or was it rapid and stormy? Were there a lot of forks in the river, and what did this fork represent? Even if the decision or fork in the river was made by a parent or loved one, capture how this fork changed the trajectory of your

life. You can accompany this sketch with words or thoughts. You can even sketch guideposts or signs marking each of the different points on the river.

As your river progresses, take note of the areas where the river was meandering versus when it was straighter and more predictable. Have fun sketching through the memories of your life and visualizing how the river can represent how you felt in those moments.

Have fun adding visual elements such as rocks, wind, animals, etc. to the river to represent other factors in sharing your life story in this way.

Below are some visuals to help spark your imagination as you begin:

- As you think about how the river flows, think about the lines and marks you are making and how they represent this flow. For example, if it is calm and certain, your lines can be straight and clean. If the river is rough and choppy, add texture by adding hash marks or lines depicting rough waters.
- For the forks in the river, were there only two paths or multiple paths you could have taken? If so, show the multiple branches in the river and add symbols or signs to highlight what these choices represented.
- When you think about critical milestones or events throughout your life, add imagery or symbols near the river, depicting what each milestone represents. Keep the visual expression simple. Something you could show a child and they would understand what that milestone represents.

Take your time to fill up the page. There is no rush in completing this exercise. You can depict your entire life to date on one page or you can extend it to multiple pages. Each page could represent different stages in your life representing a new chapter, a

new decade, a new you. However you want to visualize it is up to you. What is more important is connecting your visual expression with the emotions you were feeling as you reflect in these moments in time.

## *REFLECT*

When you are done, take a moment to reflect on what you sketched:

1. What patterns, themes, or images arose?
2. What emotion(s) did you feel during the sketch?
3. How did your body respond throughout?
4. Did any memories, thoughts, or insights surface?
5. Did you observe any shifts in energy or perspective?

You may choose to use the visual metaphor as inspiration to reflect on your future. How you want it to flow and the potential risks of what lies ahead. If it isn't a river, it could be a road. If it's not a road, it could be a trail on a mountain. Whatever metaphor speaks to you, go with it. All of these prompts are intended to spark your imagination.

Sketch through what you go through, and let your pen do the rest.

— SKETCH —

## — TESTIMONIAL —

"I have been pursuing my artistic dream for over forty years but have not developed a reliable method to transform my feelings into images on paper. I have always had the gift of being able to draw whatever I am looking at in a realistic style. I have studied composition, design, color, principles of art, and art history. I have worked in clay, both hand-built and wheel-thrown; drawn in every conceivable medium (including digital); painted in oil, acrylics, watercolor, gouache, and ink. I have sculpted in clay, explored bronze casting, and made silver and gold jewelry. I earned an MFA in printmaking with emphasis on etching and silkscreen. I have won ribbons in juried

exhibitions, been in galleries, and sold my work to collectors in this country and around the world.

"Until I engaged in a SketchPoetic workshop with Sheila, I hadn't experienced sitting, breathing, and checking in with my feelings before sketching. Grateful for this awareness as I embark on a new practice of sketching and learning a whole new way to sketch—with feeling."

—Denise Weston, @deniseclarkwestonart

# 18

# SKETCH PLAY

Curiosity is innate in all of us. It is the undercurrent that pushes creativity to an inlet of discovery. The pure joy of exploration is exhausting and exhilarating. Curiosity sustains your attention. It leads you. It guides you to answers.

When you create, your curiosity hovers over the deep mysteries waiting to be discovered inside of you and in the world around you. While creating, you shift between past, present, and future. At first the dialogue you have with yourself is disproportionately filled with a sea of judgment and criticism, but over time, you will develop discernment. Judgment is that voice inside you that stunts growth. It is toxic. It measures every output coming from you and weighs its worth. You may be inclined to measure the worth of your sketches by the aesthetics of them. In other words, do they look good to you?

However, judgment does not have to be heavily laden with guilt, shame, or punishment. Judgments can also be forgiving, liberating, and exonerating. It is easy to forget that part of judgment. Discernment teaches you to recognize the difference. The way you learn discernment is through play. Sketching is play.

As a mother, I have watched the way my daughter Leila's sense

The important thing is not to stop questioning. Curiosity has its own reason for existence. One cannot help but be in awe when he contemplates the mysteries of eternity, of life, of the marvelous structure of reality. It is enough if one tries merely to comprehend a little of this mystery each day.

—Albert Einstein

of play has evolved and matured over the years. As a toddler, it was entirely sensory driven and expressive. The highs that came from discovering and experimenting were hysterical and the lows that came from disappointment and misunderstood expectations were challenges. As she developed into a child, the same range of emotions were there, but they were informed by experiences. Scribbles became recognizable shapes. Shapes became recognizable objects like houses, rainbows, and people. The objects became even more defined and refined. I asked her one day what she thought about while drawing. She said: "Nothing really. I just let my mind freely go."

Free association. She just let her mind freely associate her experiences with experimentation. When there is no grade, no assessment, no criteria to measure the value or validity of our work—it is play. It is pure, innocent, guiltless, unbridled play. Rarely did my daughter melt down, unless she was trying to make it look like something and she couldn't get it to look the way she saw it in her head. When you try and force your sketches to be something they aren't, you will experience the same frustration. You may have experienced it already in a few of the sketching experiences I have provided you so far. Perhaps you tried to draw a real boat or a real portrait of yourself and felt yourself feeling defeated. This feeling may have led you to remembering experiences of failure. Then the judgment, shame, guilt, and disappointment all flooded to the surface. You want to stop sketching. You may even stop sketching.

Keep sketching. Why do you feel like a failure? Why are you trying to draw a replica of yourself? What measure of success are you fighting against? What would it feel like to simply scribble on the page? What if you didn't plan, didn't think, didn't work, didn't try, and you just followed your bliss?

Joy is driven by curiosity. When you measure the value of your sketches by the joy you had in creating them, you are elevating your judgments. You are liberating your senses. You are exon-

erating yourself. In that awareness, you can enjoy the mercy of forgiveness, grace, and innocence. You can play!

Curiosity is not a construct that can be bound by time, because it lives in the moment and for the moment. I ask you to time your sketches because it is necessary to learn that not everything needs to be complete or resolved. Sometimes, if we don't shift our focus and step away from the work, we overwork our curiosity. We create problems where none existed. It becomes counterproductive to continue.

The objective of sketching is not solution-oriented. It is trial and error. It is controlled risk. It is experimentation and play. In the rumble, mess, and collision of lines some ideas take shape. As you witness them forming, they are given life off the page. They translate into your life. Some ideas are not as good. When that happens, you simply turn the page, start fresh. A new page awaits.

"I am an artist." These words rolled off my tongue the way honey drips from a honeycomb. It was the first time I had spoken these words without fanfare or diminishing explanation. Prior to this moment, when anyone asked, "What do you do?" I would respond with a quick synopsis of my day job and a lengthier monologue about my passion and purpose of elevating art as a tool for healing. It was never a short answer, because in my heart, it wasn't a simple question.

For a while, I viewed this response as noble because it wasn't solely about me. It was about a cause, a mission, something worthy and greater than any vocation or title. But my response masked another truth: I had not yet embraced my gift as an artist.

This proclamation has traveled a long, weary path from my first pack of crayons to the tips of my Micron pens. These words have floated in and out of existence throughout the canvas of my life. The title of "artist" carried with it so much reverence, it was a crown I didn't feel deserving of. While I had been gifted an innate

talent to draw, it never quite matched the lofty expectations of what being an artist meant. Instead, I played small. I ignored all the obvious signs of getting As in art class, winning art contests, and seeing my sketches on the walls of people's homes. It was never enough. . . . I was never enough.

From a young age, I had always dreamed of being an artist or owning an art gallery in New York City. I had romanticized every part of this idea. Hosting salons with poets, writers, artists, musicians, and intellects in my small, cramped studio apartment exploding with art and music. I imagined the gritty struggle and the gypsy, carefree way I moved through it. This was the snow-globe world of my imagination containing a part of my identity that had not yet been nurtured or felt.

As life progressed, this vision became less and less of a reality. My chameleon nature adapted to the creature comforts of suburban life. I was desperate for independence and a life of my own, so at eighteen, I purchased my first home and climbed the first rung of the corporate ladder, locking me into the American dream that became deceptively my own.

This path took me further away from my dreams. I traded in my mismatched and unsure style for heels, stockings, and a pencil skirt. This business uniform masked the internal conflict of the creative spirit spiraling within. Before long, my artist's dreams began to fade and my sense of self with it. I embraced everyone else's truths and walked the safer path of least resistance. Every conscious choice led me further away from my unconscious desires. I couldn't see beyond the layers of camouflage or my fabricated air of confidence. All of it served as a protective shield hiding the creator and the creation.

It would be close to twenty years before my life's path converged with my soul's purpose. In addition to the pervasive anxiety permeating my world, there was a tectonic shift and a return to alignment, calling me back home to my true north. Material

success, social acceptance, and external validation no longer filled an internal need. Instead, they became the obvious blocks stopping the flow of peace and stillness I had been craving. It was time to let go of an identity I had held on to and that once had served me. I was now ready to remove these blocks that overburdened my mind and body with day-to-day stresses and the tiring race against time.

My keen awareness of time, or lack thereof, would serve as the foreshadowing of my journey to SketchPoetic. It showed up in my obsessive focus on future goals and metrics, the surface nature in which I engaged, and my shameful inability to be present at any given moment. Each grain of sand in the hourglass became the quicksand tightening around me.

As I began to go inward, I noticed my kindness and loving nature did not abandon all that I had become. It didn't reject, judge, or criticize the person I needed to be to survive. Instead, I acknowledged with full compassion all of the many ways it had helped me thrive with grace and in situations where most would have been left broken or buried.

It was this coming home to self, where my reverence of art and the artist began to shift. It no longer carried the romantic expectations of my childhood dreams. It no longer held this precious place in my heart. It no longer became an untenable goal only a few artists could attain. The light in which it once shined, no longer illuminated all of the ways I fell short. Instead, my focus became about the joy of the process, the release of my emotions, and the practical nature of art as a tool for expression. Through this lens, I was able to view art as a lifeblood to sustain and heal and not as an identity, label, or vocation to claim.

There was a certain familiarity and knowing when this shift occurred. The inner voice that once whispered my shortcomings, now boldly and loudly spoke in every line and mark created. I wasn't fixated on where these lines were taking me or what the

final destination may look like. Instead, each page became an invitation to be present. The stillness gave way to my emotional release and this release created space for my creative soul to play.

I had rejected the label of artist because of the grandeur it held. Expectations formed by critics, society, and those I loved. As I became more aware of the power of art as a tool for healing I rejected the title once more out of fear that the only people who would try it were artists themselves. It mattered that people didn't associate this practice through the lens of an artist. It was evident in the many workshops I had facilitated that anyone could harness the power of daily sketching. I realize now that I did not have to make this choice. I can be an artist and trust my journey will inspire non-artists. I can be an artist and not feel confined by the definition of it. I can embrace my God-given talent and be grateful for all of it.

When I reflect on the reasons why I denied myself as an artist it came down to a revealing truth: I never felt comfortable standing in the power of my own gifts. It was much easier to shine the light on other people's gifts than to step out of the shadows of my own. Through my sketches, I was able to strip away the façade and layers of my denial and embrace all the parts that make me who I am today.

One of the most unexpected, but welcomed parts of this healing journey is the impact it has on the people around you. When you begin to align

your purpose with your identity, your relationships will reflect the same. At first, it can be challenging and uncomfortable to see the shallow and imbalanced connections reflected back. For some relationships, it will be the conduit to a closing of this chapter. For others, it will be an invitation to build a more meaningful connection or spark a new one.

Whatever happens, embrace all of the ways you show up in the world. This reflection may bring regret, shame, guilt, or may require forgiveness. Allow yourself the grace to do so. It is through self-compassion and self-love that our character is nourished and rooted.

Hover over the deep in your life. Play with the darkness. Let there be light.

# PLAY SKETCHES

*A drop of ink may make
a million think.*
—Lord Byron

When we sketch, we experience the awe and wonder of creation. Our mind, body, and spirit merge with our ultimate creator. Creative expression gives birth to ideas, thoughts, dreams, visions, and truths. It meets us where we are. It does not ask us to be bolder, smarter, more eloquent, more talented, or more or less of anything other than who we are today.

Our sketches invite us to ruminate and illuminate the truths we may not want to see. Yet, it is in this soul-aching and soul-giving space where our empowered selves emerge. You will wonder at the majesty of how one sketch can move you and connect you to a time and place not of this world. You will loosen your grip on the physical world and float in the ethereal richness of the unseen one.

You will visit this knowing even in the pauses in between your daily practice. You will see it in your dreams or on the signposts of daily life. You will see it in the divine creations of others, in harmonious songs, fluid dances, ecstatic performances, illustrative words, nurtured gardens, and nourishing meals. Each person creatively expressing their language of eternal and unconditional love.

## SKETCHING THROUGH EXPERIENCE

( 30 MINUTES )

### *OBSERVE*

The marks we make serve as a metaphor for the now. It shows us that we are worthy of the space we take up. That no mark will ever exist in this way, at this time ever again. It reveals how quickly

our emotions can shift, when a line we create disrupts the peace of what we thought this sketch would be. We want to erase it. We want to start over. And maybe even discard it, because we don't want to be reminded of how easily our expressions can move us.

Yet, if you stare at the metaphor of such actions, you will understand that every mark (seen or unseen) is already done. The moment has passed, it is our attachment to it that remains. This is the challenge and opportunity for transformation.

## SKETCH

Imagine yourself as an archaeologist about to go on an excavating expedition. The blank page represents the surface layer of the ground you are about to dig. Think of your pen as the small shovel that is about to unearth the layers below it. Do you dig in a small area of the page or do you explore the entire surface from one border to another?

Begin the sketch by imitating the lines you would make digging. What direction do they take you? Follow that around the page.

As your pen continues to explore, something appears in the lines you are making. Your curiosity is piqued, what could it be?

- Is it treasure, fossil, bones, or something completely unexpected?
- What does this discovery represent?
- How is it connected to you and your life today?

Once an image or object surfaces, take the time to continue excavating by giving it shape or digging further to see more of what you have uncovered. Remember, stay curious, you never know what your unconscious will unearth before your eyes.

Refer to this prompt whenever you want to explore or uncover

Creativity is about play and a kind of willingness to go with your intuition. It's crucial to an artist. If you know where you are going and what you are going to do, why do it?

—Frank Gehry

buried truths. There is always time to unearth the layers hiding the treasures within.

## *REFLECT*

When you are done, take a moment to reflect on what you sketched:

1. What patterns, themes, or images arose?
2. What emotion(s) did you feel during the sketch?
3. How did your body respond throughout?
4. Did any memories, thoughts, or insights surface?
5. Did you observe any shifts in energy or perspective?

 SKETCH

# SKETCHING WITH LIBERATION

( 30 MINUTES )

## *OBSERVE*

Art enables us to find ourselves and lose our-selves at the same time.
—Thomas Merton

A caterpillar turning into a butterfly is a universal symbol of transformation, showing us how nature or life can evolve in the most wondrous of ways.

Using this symbol as creative inspiration, think about your journey of personal, professional, or spiritual transformation. Where are you on this journey today?

- Are you a newly formed egg?
- Are you a young caterpillar exploring the world?
- Are you an older caterpillar preparing to cocoon?
- Are you in a chrysalis transforming into a butterfly?
- Are you emerging from the chrysalis?
- Are you a butterfly?

## *SKETCH*

Sketch which stage you are in along your journey and how it feels. Sketch the emotions you feel as you imagine yourself in these stages. Play with marks and lines to convey energy and movement.

Consider these questions as you express your current state of transformation:

- Are you dormant or active?
- Are you small or expansive in size?
- Are you eager or patient?

- Is your energy high or low?
- Is your pace fast or slow?

If you are struggling to understand where you are in this process, use this same prompt to imagine what your full expression will be and sketch that. Do not limit yourself to the idea of the caterpillar and butterfly. It is there to serve as inspiration to guide you as you think about your own evolution. Have fun with it and explore the many ways it can be expressed.

## *REFLECT*

When you are done, take a moment to reflect on what you sketched:

1. What patterns, themes, or images arose?
2. What emotion(s) did you feel during the sketch?
3. How did your body respond throughout?
4. Did any memories, thoughts, or insights surface?
5. Did you observe any shifts in energy or perspective?

Similar to the caterpillar and butterfly, our shifts can lead to a change in shape, adapting to circumstance or a change in form driven by necessity. We adapt and give flight to new perspectives, making room for the humanity of struggle and the joy of transformation.

Revisit this prompt intermittently to recognize your progress and as an act of self-compassion. Depending on where you are on your healing journey, you may need a visual reminder that every step is leading you forward, even if it means being in a cocoon of your own creation.

— SKETCH —

## — TESTIMONIAL —

"I found art later in life—only a few years ago. When first starting, my practice was to sit down with no real intention and to just make lines. I loved seeing on paper what was coming from deep within. Things that I wouldn't know were there had I not sketched them out.

"Over the years I lost that practice and began more formal, technical drawings. While this new style fulfilled me in different ways, I missed the spontaneity and rawness of my earlier sketches. I found Sheila on Instagram a few years ago and felt a kinship as she reminded me of my long-lost

sketching self. When she announced a virtual workshop during the pandemic, I immediately jumped at the chance.

"With the help of Sheila and the rest of the group, I have been able to play with and explore my inner world through sketching. I have also been able to break free of the confines of what I deem I 'should' be drawing. I cannot say enough how special this experience has been. Not only was I able to tap back into myself through sketching, I found a wonderful group of humans who support each other through the turbulence of life—both good and bad."

—Caroline Qureshi, @emotionally_driven

# 19

# SKETCH PURPOSE

Before SketchPoetic, my priorities were defined by preplanning every single minute of the day ahead. To-dos, schedules, check-ins, and goals premeasured the value of my time. My "busy" life gave me a sense of purpose and worth. It validated my existence and my definition of success. Corporate life further mired me in this way of thinking with performance-based rewards, promotions promising wealth, and unrealistic, ego-driven expectations. These were truths I thought were my own, but only really borrowed until the due date had arrived. Each time I delivered, I felt something irreplaceable was taken from me.

As I rushed from one task to the next, my exhaustion mounted. My anxiety heightened. My relationships lacked depth. My joy waned. My income never felt like enough. Shouldn't my employment and work product each day translate into some sense of peace?

It didn't.

"I know you're busy . . ." a colleague would say. "Let me know when it is convenient for you."

"I know you're busy . . ." my dad would repeat into my voice mail. "Please call me when you have time to catch up."

There is no greater gift you can give or receive than to honor your calling. It's why you were born. And how you become most truly alive.
—Oprah Winfrey

"I know you're busy . . ." a good friend would say as I ran past her at the grocery store. "Hope we can find time to get together."

"I know you're busy . . ." my daughter would say. "Can you please chaperone our field trip?"

"I know you're busy . . ." another mom would say. "I don't know how you do it all."

"I know you're busy . . ." my husband would say. "We haven't talked much lately. I wonder if you're doing okay."

Busy was my chosen vocation.

It fit the narrative I had crafted of belonging. Everyone around me was busy. *People of importance and accomplishment are busy.* I convinced myself it was true, but underneath it I was brooding. Because it was the way I measured my worth, it was also the way I measured the worth of others. This ethic translated into unfair expectations that I placed on everyone.

Each unmet expectation inevitably led to disappointment. I was angry, disillusioned, embarrassed, sad, and lonely. All of these emotions vibrated so close to the surface that when any disruption occurred in my ability to work, I interpreted it as a threat to my value and worth. I stayed busy to avoid these feelings, but I was only exacerbating the problem.

If busy was my vocation, then total control was my mission statement. Externally, I projected an image of a captain navigating her ship across the wild ocean with calm, stoic resolve while adapting to the constant motion and inevitable winds of change testing my direction. Internally, however, I was more like a passenger searching for any sign of land so I could feel grounded. Finding that ground came through my sketchbook.

It was in the stillness of daily sketching that my work truly began. It required the same passion, discipline, skills, and commitment as any job I had ever had prior. The difference was that I reframed what I was calling my "work."

In sketching, there is no measurement of performance. Committing to the process is the only measure. There are no due dates. You

can leave work unfinished. There is no income. It pays in terms of peace. There is no promotion or title to achieve. It is personal growth that matters. There is no pressure to build a network. It happens naturally. The culture of sketching allows for innovation and design. It creates and recreates it. There is no corporate language to adopt. The visual language of sketching is wordless.

When I started daily sketching, I didn't do so with an intention to pursue art. In fact, my vision of being an artist looked nothing like this. It was in the loosening of the tightened beliefs I had around art that led to the evolution of SketchPoetic from a mental health tool to a spiritual one. All of it was a process of unfolding. Unearthing the person I had become to the person I knew myself to be.

Each sketch disrupted the sediment resting deep within the ocean of my soul. The process felt unsettling, but familiar. There was an ease in returning to this part of myself I had long ignored. Gone were the comparative measures, and all that was left was the liberating truth. Through daily sketching I was able to explore my feeling self. It led me down a path of healing and transformed the way I moved through life. I had nothing left to prove, and only everything to gain on this vocation of self-discovery.

When Camilla joined one of my SketchPoetic workshops, she was in search of an artists' community where she could rekindle her artistic ability.

"The last time I was around creative energy was in art school," she shared at the beginning of the workshop. While it had been her dream to attend one of the top art schools in the country, she didn't continue as an artist after she graduated. There was a paradox she couldn't reconcile. She thrived off the constant iteration and inspiration of ideas circulating in and around her, and she also felt the death of those ideas in critiques. She never felt a sense of belonging in the art community. There was a bourgeois nature in the culture of it and an elitist perspective that she didn't share. At the same

time, she missed the interaction. She was unsure about what to expect when she found out the focus of my workshop would be more about expressing emotions than a critique about art. Camilla had never heard of this idea of using art as a tool for healing. The idea unsettled her, and I noticed a shift from hope to disappointment almost immediately as I explained it.

As the workshop continued, I could see that Camilla was struggling.

She cared deeply about the outcome of her sketches. It was hard for her to put down the pen. In discussion, she had a tendency to criticize or offer tips on approach and technique. She wrestled with the opinion of others when it came to her own sketches. She wanted to hear them say things that positively reinforced her achievement and skill. None of her sketches felt "good" to her. She carried a certain restlessness and unease when things weren't up to her standards. She was both judge and jury when it came to claiming satisfaction or reward for a job well done. Despite her incredible work ethic and impeccable craft, it never seemed like enough.

During the weekly check-ins, Camilla began to reflect on the differences between the SketchPoetic community of creators and her art school community. There was no sense of competition or comparison about each other's creations except for the competition and comparison happening inside of her. Rather, the group focused on feelings, emotions, and the reasons why each mark was made. Some of the most insightful and provocative questions that she'd ever considered about art were being raised by creators who proclaimed themselves to be "non-artists." They understood their own art in ways that many artists seek to learn.

"I didn't start this as a search for meaning," she said in one of the last workshops. "I realize now I started this as a search for acceptance and perfection. So, at first, I was not vibing with it. I struggled, but slowly, as I reframed my intention, I found what I was looking for. I found acceptance and perfection from interpreting the

meaning of the work with all of you, from the process of creating it next to all of you, and from the emotions I was allowing myself to experience while making art with all of you. I wasn't looking for a community of artists. I was looking for a community of creators."

While Camilla experienced discomfort in the process, she also faced it in her own evolution. The comfort she once found in group art critiques was replaced with vulnerable self-reflection. Her self-conscious and awkward communication style made way for a more fearless assertion of self. Her walls of perfectionism softened, making room for the acceptance and trust in her creative gifts.

There are times when discomfort feels disorienting, like a huge wave crashing over you. When this happens, surrender to its fierce energy. Do not resist or fight it. Trust that you will ascend and find

your way back to the surface once more. It can also feel like a slow and gradual tide. Shifts that are subtle or barely noticeable to the naked eye. This change may seem less dramatic and more manageable. Yet both shifts are necessary in our path to personal transformation.

You may be surprised to learn that discomfort is not always associated with emotions such as fear, doubt, or uncertainty. Sometimes, it is associated with emotions such as peace, joy, and love. As you embrace the process of daily sketching, an inner conflict will arise between the person you are today and the person you are becoming. You will attract positive energies. You will notice doors opening. You will invite new connections. All within the comfort of the safe space you have created for yourself.

Learning to reframe what causes discomfort is part of the healing process. As you surrender to the process, the factors that once triggered or influenced your response will change. It is an inevitable part of growth for the challenges to evolve as you do. Surrendering is not a one-time decision. It requires a conscious awareness and commitment to the process. Check in with yourself from time to time and ask, "What has shifted within that has changed the way I see the world?" The answers may surprise you.

One day you will stare at your reflection with a *Mona Lisa*–type smile. A magnetic smile that draws people into the inner peace of your knowing.

# PURPOSE SKETCHES

From the beginning, I knew I was embarking on a search for meaning. It is a seed planted in the soil of all of my creations. It is at the core of my why and what propels me to be of service to the greater good.

A longing for safety is the feeling that vibrated in my earlier sketches. It was in my weighted thoughts of control, anxiety, and tension. It was in my vigilance of perceived or real threats. It was in the punishing memories that surface as I sketched. It kept me on my toes and put me in a perpetual state of awareness. I learned through this process that I cannot guarantee safety, nor can I do anything to avoid a life without any pain or suffering. It is part of my human experience. My growth comes from it, navigates around it, and incorporates my experiences into it. How do I frame my experiences? How do I look at them? Is it through the lens of destruction or through the lens of creation?

Sketching has shown that there is reason for every mark ever made. They tell a story of reformation. They capture moments constantly unfolding. They incorporate accidents. They remind me to follow unplanned lines and put the pen down to rest when I recognize a sketch is being overworked. They flow with overwhelming and underwhelming emotions.

I frame my purpose in life now differently than I did before as I believe you are beginning to do, as well. Not only am I strengthening my own connection to hope, faith, and love, but I am here to support your awareness and connection to these experiences that we share.

Our work is a vocation to which we have been called from the beginning of time. When we work we are partaking in and joining with God's ongoing creation of the world.

—Peggy Noonan

287

# SKETCHING THROUGH REVISION

( 30 MINUTES )

## *OBSERVE*

The art of being busy. We justify and glorify it as a necessary evil. We fill our days with never-ending tasks and to-do lists, chasing the sun from dusk until dawn.

There is a fine line between spending time getting things done versus spending time on the things that matter. If you're lucky, both are aligned. For many, what matters to us either drops to the bottom of the list, or the question of what matters is never asked.

The moment daily sketching becomes a task or a chore, ask yourself, what has changed in your life to cause it to be so? Do not assume it is a sign to give up and certainly do not judge yourself for it. Use it as an opportunity to make sense out of the senseless. There is a reason we stay busy, just as there is a reason we stop doing the things we love. It doesn't happen overnight. It is a gradual decision we make in our hearts and minds before any act makes it so.

Use this time to engage, revise, and repeat. Who knows what you'll uncover when you do?

> Vocation does not mean a goal that I pursue. It means a calling that I hear.
>
> —Parker J. Palmer

## *SKETCH*

Imagine your pen is on a mission to fill the entire page, but with one caveat: you cannot lift the pen off the page at any time.

As you sketch, think about all the ways life challenges you along the way. Visually represent these obstacles or tests as your hands move across the page. Let it be full of twists and turns or with minimal changes at all. It can be jagged, direct, spiraling,

or scribbled. Do not force it. Take your time and let your intuition guide you.

Start sketching now and remember, stay focused on the task at hand. Pay attention to how often you want to pick up the pen. Resist the urge to do so. Stay focused on your goal.

If at any time it becomes difficult to not lift up your pen, keep your pen on the paper. Pause. Take a breath and start again. Take note of how you feel in this pause. Reflect on what led you to this point and what inspires you to keep going.

## REFLECT

When you are done, take a moment to reflect on what you sketched:

1. What patterns, themes, or images arose?
2. What emotion(s) did you feel during the sketch?
3. How did your body respond throughout?
4. Did any memories, thoughts, or insights surface?
5. Did you observe any shifts in energy or perspective?

— SKETCH —

# SKETCHING WITH EVOLUTION

( 30 MINUTES )

## *OBSERVE*

Think of your daily sketch as an emotional selfie. Not the angled, duck lips, "damn, I look good" type selfie. It's more the unfiltered, pure, unknowing of your inner world sketched on a blank sheet of paper selfie. An expression made with your hands and created with ink sourced from the deepest well of your being.

This is the type of selfie that makes you feel good about yourself and doesn't require a filter. It is the most honest portrait of who you are today. A snapshot with your eyes wide open and a smile so big even a sketchbook can't contain it. Pages upon pages of sweet expressions will flow through your pen each day. The lines you mark on paper with intensity and passion give your voice new power and strength. Instead of being intimidated by the negative space in between, you will feel emboldened. It will dissipate shame, fear, and darkness. It will become a part of who you are and how you learn to express yourself at work, in relationships, and in life.

Our context or circumstance does not define who we are. We may be forever changed by an experience. We may carry the permanence of the scars it creates. We may even shoulder the burden of the weight of its suffering. But the sacredness of our heart will always carry the divine truth of who we know ourselves to be.

Her sense of self is built on a strong inner foundation. She's cultivated her breath and tapped into her connection with the entire Universe. What accolades other people may give her do not matter. She is reinforced by life and nature as her exuberance and enthusiasm radiate from within.

—Pedram Shojai

## *SKETCH*

Take a moment to stare at your reflection. Choose surfaces that reflect various distortions or perspectives to look at such as a mirror,

window, plate, cup, or even a puddle. Observe with curious wonder how each surface changes the reflection of who you are.

- What do you notice in each reflection?
- Which reflections amused you?
- Which reflections repelled you?

Sketch which reflection most piqued your curiosity. Use it as a starting point for your creative expression. Do not worry about trying to think of this as a self-portrait. Rather, think about the emotional response you had to this prompt and what thoughts arose as you viewed yourself through different perspectives.

You can also choose to sketch a part of your reflection versus the whole as a creative way to expand on this exercise.

## *REFLECT*

When you are done, take a moment to reflect on what you sketched:

1. What patterns, themes, or images arose?
2. What emotion(s) did you feel during the sketch?
3. How did your body respond throughout?
4. Did any memories, thoughts, or insights surface?
5. Did you observe any shifts in energy or perspective?

Even in a direct and simple task, we learn to engage our mind, body, and spirit to support us on our mission. Every part of our being wants us to succeed. The question becomes who or what gets in our way? And why do we allow it to happen?

When the world looks at us, they may choose to only see a part of who you are and not the full self. While we cannot change how others see us, we can choose how we see ourselves. Build yourself up so you can feel love and acceptance in your reflection.

Anytime you need a moment to reflect on the greater good and how your life aligns with it, come back to this prompt and repeat it. When you do, compare it to the previous sketch, and notice what has evolved and what has remained the same in your expression. See if there are any patterns that can help you gain perspective on where you are today or what your purpose may be.

— SKETCH —

## — TESTIMONIAL —

"I am dedicated to this practice because it is unobtrusive and fun. You don't have to tell anyone … anything. You don't have to share. You just have to be honest with yourself. There is no dominant force telling you that you have issues. There is something empowering about creating a visual symbolic language that only I understand—I can really release myself and stay anonymous, no judgment, no disbelief—just the truth hidden behind my unique lines.

"These feelings I have barricaded inside for almost a decade, painful triggers, are blockers for my growth and my ability to help others. In my mind everyone has pain, but the longer it is kept inside, the worse it gets. I know the more I commit to the SketchPoetic practice, the more willing I am to let go of what is trapped inside.

"I strongly recommend this creative expression tool to all art students that have been battered down by old and outdated philosophies of what 'good' art is. SketchPoetic challenges you to see everything at face value when you are sketching—there is no good or bad—it just is and it is up to you to find out what it means for you and how to communicate it.

"This practice gives me thirty minutes a day to dwell on the past or present without avoiding my thoughts. This alone gives me a sense of peace. Sketching daily without a system is daunting, especially for me, so having this structured process really helped frame it in a way I could embody."

—Ayka Pogrobinsky, @ukulanllc

# 20

# SKETCH DESIGN

To be or not to be? That is the question. Or is it? What if it was the answer? *Que será, será*. Whatever will be, will be.

Do you have freedom to design your life? Do you have freedom to choose your passions in life or are they thrust upon you through suffering and circumstance?

You are born with natural talents that guide you to your purpose or connect you to a greater good. You hope. You have faith. You love. You believe. You trust you will find your way. It is the protagonist's journey. There is an idealism in the way we all start our journey that leads us to believe if we do everything right, it will be easy.

At some point, though, each of us gets wise to the fact that there is effort involved in opening yourself up to possibilities and potential. The truth about yourself, your choices, your talents, your world is more complicated than you originally thought. It's hard to use them for good. It's hard to recognize good. You become aware that your talents are wrapped in a set of oversimplified beliefs that must be unwrapped through a series of unfortunate events. You spin around looking for ways to avoid the shredding of your beliefs.

What you need is a way to express it. Without expression, it can

> You are here … It doesn't matter where you come from, where you think you are going, what job or career you have had or think you should have. You are not too late, and you're not too early. … Once you design something, it changes the future that is possible.
>
> —Bill Burnett and Dave Evans

feel as if you won't survive the deconstruction. We all eventually find ways to express it. Unhealthy ways of expressing your conflict lend themselves to self-destructive habits. You perhaps don't understand why you end up in the same set of circumstances. You question your very existence—to be or not to be? Healthy forms of expression, such as sketching, lend themselves to self-constructive habits. You are the answer. *Que será, será.* Whatever will be, will be. You find a way *through* the experience. You surrender to it instead of avoiding and prolonging it.

Suffering is the way your passion is ignited. Passion is suffering.

It is upon reflection of your expression and experience that you become inspired, and as you share your inspiration, you realize your vocation is not defined by employment. The compassion you have for others fuels more inspiration and sustains you through the next levels of your own personal growth. Your endurance expands and kindness flourishes.

It is here, in this place, where you can play with your passions, my friend. Reimagine and redesign your life with purpose. It is here. You have only just begun.

Music was always on Lenora's heart and in her mind. However, when her parents passed away, she inherited her family's restaurant. For seventy-five years, it had been an enduring staple in the community where she grew up. It was an integral part of her, and she was an integral part of it. Her great-grandparents had started it, her grandparents took it over, and her parents maintained it. It held generational memories for most of the town.

As an only child, there was an unspoken expectation that she would keep the family legacy going. No one asked if it was the path she had wanted for herself. It wasn't, but she also didn't have the heart to close something that meant so much to so many other people besides herself. Selling it would change the culture of the place. That didn't feel entirely right either. Lenora felt a boulder of expectations weighing her down. She decided to keep it running.

Lenora had never had children of her own. Her customers were her family. She was fondly known as Auntie L, a sweet connection to her parent's nicknames, Mama G and Papa C. It was this familial love that kept her going, but it wasn't enough. She was alone. Between the long hours and daily grind, Lenora was consumed with work. She resigned herself to the tasks each day despite a spiraling sense of solitude. So much time had passed, she could no longer imagine an alternative, and as her disillusionment mounted, so did the tension building in her chest.

She made the agonizing decision to sell to a local developer whose vision was to tear the property down and turn the land into a recreation center for local youth. Knowing the land would continue serving the community in such a positive way seemed like a fitting tribute to what her family had built. But in the weeks following the sale, Lenora didn't feel relief. She felt an emptiness she couldn't quite process. The restaurant held so many incredible memories, experiences, and connections. All of her employment was gone. Along with it the photographs, the awards, the mementos her parents had left behind. Her parents were gone. She had not realized she had been using work as an excuse to avoid grief. She'd also been using it to avoid forging a path for herself that was not rooted in the business her family had created.

In her grief, Lenora felt free. She used it as inspiration to start writing music again. Page after page of new songs flowed through her like a geyser exploding in an ecstatic symphony. With each day that passed, the sadness was replaced with joy and gratitude. She had found her way home to herself again.

Every company that I have ever worked for and every client that I ever represented had a powerful purpose statement. It served as their North Star—their guiding light. My job, regardless of project size, was to help each company actualize that purpose. Every single aspect of my design for them had to connect back to the reason why the company existed. I admired this part of my work,

but much like Lenora, I didn't ever question my own purpose. It was easier to embody the mission of others than to stand in my own truth. It felt safe.

Lenora's story represents what happens when we let someone else be the protagonist of our own story. It could be a parent, child, friend, boss, or anyone we can point to as the reason why we can't live up to our own potential. They are our excuse. We fool ourselves into believing their story is our story.

When I first began sketching, I could easily distance myself from what I was creating. I did this through criticisms, judgment, and a tendency to focus on perfecting the outcome. The distance felt safe. I didn't have to take action. I could just react. I knew I was embarking on a search for meaning and to do so meant that I would eventually have to take action. It meant I would have to experience and feel my own pain.

As you think about falling deeper into this practice, how do you need to reframe your life? How do you need to redesign it? How do you need to recreate it?

If you look around you, there may be physical reminders of instruments gathering cobwebs, sketchbooks hidden in the backs of closets, journals gathering dust on a bookshelf, ballet shoes packed in a box, or art supplies in a drawer you haven't touched in years. Each embodying neglect and highlighting the dissonance between your heart's and soul's desires with how you choose to live your life today.

# DESIGN SKETCHES

When you are wired for achievement, you are living for someone else's approval. You don't feel free to lead and make your own plans. When you try to begin an inward journey, this mindset robs you of your energy. It depletes you rather than regenerates you. As you gain insight into the way in which performance impedes your progress, you will find the kind of energy you need to truly experience change. Over time, your mindset develops around growth and the change process accelerates with more and more fluency.

Independence from external forms of validation is both terrifying and liberating. Both emotions are natural fuel. Experience is the natural compost of change. Freeing your imagination allows you to process new information without having to act on every impulse. Reactive, protective responses evolve into fearless awareness.

It is easier to live through someone else than to complete yourself. The freedom to lead and plan your own life is frightening if you have never faced it before.

—Betty Friedan

## SKETCHING THROUGH CONFUSION

( 30 MINUTES )

### *OBSERVE*

When exploring your inner world, it is inevitable that you will experience a natural tension. This tension comes as you recognize your capacity to create and destroy. You may or may not be immediately conscious of what part of you is casting the shadow. However, learning to see our shadows is an integral part of accepting and loving our whole selves.

Some examples of our shadow self could be based on traits, behaviors, or attitudes we do not like about ourselves. It could also originate from experiences or memories we have avoided or

suppressed. It may even be inherited from the generations before us. Whatever the source, our shadows bring to light the balance of both.

The following prompts are examples of how you can learn to play with the shadows. Let your imagination expand the way in which you understand your own agency and provide insight into the way in which others affect you and the way you affect the world around you.

Discomfort is the price of admission to a meaningful life.

—Susan David, PhD

## *SKETCH*

Place an everyday object, that is, a cup, toothbrush, leaf, etc., on your sketchbook and let the light cast shadows on your paper. Rotate your object in different ways to find a shadow that appeals to you. Now engage with this shadow by either creating an outline, bringing out an image you see from it, or using it as a starting point to express the emotions you are feeling.

This prompt is an invitation to understand who you are, the way you take up space in the world, and how you want that space to make others feel. It is also a way for you to see the positive and negative expressions in your life. Be curious about what you see, and experience what it is like to play in the shadows.

Some of you may already have a natural inclination to look at the shadows of your life. If so, I encourage you to design in the light around the shadows instead.

If you choose to repeat this experience, you may want to choose an object with sentimental value or meaning. When you repeat it, pay attention to whether your emotions change toward the shadow of this object when compared to the shadow of an everyday object.

You can also explore shadows in the environment around you, that is, from a window, skylight, stairs, tree, etc. Let the world around you cast a shadow on your page and find one that piques your interest. Outline the shadow or create lines and patterns inside

or outside the shadowed spaces. Play and engage with the whole page and pay attention to the emotions you are feeling.

Find the balance of exploring your shadows, while feeding the light. Set the intention to counteract the heaviness of what emotions this prompt may evoke and with the playfulness of its expression. Use the presence of both darkness and light, play and exploration, as a way to view all parts of a whole.

## *REFLECT*

When you are done, take a moment to reflect on what you sketched:

1. What patterns, themes, or images arose?
2. What emotion(s) did you feel during the sketch?
3. How did your body respond throughout?
4. Did any memories, thoughts, or insights surface?
5. Did you observe any shifts in energy or perspective?

— SKETCH —

# SKETCHING WITH CLARITY

( 30 MINUTES )

## *OBSERVE*

Think about how sculptors approach their work. The way they see the full compass of the form they are molding from every angle. Each perspective guides them to shape, guide, smooth, work, cut, shave, poke, slice, wet, dry, soften as they add, subtract, and refine the clay into the form they imagine. Each action is a reaction that leads to another action.

For this experience, I want you to think about the way in which your hand can mimic and imitate the movements a sculptor would make while sculpting. As you do, I want you to imagine what you would be molding if the clay was in your hands. You will need a variety of thick and thin pens, brush pens, or watercolors to complete this piece.

The artist must create a spark before he can make a fire and before art is born, the artist must be ready to be consumed by the fire of his own creation.

—Auguste Rodin

## *SKETCH*

For the first ten minutes, begin the sketch by imagining what your hand and wrist may feel like as they are kneading the clay. Imitate that action on the page. Mimic the swirling movements with the thickest pen you have.

For the next ten minutes, imagine your hands shaping or molding the clay. Use a medium-size pen to create the upward, downward, or sideway strokes to form it.

Lastly, imagine your hands carving the intricate details. Use your finest-tipped pen to imitate the way in which you would carve the finest details.

After you have sketched through the motions of sculpting the

clay, pay attention to the physical response of your limbs, muscles, and joints.

Once you've explored and expressed the physical movements of sculpting, turn your attention to the visual and emotive quality of it. Build upon your sketch and consider the following:

- Is the shape recognizable or abstract?
- Is the surface textured or smooth?
- What did your mound of clay become?
- Did you have any expectations of what it would be?

## *REFLECT*

When you are done, take a moment to reflect on what you sketched:

1. What shapes, patterns, and/or images do you see?
2. What emotions did you feel during the sketch?
3. How did your body respond throughout?
4. How do you feel after sketching versus before?
5. Did any memories, emotions, or insights surface?

In creative expression, there is no such thing as too much or too little. It welcomes you as a creator. It does not boast in the outcome. It revels in the beauty of the process. It heralds your effort. It celebrates your commitment. It doesn't blame you when you falter. It asks you to show up as you are.

Take the time to recognize your effort and draw insights from this process. What does this form represent in your life? How do you mold the shape of who you are each day? Is your life already defined or do you make room to create it?

Revisit this prompt if you are thinking of starting a passion project or are in the midst of one. It is important to pause and reflect on the why and to ensure our actions are in alignment with what we had envisioned. You may even want to buy some Play-Doh or clay and play with it to get the full experience.

## ― TESTIMONIAL ―

"I have a stomach of steel. I can eat anything without distress, but the night before I sketched this a pain on my right side woke me up at two a.m. and kept me up till five. As the pen moved across the page, I imagined that the literal knot in my stomach was being released, spiraling out from inside— some of it evaporating into space and some settling with density down into the earth. I didn't know what the knot was but I wanted it out. The pain subsided through that day but in the evening, it came back. I lay down with a hot water bottle, holding the achy area and decided to dialogue with it, sense into what it might mean from an emotional perspective.

"Suddenly, I understood the pain was slowing me down so I would stop long enough to identify it. The pain was asking me to see my smallness—not a knot at all, but all the nots. I do not want to be seen. I do not want to be self-expressed. I do not want to be the most powerful and vulnerable version of myself. Why? Because I'm scared. There was this tiny, hardened version of myself

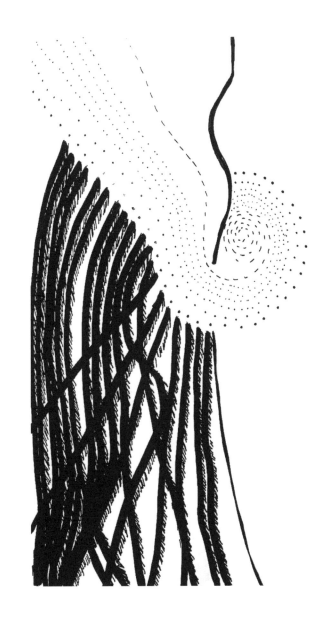

who believed it was keeping me safe through silence and invisibility. I stayed with it and loved it and under my hand it dissolved the way I sketched it earlier that morning.

"Days after, I had conversations I'd been terrified to have for years; six weeks later I executed a project I'd wanted to do for decades; and more importantly I accessed a new level of authenticity that had never been possible. I moved past my fear. I expanded. I got bigger. And as for the physical pain, it never returned."

—Michelle Fiordaliso,
@michellecarmelafiordaliso

# 21

# SKETCH THROUGH

"Am I doing it right?" This inevitable question, or one similar in vein, arises in every participant who has taken the leap into daily sketching. It is a question wrought with complexity and meaning, drenched in a waterfall of expectations and doubts. At times it is directed as a desire for validation or affirmation, but for others it is a rhetorical question laced with the first taste of their unknowing.

It is a universal question felt in the most personal of ways. Each person's story has its own antagonist, story arc, and plot twists. To ask this question is to listen to the internal resonance vibrating within. A frequency of truth and insight waiting to find its way onto paper, giving itself permission to live outside of this inner world we have crafted to protect and to disguise who we are and how we came to be.

My response to this question is never an answer. It is in the recognition of the power of the questioning, the contemplation, and the Socratic dialogue that ensues when we examine with pure childlike curiosity the fleeting thoughts that flow in and out of our minds each day. It is in the thoughtful, trivial, indiscriminate questions where the image of our whole selves is revealed. To question is to awaken.

The most authentic thing about us is our capacity to create, to overcome, to endure, to transform, to love, and to be greater than our suffering.

—Ben Okri

There is no right way, only your way. It is in the courage and vulnerability of the doing where the magic lies. There is no expert, teacher, artist, peer, critic, or loved one, who can argue, affirm, dismiss, or validate your self-expressions as their own. Each sketch is yours and this truth is the invitation you have been seeking all along. To stare at the belief of how something created only for you can seem less worthy of your time, energy, or comfort is one we can ponder for hours, days, or weeks. It is ripe for inspiration and the first of many questions that will arise.

As you begin to create and express this image of self, you will flow into the current and energies in and around you. You will embrace the comfort of grace as things begin to connect and reconcile the felt sense of your inner world with the nonsensical existence of your outer world. You will find peace with your past selves, the many selves who had to attach or detach in order to survive or thrive. You will be challenged in disruptive and immutable ways, to see it mirrored in the uncertain or certain marks you will create. You will surrender to the darkness and light that exists within. You will accept both as parts of who you are. You will cherish it with the love and reverence it divinely deserves.

If at any time during this process you pause, stop, or perhaps never got started, know that all of it is okay. SketchPoetic is a tool for creative expression. As with any tool, the opportunity will present itself. Set this book aside. Let these words simmer and settle within your soul. Explore other tools in sync with your natural expression. Sing out loud, play an instrument, write poetry, journal your thoughts, dance to release, whatever your heart desires. Revel in the many tools available for self-exploration and self-expression. Wherever you are in the spectrum of readiness, may this book renew and revitalize your relationship with art and open your eyes to the dimensional and textured world of creation.

Let your sketches give voice to your story. It may seem daunting and scary, exciting and exhilarating, or maybe even luxurious

and indulgent. Whatever critical emotions arise, invite them in. Give every emotion permission to be felt, seen, and heard. Begin to be an observer and witness to your story. Seek to understand the tremors of the seismic shifts happening within. Seek to find freedom in the act of play and creation. Seek to hold compassion for one's self as you stumble upon the uncomfortable truths evident in our imperfect and perfect humanity.

We all have these intuitive moments when we know that our lives are about to change. When it does, it is natural for our mind and body to resist and hold on as tightly as possible to the now. There is no promise of tomorrow we can guarantee. Yet we spend so much of our lives chasing it.

You have been waiting for this moment to begin. All of it is guiding you in a direction of your growth. You've experienced the joy and pleasure of creating.

There will be pain.

Sketch through it. Each time you do, your ability to navigate similar experiences becomes agile. Your understanding and confidence are surer.

There will be fear.

You are recreating your existence. You'll lose the control that has comforted you and regain your ability to play in the wild. You'll unravel the conditioned values, beliefs, or attitudes that no longer serve you. You will sit in the energy of your inner world and find safety in the vastness of it. You are the key to the possibility of its promise.

You do not have to be a parent to understand the agony and ecstasy of giving birth. At the core of the creative process is an archetypal journey of giving birth to creation. It begins with an experience that we incubate until it is time for it to have a life of its own. We become transformed in the process of its creation. We become co-creators, collaborators, conspirators with the constant creation of the universe.

I invite you to push through this moment and to remember:

There is no perfect time.
Nothing can prepare you fully.
There is nothing to figure out.
There is no right or wrong.
This journey is uniquely yours.

You are the key to unlocking the power of this daily practice.
As you leap into it, may you observe the ways in which your hope, faith, and love are activated.

As you sketch, may you hear in the silence the sound of your breath, the cadence of your character, and the heartbeat of your truth.

As you examine your beliefs, may you have the courage to trust your intuition and let go of narratives that no longer serve you.

As you flow into this practice, may you perceive with insight the truth you are expressing.

As you reflect on what you are creating, may you provide yourself with a safe space to surrender and trust the wisdom growing within you.

As you find renewal, may you share your inspiration, sustain your progress, and learn to play with your experiences.

And finally, may you begin what you have already started with a clear sense of purpose and design.

*Sketch by sketch*—my friend, sketch through what you go through.

## — TESTIMONIAL —

"The journey of SketchPoetic has been the most empowering experience I ever had in my adult life. Through the community we have emerged into, I feel held and heard. It really helped me to come out from the protective walls I've built and step into the creative power that regenerates into its fullest presence in my creations. Now, I proudly show up in the world as an artist.

"I first started following Sheila on Instagram more than four years ago. The synchronicity started there as I was also given the gift of intuitive drawing. However, back then, my stubborn self was so frightened—I stuffed my intuition into a box and hid it in the corner of my life. I kept myself busy with things that brought me suffering. The pain was becoming so overwhelming, I began to start sketching again. It was the only way I could get through the day.

"Meeting Sheila and the group this year felt like discovering an oasis in a desert. At first, I couldn't even believe it was real: everything from theory to practice that Sheila had preached resonated with my own experiences. I needed the validation back then to feel ready to embrace

who I am and to no longer hold myself back from this creative expression.

"As I finally surrendered and allowed myself to feel the pain in its fullest, the new skin started growing back around my wounds. These creations are stories and emotions that still bring me to tears as I look back.

"Lastly, what I am the most grateful for is the emotional communication this sketch community has opened up in my life. Through them, I have (re)learned that art is the language of emotion that we, modern humans, have forgotten. Art provides nourishment for our souls and we need it everywhere and urgently in the world today."

—Charlotte Qin, @qintheory.studio

# Q & A

What if I am not an artist? Is this book still for me?

If you go into this practice with the intention of choosing to release something in your creation, then you are already halfway there. Most people naturally experience a wide range of emotions, and these emotions equip you with everything you need to embrace the process as fully as any artist would. While creating art is one of the inevitable outcomes, it is not the primary motivation for this work. Your intention is responsible for the beauty and significance.

Think of art as a healthy way to express something in your mind and in your heart. Something that has been weighing on you. Something that perhaps you consciously or unconsciously know you need to let go of. All of these thoughts and emotions can serve as inspiration.

I purposefully call this practice "creative expression" and not "daily art" because you will be using your pen and paper to tap into this inspiration and creatively express how you feel each day. It is not about creating a masterpiece, or even making something you would consider aesthetically pleasing. It's about releasing the emotions you are holding and manifesting them onto paper. These visualizations will empower you to move from the gift of sight to insight and awaken the wisdom of your mind, body, and spirit. So,

this practice is not dependent upon skill, but rather on the willingness to see its unfolding as equally creative and spiritual.

Is this a "How to Draw" book?

No, it is not. While you will learn to creatively express yourself using sketching techniques, there is no predefined object or image you are learning to draw. Instead, the marks you make will likely begin as rough doodles that will transform into more refined illustrations. With time, you will develop your unique visual style best suited to your unique personality. Similar to improv or jazz, the movement of your pen on paper will progress to the beat of your own rhythm.

In terms of the sketching techniques used, I will ask you to think in more abstract terms throughout the beginning of this process. Therefore, the outcome will look more like abstract art than realistic portraits, landscapes, objects, etc.

Does it have to be abstract, or can I sketch something I recognize?

Emotions are complex by nature, and so is our ability to visualize them. I encourage you to venture beyond familiar images, symbols, and objects and remain open to exploring the emotions swirling within. For example, if the emotion you are feeling is peace, an image of a dove or a peace sign may appear in your mind. Initially, it may seem logical to sketch these images to convey your feelings. However, with further introspection, perhaps you realize that what you are really expressing is how the idea of peace is stereotypically interpreted and communicated in the external world.

Instead, it can be helpful to think about visualizing how "peace" makes you feel inside. Taking this step in assessing what an emotion feels like to you and not how it looks to others is critical for your self-awareness, healing, and growth.

What if I don't know what emotions I am feeling?

This level of emotional awareness can create a challenge for some beginners when they are first adopting a daily sketching practice. If you aren't familiar with identifying your feelings, then expressing them with pen and paper can feel like an impossible leap. I try to remind everyone that we probably didn't have the words or understanding to articulate how we were feeling as young children. However, when a child plays or creates, the emotions they are feeling are organically expressed.

Thinking and sketching in abstract terms will allow you to create a tangible representation of your internal experience, without analysis or rationalization getting in the way. It can mirror what is emotionally taking place in your body without requiring a literal representation. Returning to this daily will eventually lead to deeper levels of emotional awareness and understanding.

It is important to remember that the act of creation, in and of itself, is healing. This holds true even if you don't consciously know what your art is saying or expressing. As your awareness develops, you will notice a shift in what you are able to recognize and how you find meaning. You will start to connect the imagery and themes in your artwork to what is happening in the world around you. This will come with time, so try not to rush the process. Focus on simply creating.

Are there any "art basics" I should be familiar with before starting?

There are several base assumptions I make when first introducing this practice to an individual or to a group of people. First, I assume you have picked up a crayon, pen, or marker at some point in your life. Second, I assume you have had to visually express something at work, at home, or in play. For example, even

computer engineers and mathematicians must visualize complex systems, diagrams, or formulas to develop and communicate their ideas. This can be thought of in a similar vein. Of course, the main difference is your expression of emotions and feelings instead of numbers and theories.

If you have held a pen and visualized an idea, then you have all of the basics you need to get started. For additional support, I have also included a Visual Library of sample marks and patterns you can use as a starting point. However, if you still desire to learn any additional tools or techniques for drawing, I highly recommend searching on YouTube or buying a book on learning to draw.

What materials will I need?

In the beginning, I recommend using whatever materials you already have access to. It could be scrap pieces of paper, an old notebook, paper towels, napkins, or even Post-it Notes. This same train of thought can be applied to the pen you use, as well. Pick up any black ballpoint or ink pen you can find at home, at work, or in public spaces (libraries, hotels, restaurants, etc.). With these basic materials, budgets or limited resources should not be the reason you don't give it a try.

If you choose to invest even more into your practice, you can purchase a black hardcover sketchbook at any regular art supply store (such as Blick or Michaels) and a Sharpie fine-point pen or Uni-ball gel pen at most retail stores (such as Target, Staples, or online via Amazon.com).

Will I eventually invest in high-quality materials?

As your practice develops, you may choose to invest in higher-quality, archival materials to ensure your sketches remain in the best condition long term. Examples of top-grade sketchbooks are Leda, Canson, Strathmore, Pentalic, and Bienfang. Examples

of pens are Sakura Pigma Micron, Faber-Castell, Staedtler, and Copic.

This may also serve as a great reward once you've hit your stride and created a habit for yourself. Expanding your tool kit can help you appreciate the varying "feel" and textures of materials. When you have fully connected to the power of expressing your emotions, your choice in tools can also help you with visually exploring the emotional and energetic landscape in new ways.

Whether or not you decide to invest in high-end materials in the beginning is entirely up to you, but I can share my personal thoughts and experiences. At times throughout my own journey, I have wondered if purchasing the most expensive materials created more pressure and led to old patterns of starting something new and stopping before I was finished. I have stacks of unfinished sketchbooks with hundreds of blank pages suggesting this might be the case. Eventually, I realized that using basic materials gave me an opportunity to not feel so attached to the tools and instead focus more on the process at hand. For me, simple portability and accessibility mattered most.

Can I use a pencil?

This is a common question, and the answer is no. The permanence of ink is a necessary part of the healing process. Ink cannot be erased, which often makes it feel like an intimidating commitment. You will make marks you may not be happy with, but each mark nevertheless serves a specific purpose. There is no such thing as a mistake when you are sketching through what you are going through.

When sketching with ink feels as natural as using a pencil, then you have made great strides in confronting your inner critic and perfectionist. Over time, the frustration you feel by not being able to rework or redo your creation will be replaced with complete trust in the process. This is ultimately the first step in learning to trust yourself, let go of control, and surrender to what is present.

Can I use color or other mediums (e.g., paint, charcoal, pastel)?

Timing is an important part of introducing other mediums. If you are a novice or new to creative expression, my recommendation is to get comfortable with ink and pen before attempting to introduce anything else. Pen and paper can create their own special opportunities for growth and awareness. While variety is certainly the spice of life, challenging yourself to see how far you can push the boundaries with the few options available to you is part of the transformation.

As a general rule of thumb, color and other mediums will be additive to your daily practice. Similarly to purchasing high-quality materials, these will eventually allow you to expand beyond your initial practice as a way to further explore complex emotions and layered meanings. As with all components of this process, I ask you to trust your intuition. You will know when the time is right and when your mind, body, and spirit are ready to move deeper.

What time of day should I sketch?

The specific time of day isn't as important as finding a time you can regularly commit to. I have personally found that scheduling blocks of time in the morning helps to start my day off on the right foot. Perhaps this is the same for you, or maybe you would prefer to use sketching as a way to wind down in the evenings. You can even choose to sketch during scheduled breaks at work, when the kids are napping, after everyone falls asleep at home, or after completing your homework.

Creating a new habit requires practice, consistency, and a steady schedule. Viewing it as a ritual can further aid in adapting your mind, body, and spirit to the practice. The key is cultivating something reliable and developing a sacred space, while still maintaining a sense of flexibility with life's naturally unpredictable nature.

Is there a best place to sketch?

Finding a place to sketch can be part of the joy with adopting this new daily habit. As you take inventory of the possibilities, think about the type of energy you would like to be surrounded by. Do you prefer a quiet, clutter-free space? Or, do you enjoy sitting on a couch surrounded by the chaos of normal life? Try a few different spots until you find the one that feels just right.

I personally chose a local coffee shop near my office as my sacred space during the week. The location was convenient, and the atmosphere was a home for creative people and energy alike. I was surrounded by actors, writers, musicians, entertainers, entrepreneurs, and dreamers. In other words, I was surrounded by inspiration.

On the weekends, I sit at my dining room table with natural light pouring in from the skylight above. The room also has French doors that open up to the view of our garden outside. This space represents the energy I feel going into my sketches: full of light and open to possibility.

As you can see, the particular place is unique to your process and matters less than your own headspace. When you are in flow, you are able to get lost in the act of creating as your surroundings disappear. Ultimately, the place most conducive to this flow is where you will want to go whenever possible.

Can I sketch more than once per day?

Absolutely. Through this process, you may unexpectedly discover that you are a natural artist, or you may stumble upon an intense desire to create all the time. This is often true if you have been secretly longing to connect to your creative and visionary sense of self. It can feel like seeing a body of water in the middle of a desert and wanting to drink in as much as you can to quench your thirst.

My only caution is to pace yourself. There is no need to rush this process. You will inevitably quench your thirst by returning to it daily, so take your time and ease into the excitement. Too much of anything too soon can lead to burnout. If you still have a strong desire to create beyond the scope of your daily sketching, limit yourself to two to three hours of extracurricular expression per day and limit this to two to three times each week. Use a new page or piece of paper and remember to stick to the guidelines: do not revisit or rework your daily sketch in any way. Always keep in mind that this extra time is purely additive.

What if I don't sketch every day?

This is your personal practice. If you have to skip a day or two because of unexpected changes in plans, then you can absolutely do so. It is important to check in with yourself and your intentions when you do feel this pop up. There is a difference between necessity and avoidance. Only you can hold yourself accountable for knowing the difference.

Both healing and growth require a sense of discipline. For some, a daily commitment can initially feel like a big change in prioritization. This is especially common for individuals who believe they have limited time and energy to invest in their own self-care. If this sounds familiar, I would like to challenge you to think about how you currently spend your average day. Most of us have a tendency to spend at least thirty minutes on mindless and numbing activities every single day. This might include:

- Watching TV or entertainment
- Scrolling through social media
- Reading tabloid magazines
- Gossiping with family or friends

- Engaging in one-sided relationships
- Spending time on something that (or with someone who) drains your energy

These activities can be a natural way to cope with challenging emotions or periods of life. However, these emotions and difficulties also mean that this is exactly the right time to explore a daily sketching practice. The greatest transformations often occur before we believe we are ready and amidst life's biggest hardships. Try using this as a source of inspiration to return to your sketchbook regularly. This is what it means to trust the process.

How long do I sketch for?

Starting off, I ask that you sketch for ten minutes per day. It is a short enough time frame to fit into any busy schedule, but it is also long enough to push through initial discomfort and achieve a flow state. Over time, these ten minutes will pass by in a blink of an eye. When your time is up, stop and reserve any remaining fuel for the next day. It will help you to sustain this habit.

It can also be helpful to extend this approach to feeling and working through your emotions in everyday life. You do not always get to choose how much time you have to process what is happening internally. Sometimes life will force you to move on to the next thing out of necessity or survival. Feel as much as you can whenever you can and surrender when you must.

Do I need to stick to the allotted time, every time?

The goal of time-boxing is to help create a habit, but it can also aid in preventing overworking or attaching to a certain outcome. Creating a set stopping point allows you to confront your perfectionist and inner critic. A fundamental aspect of the growth you will ex-

perience through this practice is cultivating the ability to feel okay with moving on even if your vision isn't "complete."

If you have more than thirty minutes to dedicate to your sketching, use the additional time for reflection and insight. These are vital for continued growth and healing. Supplementing this practice with writing is another powerful way to enhance the therapeutic benefits of creative expression.

If you find yourself wanting to stop before your thirty-minute mark, then go inside and investigate the motivation behind your feelings. If you are questioning yourself, your abilities, or the value of your practice, then I urge you to push through the discomfort and harness the feelings for further inspiration. It can be one repetitive and monotonous mark on the page, just as long as you are allowing your mind and body to grow accustomed to sketching every single day.

Do I have to fill the entire page?

Filling a page is certainly not a requirement. The primary intention is to sketch through the truest expression of your emotions, so your sketches may vary in size. Intense emotions may require the use of big, bold strokes and more space on the page. More complex or nuanced emotions may require finer details and significantly less space on the page.

Can I sketch on more than one page during the same time frame?

It is quite common to feel a sudden shift in energy during your practice and a desire to start sketching on a new page. You may experience an unexpected jolt of inspiration or resurfacing emotional trigger. When this happens, trust your intuition and give yourself a clean slate.

However, this guidance does not apply to appeasing your inner

critic. If perfectionism is provoking the desire to start sketching on a new page, this is once again a time to sit with the discomfort and continue with the creation at hand. If the uneasiness grows, you might try rotating the page to give yourself a different perspective.

No matter what comes up, there is a lesson to be found. Remember: you are exploring creative expression and not necessarily creating artwork. You may not find your sketch visually pleasing, but there is still great meaning.

Can I work on the same sketch over an extended period of time?

For the daily sketches, the answer is no. It is important to focus on these sketches as one-time exercises. Think of your practice as taking an emotional selfie every day. Emotions are fluid and change over time, so being able to reflect on just one sketch or emotion allows for deeper introspection and insight.

However, if the desire to add on to a previous sketch is still present, I recommend using a separate sketchbook or larger sheet of paper. This will enable you to honor the process of the daily sketching practice while exploring additional projects that require more time and patience to complete.

Please refer to "Can I sketch more than once per day?" for additional guidance.

Should I sketch in silence or with music?

Initially, I ask you to sketch in silence or with natural ambient sound (i.e., sound that does not come from any speakers). This will allow you to hear your internal thoughts or musings without distraction. Your relationship with silence can play a major role in your transformation. For some, silence is comforting and supports

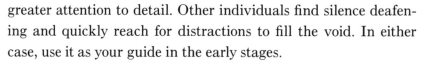

greater attention to detail. Other individuals find silence deafening and quickly reach for distractions to fill the void. In either case, use it as your guide in the early stages.

When you have mastered the habit of daily sketching, you can begin to introduce music. Music has an intrinsic ability to influence and inspire. It can unlock deep emotions, intensify the ones you are already aware of, or spark an influx of new imagery. Holding off on anything that can amplify your emotions in this way (such as scents, sounds, etc.) is a wise decision when starting off.

What if I get distracted while sketching?

Distractions are an inevitability. The goal is not to avoid them altogether, but rather to minimize how often they occur. It can be difficult to stay focused on one task without the mind wandering onto something else. This is why mindfulness has become essential for our emotional and physical well-being, and why schools, companies, and organizations are promoting it as part of their health and wellness programs.

Utilize the tenets of mindfulness when you can, but don't be afraid of leaning into a distraction. Instead of pushing it away or pretending it's not there, I encourage you to acknowledge and create deepened awareness around what is causing the distraction. Use this inner dialogue as a source of inspiration and continue to sketch through the mental conversation. Similar to emotions, distractions can serve as additional guidance if you take the time to listen.

What should I do when I get stuck?

If blocked is what you are feeling, then sketch what it is like to be stuck. Visualize the patterns, textures, and marks. If you are frustrated, then try sketching some scribbled lines to convey the

frustration. If you are annoyed, then try sketching swirls to convey the annoyance.

It is helpful to acknowledge that there is usually a deeper emotion beneath any interpretation of stuckness. Remove the layers until you get to the root of your experience.

Will sketching unearth emotions or memories that I do not want to feel?

Yes, this is possible. However, our desire to feel (or not feel) something is quite different from our need to feel it. This practice will require you to remain aware of and even confront the emotions you have previously chosen to ignore or bury.

Sketching is a self-paced, self-guided exercise, so you have the opportunity to titrate how deeply and how quickly you explore an emotion or memory. If you feel triggered or unnerved, pause and return to your breath. If you need additional support, seek professional help. A licensed art therapist can support you in further exploring your emotions in a creative and facilitated way.

What should I do if my emotional state doesn't have a corresponding prompt or guide?

It is very likely this will happen. Over time, the evolving visual language you develop will foster greater emotional and intuitive attunement. Use the sketching skill set you have nurtured to create your own internal prompts. You will learn what marks to use to convey your emotional and energetic landscapes.

What should I do when I run out of prompts?

Each prompt can be expanded or repurposed throughout your journey. As you progress in your practice, you will discover that many old prompts begin to take on new meaning. A nuance that

you once saw as trivial can become monumental. You can also deepen your insights and reflections by observing one specific prompt over a period of time by returning to it with repetition.

As explained in the previous question, you will inevitably develop your own unique set of internal prompts for your evolving emotional experience and expression. In this sense, you will never truly run out of guidance.

Can I supplement this practice with other creative tools?

Absolutely. In fact, I encourage it. The choice of daily sketching was inspired by Morning Pages from the book *The Artist's Way* by Julia Cameron. But this time, instead of writing three pages a day, I sketched a page a day in my sketchbook.

Over time, sketch by sketch, my inner voice grew bolder and so did my desire to express it. It was then that I started to introduce writing as an expansion of it.

Many participants in my workshops often complement their sketches with other forms of creative expressions, specifically with poetry, painting, dancing, performing, composing, singing, cooking, and gardening.

Do I need to share my sketches with others for input and insight?

This is a personal preference, rather than a requirement. Sketching is deeply personal. What matters most is what you are trying to convey and what you see, rather than what another viewer might think and believe. However, sharing can also play a role in your healing process. This type of vulnerability is a beautiful and meaningful way to connect with others. You can open yourself up to being seen in your authenticity, which can be an integral piece for experiencing growth, love, and belonging.

In the early stages of your practice, I recommend focusing more on developing your own insights and opinions in isolation. Ab-

sorbing others' perspectives can hamper your ability to tune in to your inner knowing, lead to harsher self-criticism, or influence an attachment to the visual outcome. Share only when you are able to remain grounded in your personal experience while simultaneously listening to observations from external sources.

What is the best way to approach someone if I decide to share a sketch?

There are several factors to keep in mind when approaching someone. First, acknowledge your intention for seeking an external opinion. Are you looking for a new way to cultivate meaningful connection (as previously explained) or are you hoping to receive validation for your skill set? Notice what expectations you are harboring and do your best to release them. You will enrich the experience of sharing by letting go of what you think you want to hear and opening up to the possibility of being surprised by a new interpretation or insight.

Second, be mindful of the nature of your relationship with this person. Your vulnerability is as sacred as theirs. Some people are not comfortable being asked, while others may jump at the opportunity to offer their thoughts. If you sense that someone is tentative because they are afraid of hurting your feelings or saying the wrong thing, offer them compassion and reassurance. You can use this time to express your intention in sharing the sketch and create a feeling of safety for honest and open dialogue.

Third, use your sketch as an invitation to better understand this person and your relationship with them. Interpretations can vary depending on an individual's emotional state, level of attention, or history. There is truth to what they see and feel, just as there was truth to what you were seeing and feeling when you sat down to sketch. To receive and hear comments from others with curiosity and compassion, you must detach from the belief that these comments are personal feedback. When you step away from

notions of "good" and "bad," you create space for healing, connection, and emotional freedom.

To help guide you, below are some questions to elicit curiosity, spark imagination, and nurture emotive responses. These questions will expand the conversation beyond the critique of your sketch or your proficiency as an artist.

- What is the first thing your eye is drawn to as you look at the sketch? What about it spoke to you, and why? (This is a great way to focus attention or ease a sense of intimidation.)
- Did this sketch evoke any emotions or memories for you? (Listen intently and with curiosity. After they share, you can discuss what emotions you were feeling and expressing, too. The purpose isn't to correct or convince them, but instead to celebrate the beauty of multiple interpretations.)
- I've been sketching for X weeks now. I'm curious to hear if you have noticed any shifts in me or our relationship? (Use this as an opportunity to discuss the changes happening in both of your lives.)

Again, the purpose of these questions is to create equanimity in space and perspective. Interpreting the sketch is subjective for both the creator and the viewer, and all interpretations are valid.

Should I share my sketches on social media?

This is also a personal preference. There are benefits and drawbacks to sharing on social media, so making this decision will require additional introspection and honesty with intention. I cannot tell you what is best for your creative process, but I can share my individual experience.

When I first made the commitment to sketch daily, I chose to

create an Instagram account to hold myself accountable. At the time, I didn't realize my sketches would resonate with so many people. Now, my online community holds my vulnerability with grace, as well as a special place in my heart.

However, a growing online presence creates its own set of obstacles. This practice is founded upon the belief that you are an audience of one, which means that your own opinion must always be held with the highest regard. Larger audiences (of any size) can lead to increased pressure to share something "worthy," aesthetically pleasing, or popular. If you experience this, try going "offline" and circling back to your primary motivation for picking up this book and beginning a daily sketching practice.

How long should I be doing this as a daily practice?

As a starting point, I would like you to commit to a minimum of twenty-one days. It is long enough to develop a habit and short enough to feel a sense of achievement upon finishing. Ideally, this is a practice you can continue indefinitely.

What is a natural next step upon finishing?

You may decide to explore new mediums, tools, or avenues for creative expression. You can try using paints, pastels, markers, clay, or collage to express yourself and your emotions artistically. Or, you may feel a pull toward poetry, spoken word, embodied movement, music, or performance art. Your intuition and unlocked creative potential will lead you to the next phase of exploration.

If your sketches feel like they are telling a story, try writing one. If you hear music as you sketch, try picking up an instrument. If your body is vibrating with intense energy, try diving into a physical practice to release the energy.

This practice does not have an end date, but it will certainly open you up to new passions, pursuits, and possibilities.

What changes will I experience, in myself and in my life, with this practice?

The degree to which you experience change in your life will be determined by what you devote to this practice. Your individual desires and intentions will pave the path forward. As such, the corresponding levels of transformation certainly vary from person to person. This accounted for, I can attest to common and notable changes in perspective, creativity, self-awareness, and interconnection.

Regardless of the details, personal transformation is never a linear process. As you take the next steps, you will experience intermittent periods of major growth and periods of small, almost imperceptible shifts. Rest assured, even in your willingness to try something new, you have already opened the door to the possibility of remarkable change.

What if I don't get anything out of this practice?

Similar to the natural variation in personal transformation, what you "get out of this practice" will be unique to you. For some, the outcome is physically intangible yet spiritually profound. For others, the opposite may be true. This practice will meet you wherever you are in your healing journey and often give you what you most need during that singular moment in time.

The key is allowing this to unfold organically and without expectation, just as you will learn to do with each of your daily sketches. The joy is in creatively expressing yourself without feeling overly attached to the end result. Embodying this mindfulness, with or without a sketchpad, is essential. If you leave this

practice with a smile on your face or a renewed sense of peace, then that is more than enough.

Is there a meetup or community I can join?

To join an online community, please visit my website—www.sketchpoetic.com or my Instagram page @SketchPoetic. You can follow me there and find many like-minded creatives. This community is grounded in open and honest expression, story-telling, and exploration. As we have discussed, it may be nice to engage with community members who are embarking on similar journeys.

To join an in-person community, I suggest starting your own SketchPoetic circle with family members, friends, neighbors, coworkers, or schoolmates. Use your time together to sketch, share vulnerably, and create an open dialogue around each other's creations. I recommend meeting on a weekly, biweekly, or monthly basis. The more often you spend time with one an-other, the stronger and safer your community will feel. If you prefer, this can also be done in a one-on-one setting with a "sketch buddy."

In either case, I do hope you find or build a community for yourself. It is one of the most beautiful parts of this journey and offers the much-needed reminder that you are not alone in what you are working through. Witnessing others' insights, awaken-ings, and challenges creates a felt sense of our shared humanity, healing, and connection.

How do I get in contact with you?

If you would like to contact me to share your journey, or ask ques-tions related to this book, you can email me at sketchpoetic@gmail.com.

You can also subscribe to my monthly newsletter through my website http://www.sketchpoetic.com, where I frequently share the latest news, spotlight community members, share relevant stories, and offer additional resources.

# READING LIST

It is common for your passions and interests to expand as you explore the art and science of creative expression. Curiosity will lead to your own discoveries and illuminate the resources you will need to support you on this journey. Use this list as a reference in your search for knowledge and truth.

Barrett, Lisa Feldman. *How Emotions Are Made: The Secret Life of the Brain.* Mariner Books, 2018.

Brackett, Marc. *Permission to Feel: Unlocking the Power of Emotions to Help Our Kids, Ourselves, and Our Society Thrive.* Celadon Books, 2019.

Brooks, David. *The Second Mountain: The Quest for a Moral Life.* Random House, 2019.

Brown, Brené. *Braving the Wilderness: The Quest for True Belonging and the Courage to Stand Alone.* Random House, 2017.

Brown, Brené. *The Gifts of Imperfection: Let Go of Who You Think You're Supposed to Be and Embrace Who You Are.* Hazelden Publishing, 2010.

Burnett, Bill and Dave Evans. *Designing Your Life: How to Build a Well-Lived, Joyful Life.* Knopf Doubleday Publishing Group, 2016.

Cameron, Julia. *The Artist's Way: A Spiritual Path to Higher Creativity.* TarcherPerigee, 1992.

Cameron, Julia. *The Listening Path: The Creative Art of Attention.* St. Martin's Essentials, 2021.

Chödrön, Pema. *When Things Fall Apart: Heart Advice for Difficult Times.* Shambhala, 2000.

Coelho, Paulo. *The Alchemist.* HarperOne, 1988.

Csikszentmihaly, Mihaly. *Flow: The Psychology of Optimal Experience.* Harper Perennial Modern Classics, 2008.

Dambrot, Shana Nys. *Zen Psychosis.* Griffith Moon Publishing, 2020.

David, PhD, Susan. *Emotional Agility: Get Unstuck, Embrace Change, and Thrive in Work and Life.* Avery Publishing Group, 2016.

Devine, Megan. *It's OK That You're Not OK: Meeting Grief and Loss in a Culture That Doesn't Understand.* Sounds True, Inc., 2017.

Doyle, Glennon. *Untamed.* Dial Press, 2020.

Dumpert, Jennifer. *Liminal Dreaming: Exploring Consciousness at the Edges of Sleep.* North Atlantic Books, 2019.

Dweck, Carol S. *Mindset: The New Psychology of Success.* Random House, 2006.

Edwards, Betty. *Drawing on the Right Side of the Brain.* Jeremy P. Tarcher, 1979.

Estés, PhD, Clarissa Pinkola. *Women Who Run with the Wolves: Myths and Stories of the Wild Woman Archetype.* Ballantine Books, 1992.

Fogg, PhD, B. J. *Tiny Habits: The Small Changes That Change Everything.* Houghton Mifflin Harcourt, 2019.

Gibran, Kahlil. *The Prophet.* Alfred A. Knopf, 1923.

Gilbert, Elizabeth. *Big Magic: Creative Living Beyond Fear.* Bloomsbury Publishing, 2015.

Gottlieb, Lori. *Maybe You Should Talk to Someone: A Therapist, Her Therapist, and Our Lives Revealed.* Houghton Mifflin Harcourt, 2019.

Grof, Christina and Stanislav Grof. *The Stormy Search for the Self.* TarcherPerigee, 1992.

Hull, Jeffrey W. Shift: *Let Go of Fear and Get Your Life in Gear.* Lyons Press, 2010.

Jung, C. G. *Memories, Dreams, Reflections.* Vintage, 1961.

Kanyer, Laurie. *Collage Care: Transforming Emotions and Life Experiences with Collage.* Kanyer Publishing, 2021.

Kaufman, Scott Barry. *Transcend: The New Science of Self-Actualization.* TarcherPerigee, 2020.

Kotler, Steven. *The Rise of Superman: Decoding the Science of Ultimate Human Performance.* New Harvest, 2014.

Lamott, Anne. *Bird by Bird: Some Instructions on Writing and Life.* Anchor, 1995.

Malchiodi, Cathy A. *Expressive Arts Therapy: Brain, Body, and Imagination in the Healing Process.* The Guilford Press, 2020.

Maté, MD, Gabor. *In The Realm of Hungry Ghosts: Close Encounters with Addiction.* North Atlantic Books, 2010.

Maté, MD, Gabor. *When Your Body Says No: Understanding the Stress-Disease Connection.* Wiley, 2011

Miller, Alice. *The Drama of the Gifted Child.* Basic Books, 1979.

Nagoski, PhD, Emily and Amelia Nagoski, DMA. *Burnout: The Secret to Unlocking the Stress Cycle.* Ballantine Books, 2019.

Nepo, Mark. *The Book of Awakening: Having the Life You Want by Being Present to the Life You Have.* Red Wheel/Weiser, 2000.

Ortigo, Kile. *Beyond the Narrow Life: A Guide for Psychedelic Integration and Existential Exploration.* Synergetic Press, 2021.

Osho. *Learning to Silence the Mind: Wellness Through Meditation.* St. Martin's Griffin, 2012.

Richards, William A. *Sacred Knowledge: Psychedelics and Religious Experiences.* Columbia University Press, 2015.

Rumi. *The Essential Rumi, New Expanded Edition.* HarperOne, 2004.

Rutte, Martin. *Project Heaven on Earth: The 3 Simple Questions That Will Help You Change the World…Easily.* Livelihood, 2018.

Schore, Allan N. *The Development of the Unconscious Mind.* W. W. Norton, 2019.

Schuchman, Dr. Helen. *A Course in Miracles.* The Foundation for Inner Peace, 1976.

Shojai, Pedram. *The Urban Monk: Eastern Wisdom and Modern Hacks*

*to Stop Time and Find Success, Happiness, and Peace.* Rodale Books, 2016.

Siegel, Dr. Dan. *The Whole-Brain Child: 12 Revolutionary Strategies to Nurture Your Child's Developing Mind, Survive Everyday Parenting Struggles, and Help Your Family Thrive.* Delacorte Press, 2011.

Singer, Michael. *The Surrender Experiment: My Journey into Life's Perfection.* Harmony, 2015.

Singer, Michael. *The Untethered Soul: The Journey Beyond Yourself.* New Harbinger Publications, 2007.

Stanton, Amy and Catherine Connors. *The Feminine Revolution: 21 Ways to Ignite the Power of Your Femininity for a Brighter Life and a Better World.* Seal Press, 2018.

Taylor, Joshua C. *Learning to Look: A Handbook for the Visual Arts.* University of Chicago Press, 1981.

Tolle, Eckhart. *The Power of Now: A Guide to Spiritual Enlightenment.* New World Library, 2004.

van der Kolk, MD, Bessel. *The Body Keeps the Score: Brain, Mind, and Body in the Healing of Trauma.* Penguin Books, 2015.

Watts, Alan. *You're It! Hiding, Seeking, and Being Found.* Sounds True, 2009.

Williamson, Marianne. *A Return to Love: Reflections on the Principles of "A Course in Miracles."* HarperOne, 1992.

Wolynn, Mark. *It Didn't Start with You: How Inherited Family Trauma Shapes Who We Are and How to End the Cycle.* Penguin Life, 2017.

# ACKNOWLEDGMENTS

To my dear husband, Micah, the love of my life and Renaissance man, with you all things are possible. As a clinical psychologist and gifted artist, your wisdom and expertise are threaded within the fabric of this book. Thank you for being my truthsayer. You are the glue that holds my storied life together.

To my daughter Leila, my creative muse and humble teacher, thank you for inspiring me each day. I watch in awe as you walk your own path with confidence, courage, and conviction. May you always be the hero of your own journey.

To my mother, Marilou, our souls are forever entwined in our shared experience of life's joy and suffering. Through your faith, I have witnessed the divinity of God's grace. Through your spirit, I have felt the purity of unconditional love. You are my hero.

To my stepfather Geary, your gentle spirit and generous heart are my constant. Thank you for all of your sage advice. You are a walking encyclopedia. I am blessed to call you my dad.

To my incredible family in Australia, the Philippines, and the U.S., the two special ones I married into (the Lintons and the Ripps), and all of my Filipino aunties and uncles connected by heart and not by blood, thank you for all of your love and support. "Ang pamilya ay hindi isang mahalagang bagay lamang. Ito ang lahat."

Rachel Smith, my writing partner and coddiwomple friend.

From our serendipitous first exchange to the birthing of this divinely guided book, every moment challenged, unearthed, and nourished the creator within. We deconstructed and reconstructed our personal truths and made way for the collective ones to shine through. What an adventure it has been to walk beside you on this meandering yet purposeful path.

Coleen O'Shea, my literary agent and fierce advocate, thank you for believing in me, this book, and for opening the door to its rightful home. Grateful for your kind heart and unwavering support.

Joel Fotinos, my editor and creative collaborator, thank you for shepherding this book to its fullest potential. You watered the seed and nourished the soil for my author's roots to take hold. It has been a true honor to work with you.

Gwen Hawkes, my associate editor, John Karle, Beatrice Jason, my marketing and PR team, NaNá Stoelzle, my copy editor, and the entire St. Martin's Essentials team, thank you for the warm welcome and guiding me every step of the way.

Mary Moitozo Stock, my high school Spanish teacher, you nurtured my inner child and believed in the woman I would become. In your eyes all things are possible.

Wendy McDaris, my college art professor, you shaped the way I see the world. You once told me, "The highest calling of art is to be in touch with your own soul." Your prophetic words echo within the pages of this book.

Amy Stanton, my cherished friend, mentor, and confidante, it is in your steadfast presence where I learned to surrender to it all. Thank you for your timely advice, intuitive insights, and unconditional friendship. Your divine magic knows no end.

Geeta Novotny, my co-creator and spirited sister, thank you for paving the way as a healing arts practitioner and being the steady voice that guided me along this path. Grateful for our continued partnership and creative evolution.

Scarlett Lam, my woo woo sister, thank you for reviewing my

book proposal and being the listening ear I could turn to on a whim. Your calming presence served as a constant reminder that everything is as it should be.

Ayka Pogrebinsky, I am deeply moved by all the ways you have supported me and the SketchPoetic community. Together with your agency, Swurl, your collective passion in bringing my vision to life is a testament to your generosity of spirit.

Zeena Darwish, Jeanette Ferrera, Rick Seymour, Susanne Longo, Margaret Reed, my lifelong friends, thank you for being an ever-present source of love and support in my life. You recognized the artist within well before I claimed it.

Gail Batac, Erik Guzman, Carrie Yury, Katie Concetta, Nathan Hackstock, Doug Abel, Melanie Currie, thank you for our creative collaborations. Sharing the SketchPoetic journey with each of you has meant the world to me.

To my TNT tribe for life, Cathy Colvin, Leena Dunn, Diana Fung, Lian Jue, Anita Manglani Mawji, Smrithi Narayan, Sunita Param-Olazabal, if I could paint the sky with the abundance, hope, love, compassion, strength, joy, and laughter felt and shared between us, it would create a light so bright even the shadows would bow in its presence.

To my Westside crew, Arati Desai Wagabaza, Matia Wagabaza, Claudia Wiehen, Lino Wiehen, Kyo Yamashiro, Matt Hergert, Jeanette Ferrera, Jeremy Millers, Falguni Lakhani Adams, Richard Adams, Sabrina Amani, Susan Derby, Johnny Parker, thank you for being my steady anchor in calm waters, safe haven in the turbulent storms, and for creating a playful space for "Tequila Sheila" to emerge. I couldn't have made it through without you.

To my Wild Sage sisters, Deborah Anderson, Julie Jordan, Kerith Creo, Patricia Pinto, Rosanne Grace, Trine Bietz, I stand beside each of you in our collective purpose to change the world.

To my fellow healing arts practitioners Geeta Novotny, creator of Revolution Voice®, Dr. S. Ama Wray, creator of Embodiology®, Lauren Sheehey, creator of Lovegrown and Hungry for More, and

ACKNOWLEDGMENTS

Michelle Fiordaliso, creator of The When Is Now, through your voice, movement, and writing programs, I have experienced the power of creative expression in its many forms. Thank you for inspiring me to follow in your footsteps.

Thank you to the entire Hay House UK team, Emily Arbis, Millie Andrew, Lizzi Marshall, Tom Cole, Portia Chauhan, Katherine O'Brien, and Jo Burgess. Thank you for believing in the heart, soul, and intention of this book. You gave it wings and made it fly to new elevations. I am truly grateful for the kindness and generosity you have shown along the way.

Thank you to the organizations who believed in the purpose of SketchPoetic—Langely McNeal, Jessie Duke, Alex Menache from the Summit Series, Fritzi Horstman from Compassion Prison Project, Jane Chung from JoyTude, Tommy Sobel from Brick, Jerold Limongelli from MVN Movement, Sarah Hernholm from Camp WIT, Aashna Patel from INI Foundation, Asha Banks from Cheer-Notes, David Angelo, Lindsay Stein from Today, I'm Brave.

Thank you to the podcasts who gave me a platform to share my story—JoJami Tyler, Lana Helda—*Ladies Roadmap,* Joseph and Lauren Sheehey—*JoeLo Show,* Nikki Barua, Monica Marquez—*Beyond Barriers,* Moussa Mikhail—*Conqueror Approach,* Andy Grant—*Real Men Feel,* Dr. Hisla Bates—*Creativity and Psychiatry,* Matt Vogl—Crazed, Robyn Goldberg—*The Eating Disorder Trap.*

To my friends at Verve coffee shop, thank you for creating a magical space for me to sketch each morning. So much of my healing journey took place there. I'll remember each of you always.

And finally, to my beloved SketchPoetic community, you have left an indelible mark in my heart. This book is my love letter to all of you.

# ABOUT THE AUTHORS

Denise Demarest

Erin Roberts

SHEILA DARCEY has twenty-plus years as a facilitator and consultant in the technology and digital agency space. Her work with Fortune 500 companies informs her understanding of what drives transformative growth in individuals and teams. She earned a bachelor of fine arts degree from the University of Memphis and a certification in social emotional arts (SEA) from UCLA. The SEA certificate empowers educators, community arts professionals, mental health practitioners and anyone interested in maximizing social-emotional benefits of arts experiences, and minimizing self-judgment and anxiety that can impede learning and growth.

DR RACHEL SMITH is a writer, professor and instructional designer. She uses the principles of design and metaphor to support change management and the development of learning for a wide range of students and clients. Dr Smith earned her doctorate in educational leadership and policy from UCLA, where her dissertation focused on designing educational technology applications for the user experience. She earned a bachelor of arts degree in English from California State University, Fullerton,

with minor coursework in child development and linguistics, and a master of arts in administration focusing on change management from California State University, Northridge. Her rich background in education, leadership and community outreach for the last twenty years effectively complements Sheila's purpose and mission and helps to extend the instructional approach of this book.

For the latest news and updates, please visit www.sketchpoetic.com